D1506170

FRANCIS BACON
INCUNABULA

Martin Harrison
and Rebecca Daniels

Foreword by Barbara Dawson
Director, Dublin City Gallery The Hugh Lane

Tracing Bacon

Entering Francis Bacon's studio was like seeing into the artist's mind. The parameters are not just physical. It is the place where the private process of art-making is investigated in advance of the public work. In this inbetween-ness, sensations are broken down and assimilated before leaving their traces on the finished canvases.

At the time of his death Bacon's studio was well known yet undiscovered. It is a small room measuring 6 x 4 metres with heaps of detritus all over the space. Photographs, books, magazines, drawings and printed images all served a purpose until abandoned once again to the finished work. Until now this material had no voice. It was the silent champion of the artistic process.

Following on the donation of the studio to Dublin, we first regarded it as an archaeological dig. The archaeologists made survey and elevation drawings of the space before taking out the material item by item. The material was subsequently documented and archived in Dublin City Gallery The Hugh Lane. This process of excavation meant what was hidden has now come to light and what was beneath the surface was equally as important to Bacon as what was seen. The material is multi-layered in meaning and with each subsequent exhibition of his paintings it grows in importance. Fascinating to view, there is a wide and disparate variety of material, some smudged with bright paint accretions, others drawn over or deliberately torn, and several creased into distortions of the figure, usually the face.

The material dates from several periods of Bacon's life; some of it he brought with him when he moved to Reece Mews in 1961. Fragile and old, its transformation as it moved towards decrepitude took on another significance. This process of mutation was important for Bacon. The meanings are intriguing as they become the fertile sediment of his painterly practice. The works on their own had a particular significance, but when put together meant something entirely different. They are constantly changing, like shuffling the figures in a pack of cards. This surrealist 'exquisite corpse' connection between objects had an enduring fascination for Bacon, as our excavations reveal. The studio material seems to become more pertinent as the years pass as it becomes inherent to an understanding of the paintings and brings us closer to the artist. As time goes by the material takes on a whole new patina. Most of the people featured are now dead and what the magazine ads promote you can no longer buy. But no matter how much is revealed through the exposure of this material, the studio remains a visceral fascination and a mystery for those of us involved in its relocation.

Barbara Dawson

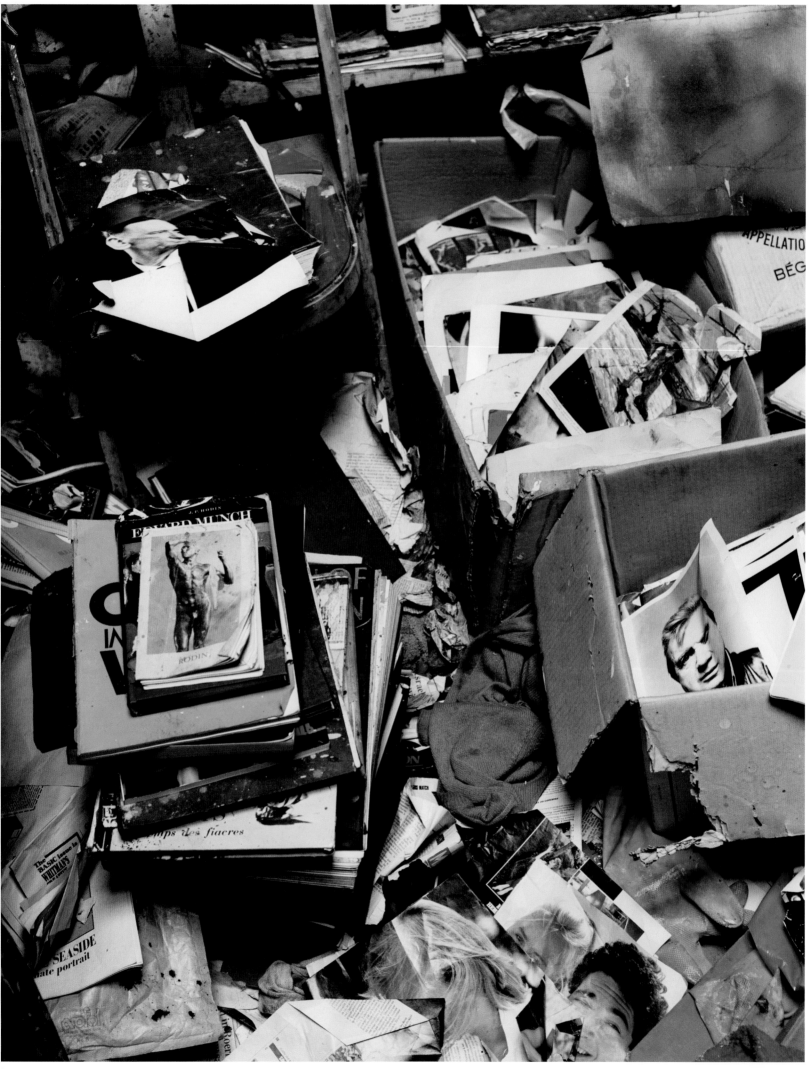

Bacon's Incunabula

Only Bacon's closest friends were allowed into his Reece Mews studio, except for the occasions on which he prepared it for the visit of a photographer, when unfinished canvases would be turned to face the wall. He was secretive about both his unconventional working procedures and his accumulation and absorption of images, and even intimates were hardly ever invited to examine the hundreds of books and magazines precariously stacked on shelves, or the hoard of images spilling from cardboard boxes and cluttering the floor. The dialogue between Bacon's nudes and Muybridge's kinetic figure studies had been publicly acknowledged since 1950, as had his admiration for Velázquez, Michelangelo and Rembrandt, but only since Bacon's death has it been possible to begin to apprehend the full scope of his visual stimuli.

The entire contents of Bacon's studio were donated to Dublin City Gallery The Hugh Lane in 1998, and most of the documents presented in this book are from the Gallery's extensive archive of more than seven thousand items. The study of these objects is still in its infancy, but the first criterion governing this new selection was that it should reflect the great diversity of Bacon's visual archive. Few of the images have been reproduced before, or they have been published with incorrect or incomplete provenances. Another guiding principle was that the specific source from which Bacon took every image should be identified and accurately dated: before any item from Bacon's image-bank can be interpreted, or related to his paintings, it is necessary to fix its terminus dates.

In 1996 John Edwards invited Brian Clarke to inspect Bacon's studio, which had remained virtually undisturbed since 1992. It was clear that many of the randomly scattered documents – whether immediately intriguing or apparently mundane – had been critically transformed by Bacon: they were, in effect, his preliminary studies. Key items were photocopied and shown to David Sylvester, who shared Clarke's sense of excitement at Bacon's tactile engagement with these mysterious but visceral objects. Twelve years later, this book forms part of a series of publications that Clarke first envisaged in 1996: as such it is partly intended as an adjunct to the catalogue raisonné of Bacon's paintings (due for publication in 2011). Purely photographic material, in the sense of original gelatin silver prints, is largely absent from this selection: the Hugh Lane is organizing a project devoted to this theme in 2009.

Since the invention of photography in the nineteenth century, countless artists have made use of mechanical reproductions. But Bacon transformed often banal raw material into paintings of exceptional potency and incisiveness. It has been argued that this base imagery is merely ephemeral, and clearly the dynamic between the items in this book and Bacon's paintings requires art-historical explication: yet from the evidence that is emerging they appear to be essential to a proper understanding of his methods and pictorial vocabulary. In regard to his public statements about 'drawing' and 'chance' they are revelatory.

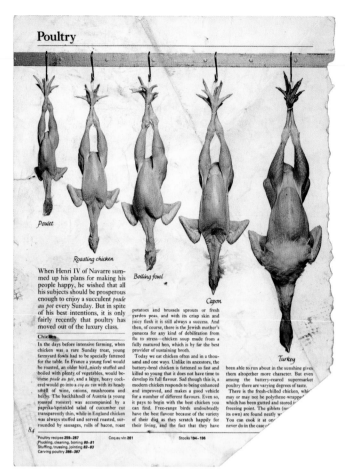

'Poultry', leaf from Terence & Caroline Conran, *The Cook Book*, 1980

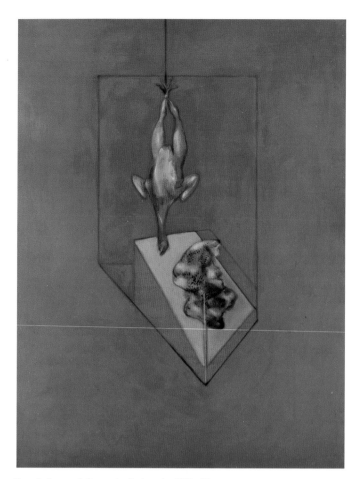

Francis Bacon, left panel of triptych, 1981–82

Bacon had little or no training in formal techniques of drawing, and seldom painted from life. Instead he appropriated images from books and mass-media publications and manipulated them into what became, for him, the equivalent of conventional preliminary studies. He also made copious notes of ideas for paintings, often variants of existing paintings, and sometimes made rough sketches of compositions.

In 1949 he found what was to remain his main subject for the rest of his life – the human body. Plates from various editions of Eadweard Muybridge's *The Human Figure in Motion* were a constant reference for his human forms but, as he explained more than once, 'Actually Michelangelo and Muybridge are mixed up in my mind together'. In about 1962 Bacon began to commission John Deakin to take photographs of friends and these fulfilled a similar function: while their poses were more static, they were sometimes fused with elements taken from the Muybridge images.

Occasionally Bacon's iconography would embrace subjects other than the human form – animals, for example, or landscapes. From childhood he was fascinated with hanging meat, enigmatically stating: 'If I go into a butcher's shop I always think it's surprising I wasn't there instead of the animal'. Once, while still a teenager in Ireland, he persuaded his friend Doreen Mills to divert en route from Straffan to the Naas Hurling Tournament to look at 'carcasses and cuts of meat hanging up' in Higgins the butcher's at Sallins.

The trussed chicken in the painting above, the left panel from a dismantled triptych, is a unique image in Bacon's extant oeuvre. It was accompanied by a Eumenides, but its significance is unclear, although it could be speculated that it was inspired by the death of his illustrious ancestor, Sir Francis Bacon, who, according to Aubrey, fatally caught pneumonia following experiments to preserve a dead fowl in snow. Presumably Bacon first had the idea to paint a hanging bird and then searched for a suitable model, although it is possible that the illustration (above, left) triggered this element of the painting. In one of his fairly direct transpositions, the chicken in the painting closely replicates the outline of the middle bird on the page.

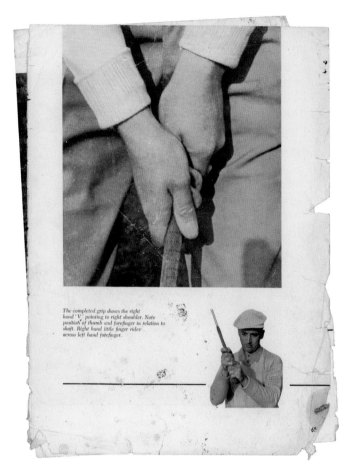

Leaf from book, Louis T. Stanley, *Style Analysis*, 1951

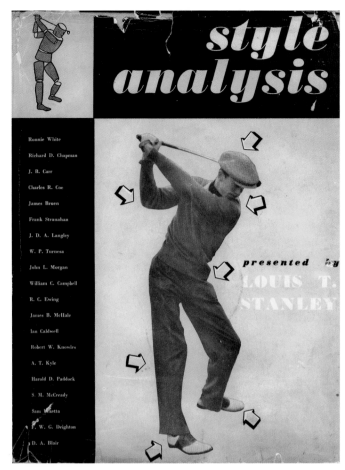

Dust jacket of book, Louis T. Stanley, *Style Analysis*, 1951

One of only two leaves that survive from a book Bacon owned on golf techniques (above) is of greater significance for his paintings than might at first appear. Ostensibly insignificant images of this kind were sometimes appropriated by Bacon for details in his paintings (they may have emerged from the floor or a cardboard box 'by luck', as he put it): a similar grip, taken from a diagram in a different book, Ben Hogan, *The Modern Fundamentals of Golf*, 1957, was transposed by Bacon into a detail in *Two Men Working in a Field*, 1971. Bacon was asked about the evolution of the directional arrows he included in his paintings from 1971 onwards and for once was not evasive, replying that he had found them in a golfing instruction manual. The identification of the book from which the leaf was taken has enabled Bacon's response to be verified, as the image on the dust jacket (above, right) confirms; this, however, was not found in his studio and is reproduced here from a separate copy of the book.

From 1929 onwards Bacon seldom lived far outside a one-mile radius from the Museum district in South Kensington, London. But in 1951, following the death of his former nanny,

Jessie Lightfoot, he peremptorily quit his studio in Cromwell Place. For four years he worked in numerous borrowed spaces, changing addresses with such frequency that it is unlikely much of his store of source imagery remained intact. Between 1955 and 1961 he occupied a room at Overstrand Mansions, Battersea, in a flat owned by Peter Pollock and Paul Danquah until, in the summer of 1961, he was able to move into 7 Reece Mews, which remained his base until 1992.

In 1959 Bacon had temporarily moved out of the constricted space at Overstrand Mansions to prepare for his first solo exhibition at the Marlborough Gallery, London: for just over three months he stayed in a rented studio at St Ives, Cornwall. His travelling companion, Ron Belton, has recalled the importance Bacon attached to his 'source imagery': 'Before we left London Francis bagged up loads of medical and zoological books, *Picture Post*, photographs, pages of children's limbs and so on, tied them in a bundle with string and took them to St Ives, where he immediately unpacked them and pinned them all on the studio wall.'

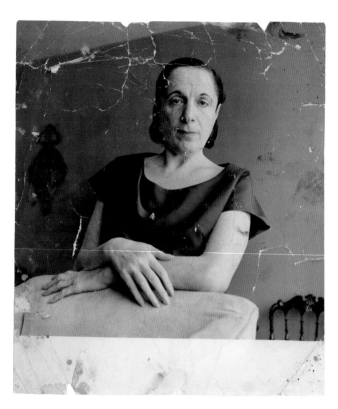

Muriel Belcher, photograph by John Deakin, c. 1965

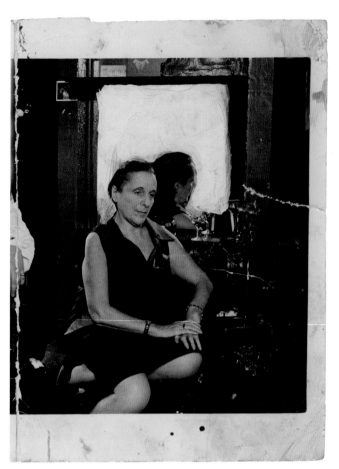

Muriel Belcher in the Colony Room, photograph (as folded by Bacon) by John Timbers, c. 1975

In 1950 the American art historian Sam Hunter visited Bacon at his studio in Cromwell Place and photographed an arrangement of his source images. Two of Hunter's photographs were published in the *Magazine of Art* in 1952, and they provide important evidence of the imagery Bacon had collected up to that point. Since none of the material recorded by Hunter survives today, Bacon either lost it in his peripatetic years or deliberately destroyed it. Bacon was ambivalent, at best, about declaring his 'influences', although he allowed Alley and Rothenstein to reproduce seven images in their 1964 catalogue raisonné and David Sylvester to publish ten more in *Interviews with Francis Bacon*, 1975.

It is unlikely we shall ever know how much of Bacon's earlier archive had survived to be removed to 7 Reece Mews in 1961, but relatively little of it remained intact at his death. Nonetheless, many of the leaves in this book ante-date 1961, and there is a strong likelihood that some were acquired and utilized by Bacon before that date. Bacon said he found a chaotic environment conducive to work, the impetus to create order out of the chaos. Yet during his thirty-one-year

occupancy of the Reece Mews studio he instigated regular clear-outs when the floor became too densely clogged, even for him. By the 1970s the interior of his studio had become a popular subject with photo-journalists. Their photographs show a now-familiar small room full of cardboard boxes crammed with photographs and loose leaves torn from books and magazines. On top of a shelf system to the left of the circular mirror, around one hundred books teetered in three piles. Bacon always removed their dustjackets and none of their spines was visible; he seems to have withdrawn books at random, as though an image he had not expected to find might trigger a chance association.

The images of Muriel Belcher (above, left and right) are both gelatin silver prints, but it is important to stress that in his absorption of disparate imagery he often employed photographs in combination with mechanical reproductions. The evolution of the painting *Sphinx – Portrait of Muriel Belcher*, 1979, is a case in point. Muriel Belcher was one of Bacon's close friends, and her significance to him is well documented. In 1948, shortly after opening the Colony Room, a private

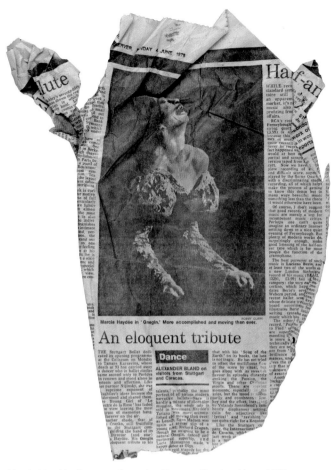

Marcia Haydée, fragment from the *Observer*, Sunday 4 June 1978

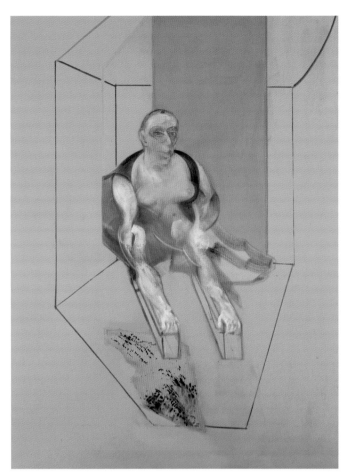

Francis Bacon, *Sphinx – Portrait of Muriel Belcher*, 1979

drinking club in Dean Street, Soho, she engaged the then penurious Bacon to attract customers to her new venture – he was paid £10 per week and all he could drink.

She became the subject of arguably his first great portrait, *Miss Muriel Belcher*, 1959, painted in St Ives, allegedly from memory but probably with the aid of photographs. A series of photographs by John Deakin, *c.* 1965 (opposite, left) was used by Bacon for *Three Studies of Muriel Belcher*, 1966. In 1979 Bacon, inspired by the various versions of the subject painted by Ingres, was planning a triptych of Oedipus and the Sphinx. In the event he painted only two of the panels, and these were separated when *Sphinx – Portrait of Muriel Belcher* was sold in 1980.

The conflation of Belcher with a Sphinx may have been partly fortuitous. She was ill in 1979, and Bacon's fondness for her was manifested in his visits to her hospital bedside – he loathed hospitals – while the painting was in progress. She died in October 1979, and it is plausible that the painting turned into a memorial of her. Bacon had painted sphinxes in

1953 and 1954, and the claws in *Sphinx I*, 1953, are particularly feline. But the exaggerated legs and claws in the 1979 version, as well as the bared chest, appear to have been informed by a photograph of the ballerina Marcia Haydée that Bacon tore from the *Observer* (above, left). The representation of a crumpled newspaper in the foreground of the painting, with its random (Letraset) lettering, may be a coded reference to the origin of this source image. The John Timbers photograph (opposite, right) was worked on by Bacon with white paint, isolating Belcher in a way that relates to the magenta 'dossal' (though without the mirror reflection) in the final painting. The splints were a device Bacon had used for one of the figures in *Three Studies from the Human Body*, 1967, which was based on an illustration in K. C. Clark, *Positioning in Radiography* (*130, 131*).

Thus, even those elements of *Sphinx – Portrait of Muriel Belcher* under discussion here were subject to complex and multiple factors, including the use of gelatin silver prints, a photograph in a newspaper, an illustration in a radiography book and reproductions of paintings from Bacon's own oeuvre, a complex

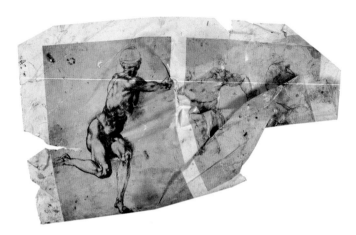

Michelangelo, studies for *The Battle of Cascina*, leaf from book, Luitpold Düssler, *Michelangelo*, 1959 (turned 90 degrees; see also *24*)

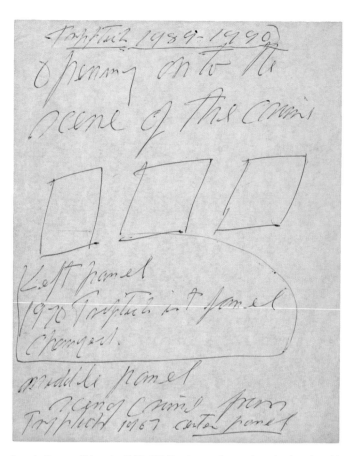

Francis Bacon: 'Triptych 1989–1990', scheme for projected triptych, with diagram and notes

synthesis that was typical of Bacon's practice. Yet the more this process is understood the greater is the imperative to maintain a distinction between these modified 'found images' and the finished paintings. Bacon's imagination may have been sparked in extremely productive ways by images he encountered in printed media, but there is no intention here to elevate them to the level of his paintings, to confuse the process with the end result, whose essence depended on his performance in spontaneous, fluid paint. As Bacon insisted to Sonia Orwell in 1954, 'I want to paint, not hunt for newspaper cuttings.'

A majority of the plates in this book are, then, of mechanical reproductions that can be regarded as preliminary to Bacon's paintings. His consistent denials that he also made drawings have become a topic of intense debate since his death, the more so since the exhibition *Francis Bacon: Working on Paper* at Tate Britain in 1999. The exhibition comprised forty-two works, mostly rough sketches of figures, executed rapidly in oils with a brush (a few were in pencil or ball-point pen), during a short time-span – from about 1959 to 1962.

The unexpected announcement of their existence was widely received as evidence that for over forty years Bacon had dissembled about what had been a secret vice.

Less widely debated has been whether these slight works by Bacon properly constitute drawing. In 1956 Michael Ayrton accused him of not being able to draw, and Bacon sardonically countered: 'Is drawing what you do? I wouldn't want to do that.' Irrefutably his sketches did not function in the same way as drawings by artists – for example Michelangelo or Giacometti – whose drawings Bacon profoundly admired (above, left). Most of the sketches retrieved from his studio are arguably more perfunctory than the Tate 'works on paper' (see *192, 193*): they are of considerable interest, but to define them as drawings is misleading, for no evidence has emerged to support a claim that Bacon rehearsed his human forms using a pencil and a sketchbook.

In the haste to accuse Bacon of an elaborate pretence it also tended to escape notice that he had clearly explained, in a 1966 television interview, that he sketched out with a brush,

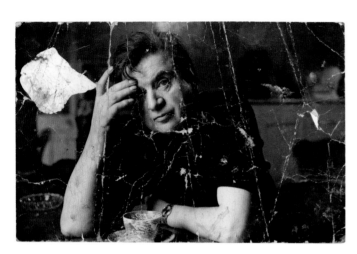

Photograph of Bacon in his studio, by Henri Cartier-Bresson, 1971

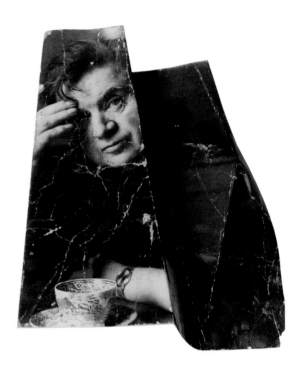

Facsimile of the Cartier-Bresson photograph (left), following the folds made by Bacon

in thinned oils, the outlines of a composition on the raw canvas: this was not drawing but the first stage of painting, and several unfinished canvases survive to demonstrate what he meant. A consequence of extravagant claims for the status of his sketches is that it has deflected from the significance of Bacon's unorthodox, surrogate 'studies' – the modified photographic material in this book. He described Velázquez's *Pope Innocent X* as having provided one of his seminal subjects: yet instead of setting out to draw copies of the painting he 'bought photograph after photograph of it.'

It has been contended that the crease marks on the photographs and printed reproductions found in Bacon's studio were incidental, the result of careless handling or damage that had occurred (as he himself disingenuously suggested) as a consequence of 'people walking over them and crumpling them and everything else'. The 'everything else' is significant. No doubt the paint marks often were accidental, although Bacon was also alert to the creative potential of these random blots (and hence entered an axis that spans Leonardo, Alexander Cozens and Rorschach). But the notion that their distressed condition was invariably accidental embodies a fundamental misconception.

A photograph of Bacon taken by Henri Cartier-Bresson in 1971 provides a compelling example of the directedness of Bacon's manipulations. Comparison with many other images with similar creases confirms that the diagonal folds, unlike the paint spatterings, did not occur by chance. By replicating the folds it can be demonstrated that Bacon manipulated the flat material into a cone-like shape – a three-dimensional form that could stand, next to his easel, independently. Working with inert representations that reduced the figure to two dimensions, he aimed to restore to them the corporeality of the person, to 'trap this living fact alive'. In the absence of a live model, but seeking the spectral quality of the human body in flux, Bacon re-formed the flat images into an inter-dimensional evocation of his breathing, transient subjects. The web of clues he left is only just being penetrated.

Martin Harrison

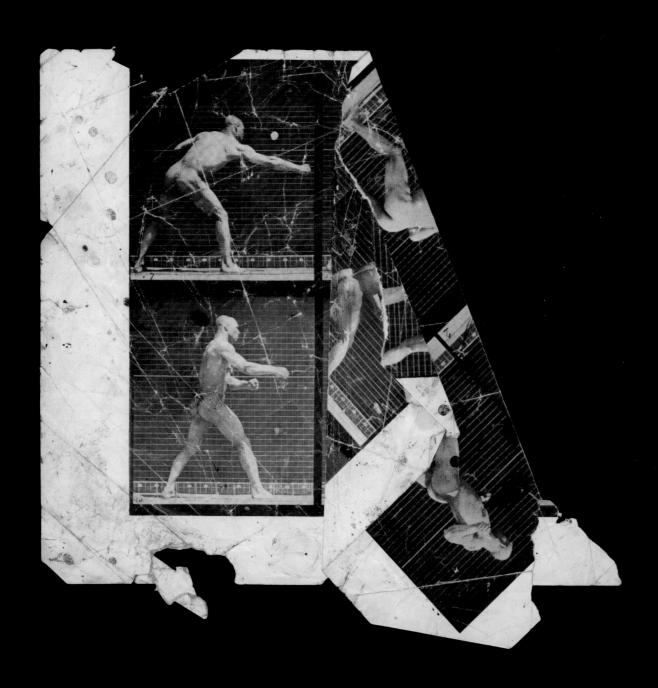

1

Art — Photography

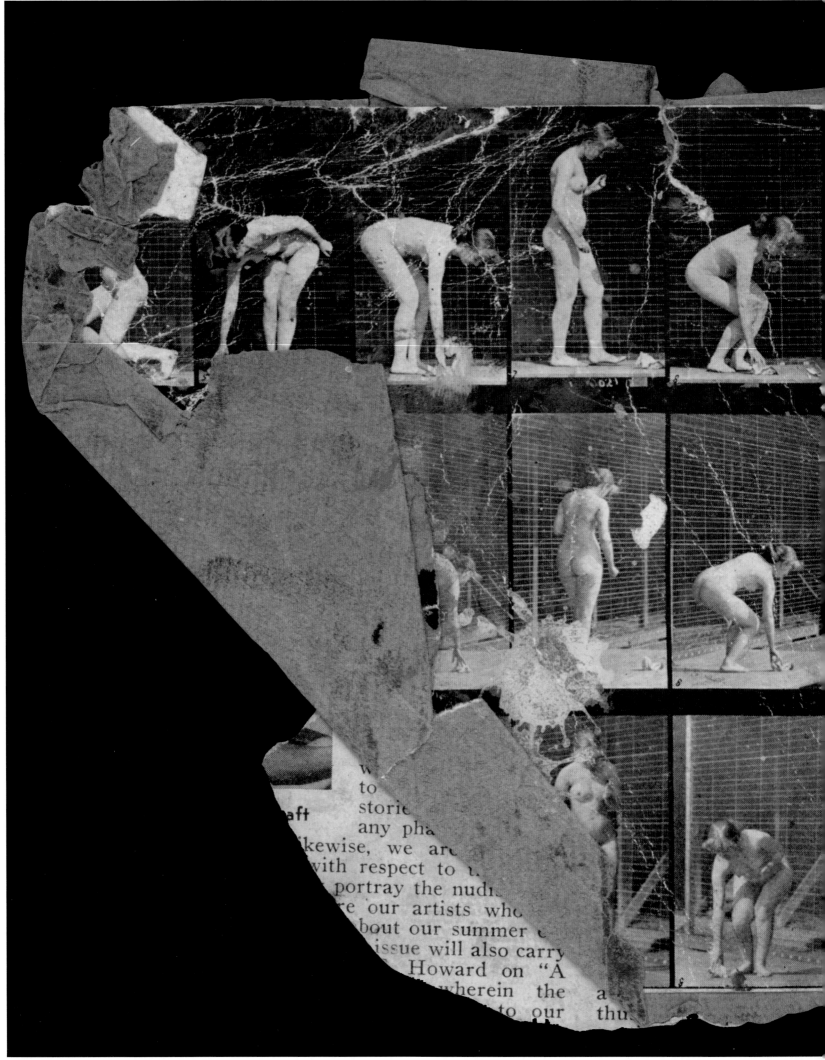

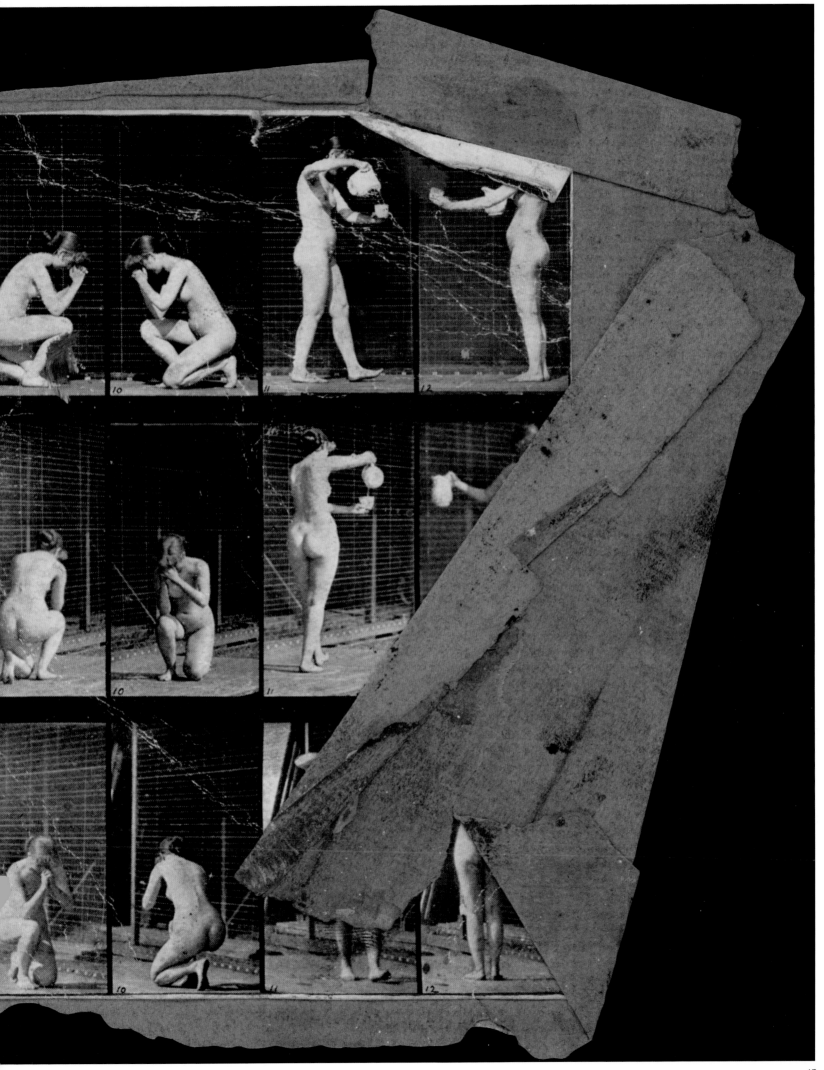

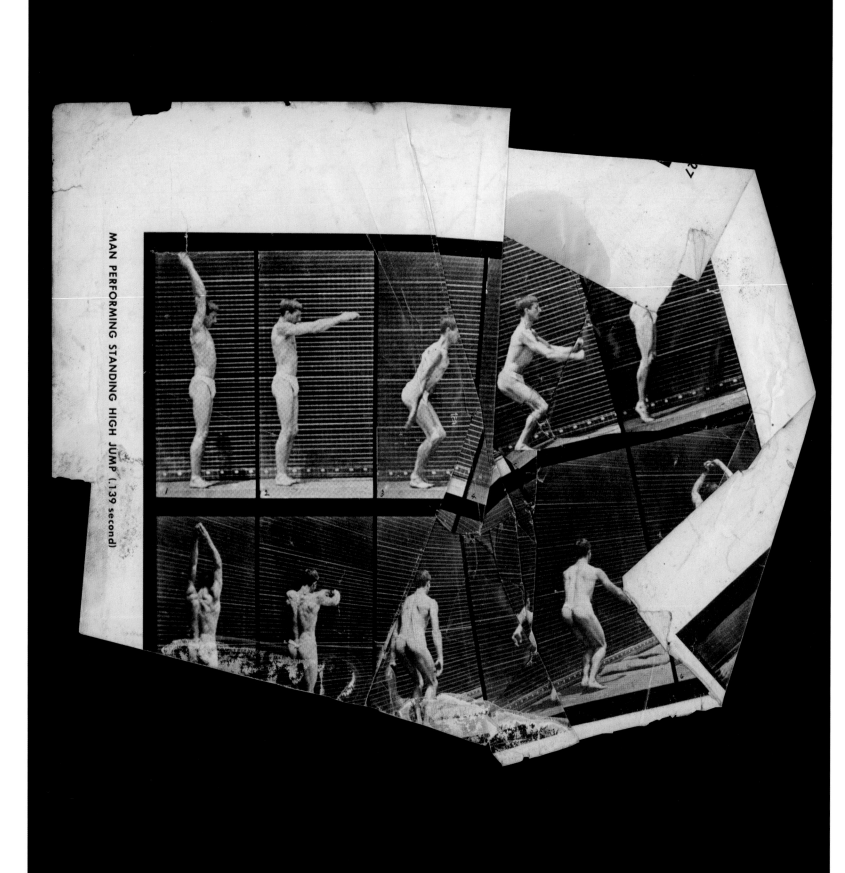

MAN PERFORMING STANDING HIGH JUMP (.139 second)

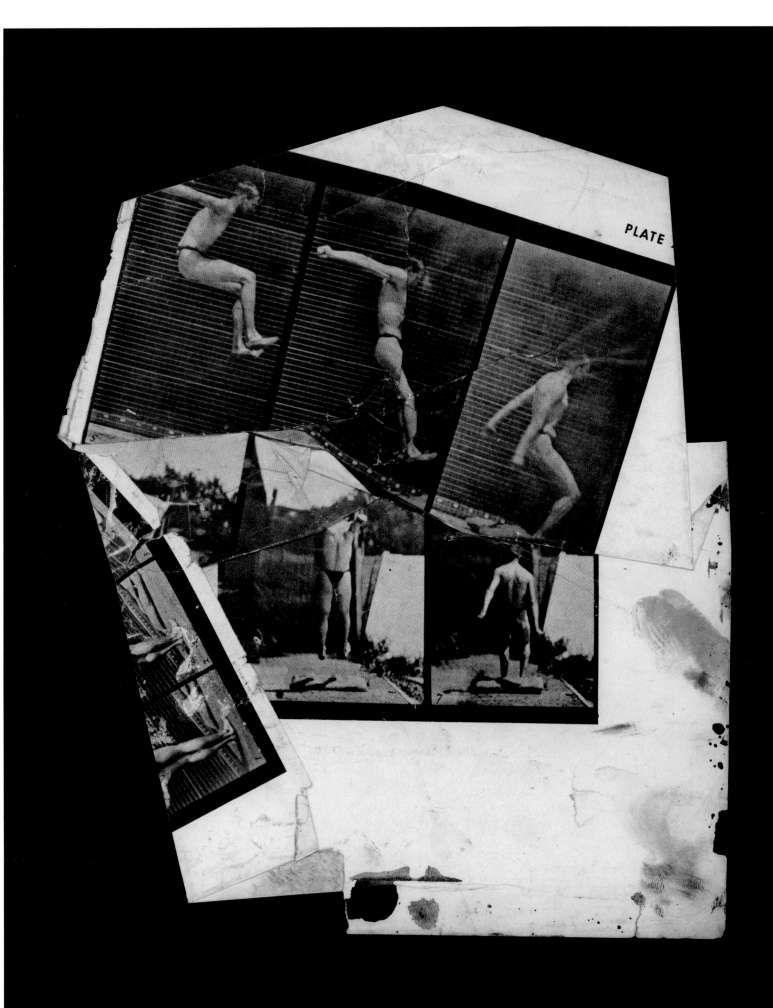

69.1 69.2

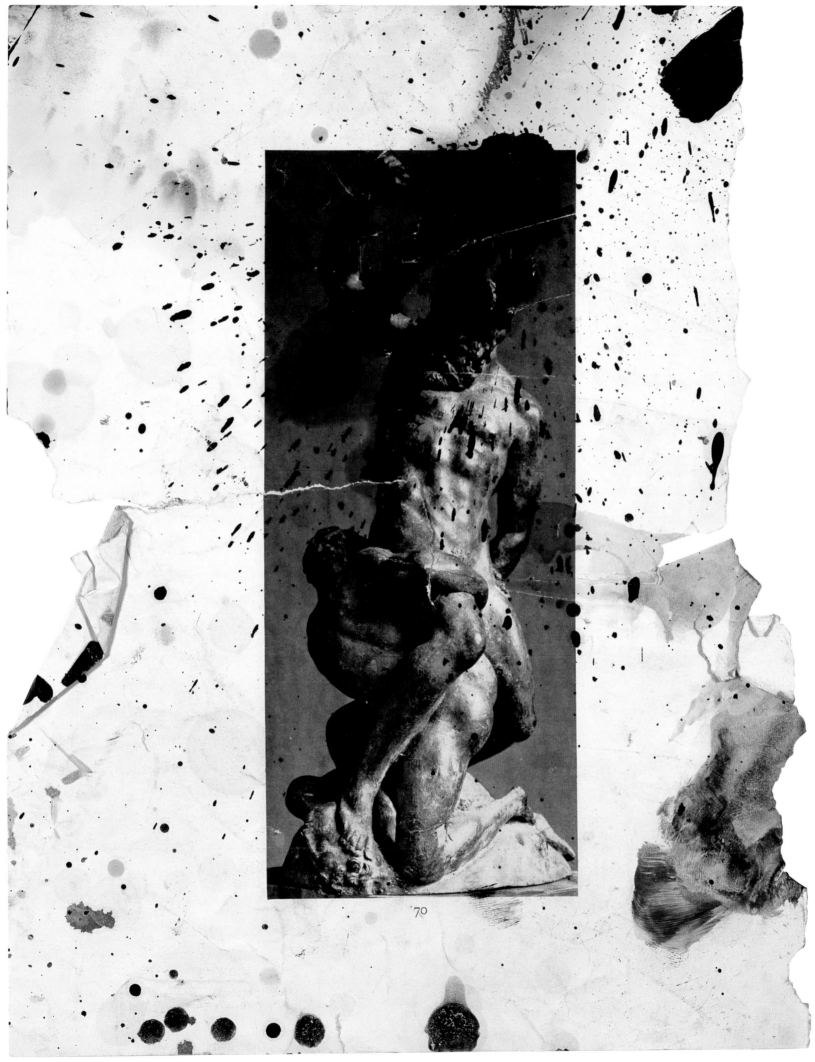

70

PLATE 73

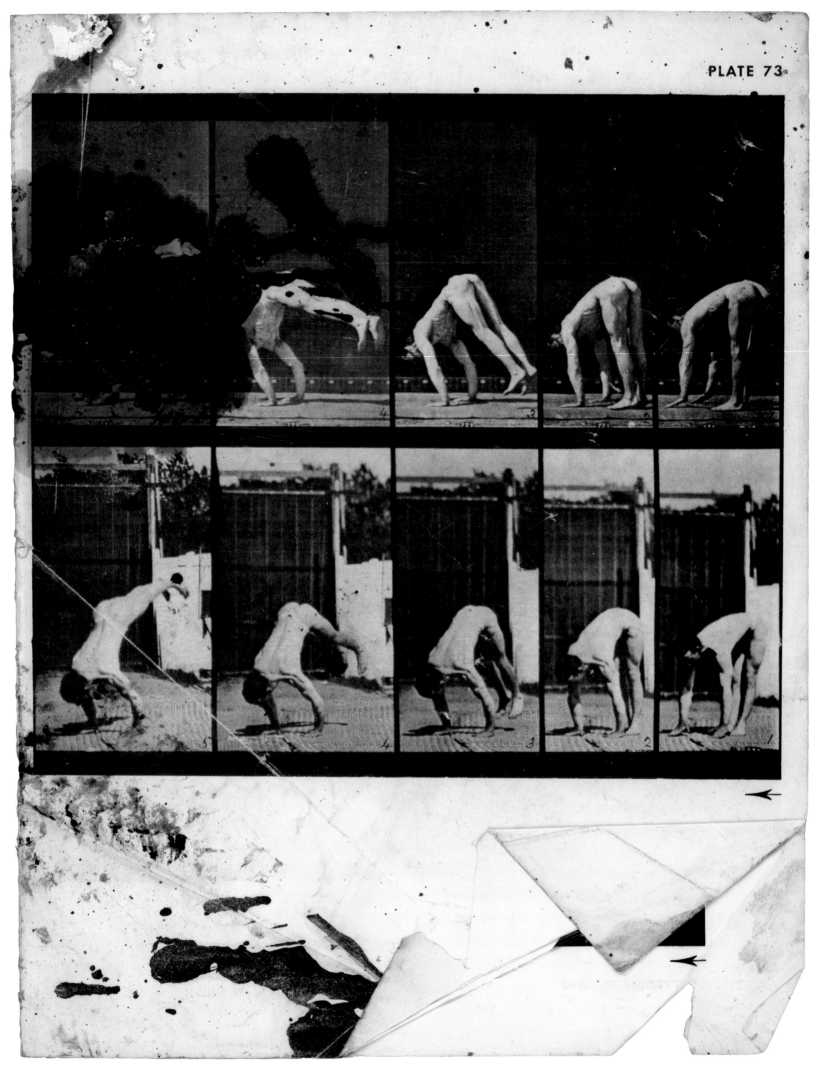

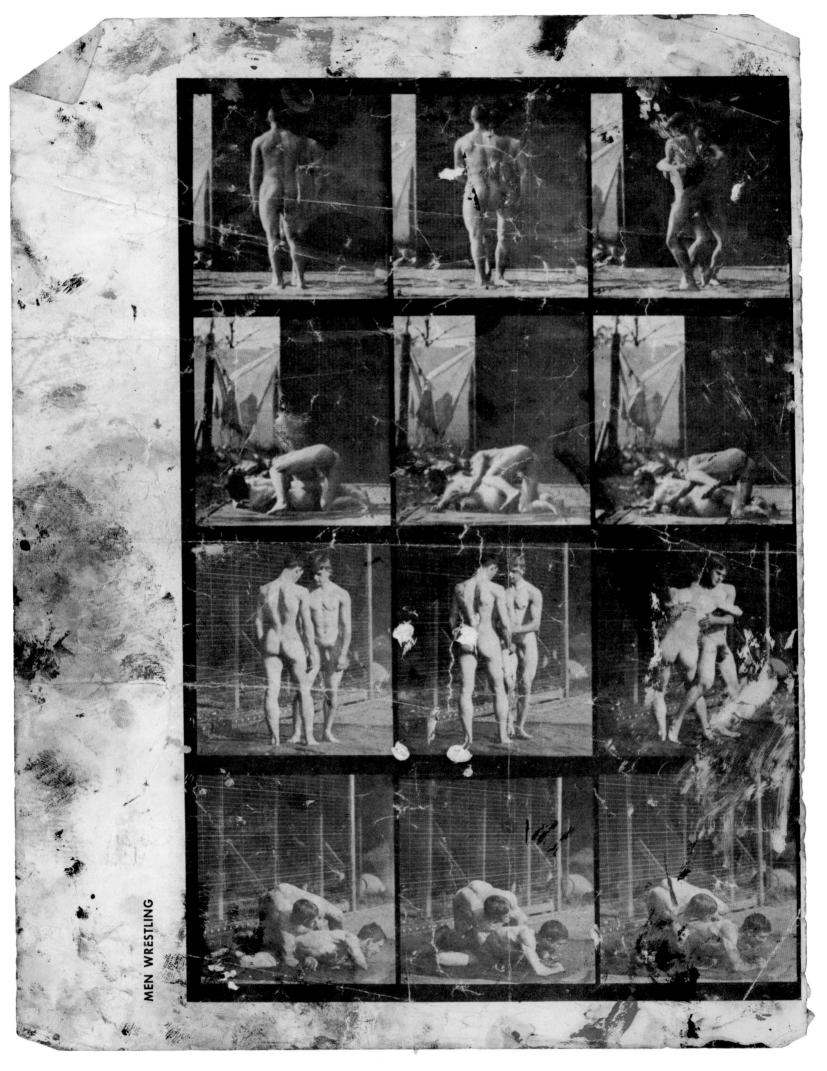

MEN WRESTLING

23

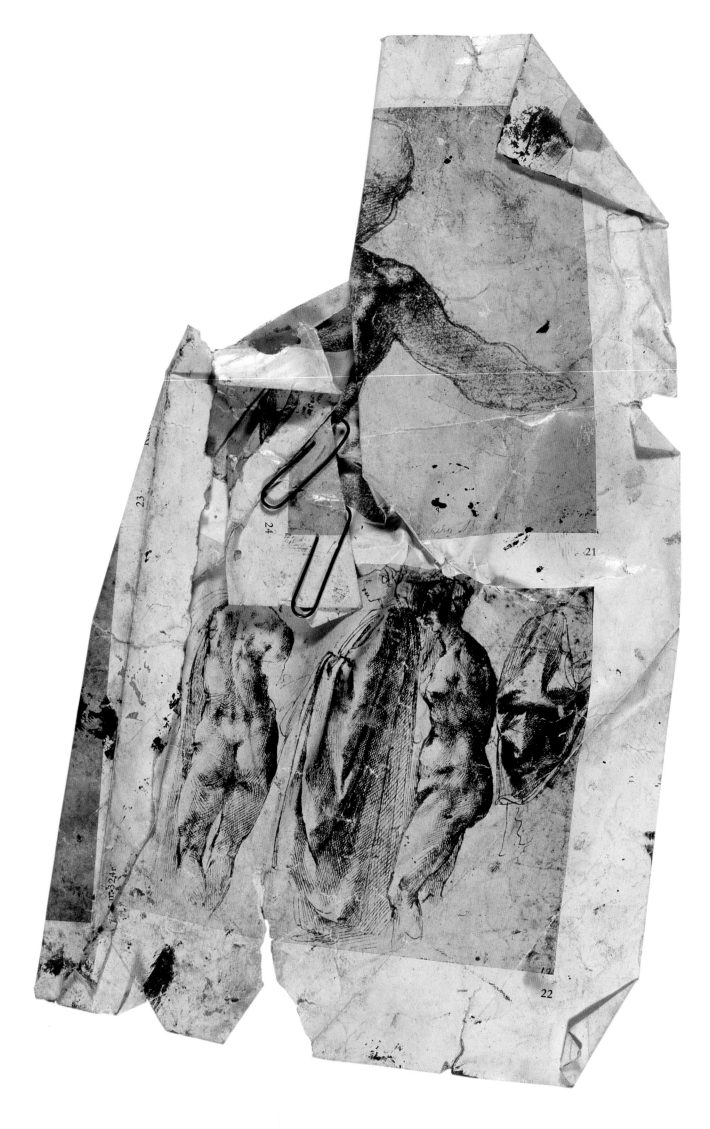

24

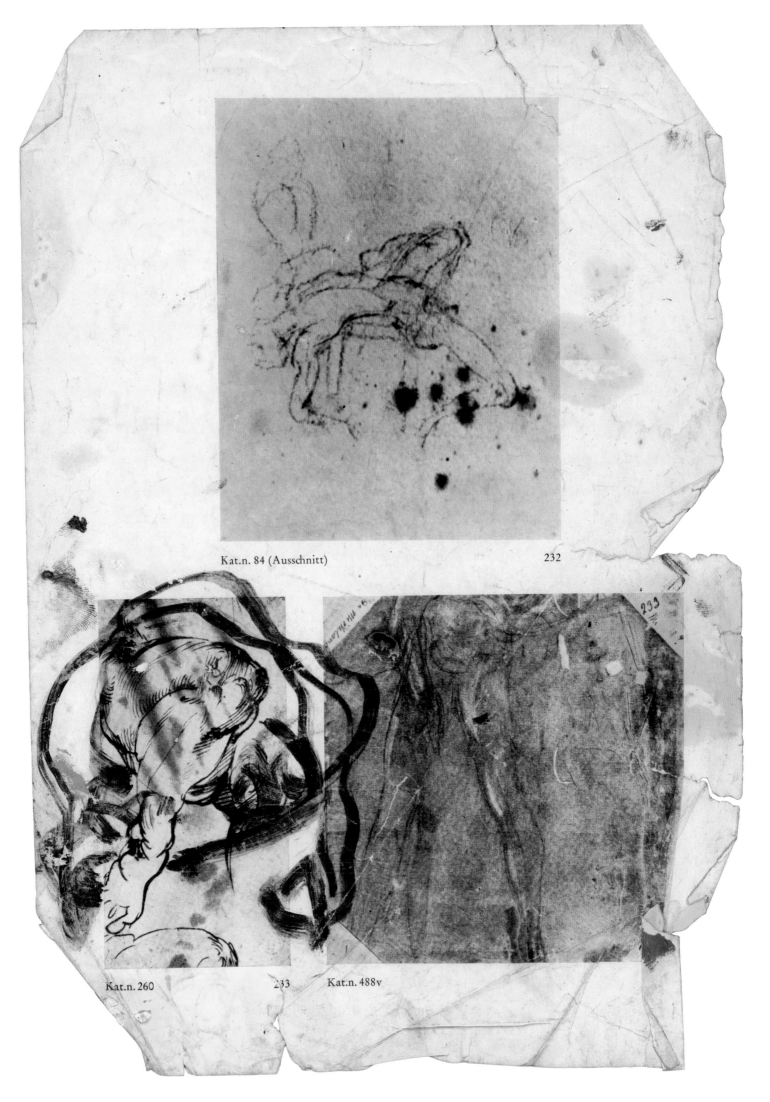

Kat.n. 84 (Ausschnitt) 232

Kat.n. 260 233 Kat.n. 488v

PHYSIQUE-PICTORIAL

35

RODIN

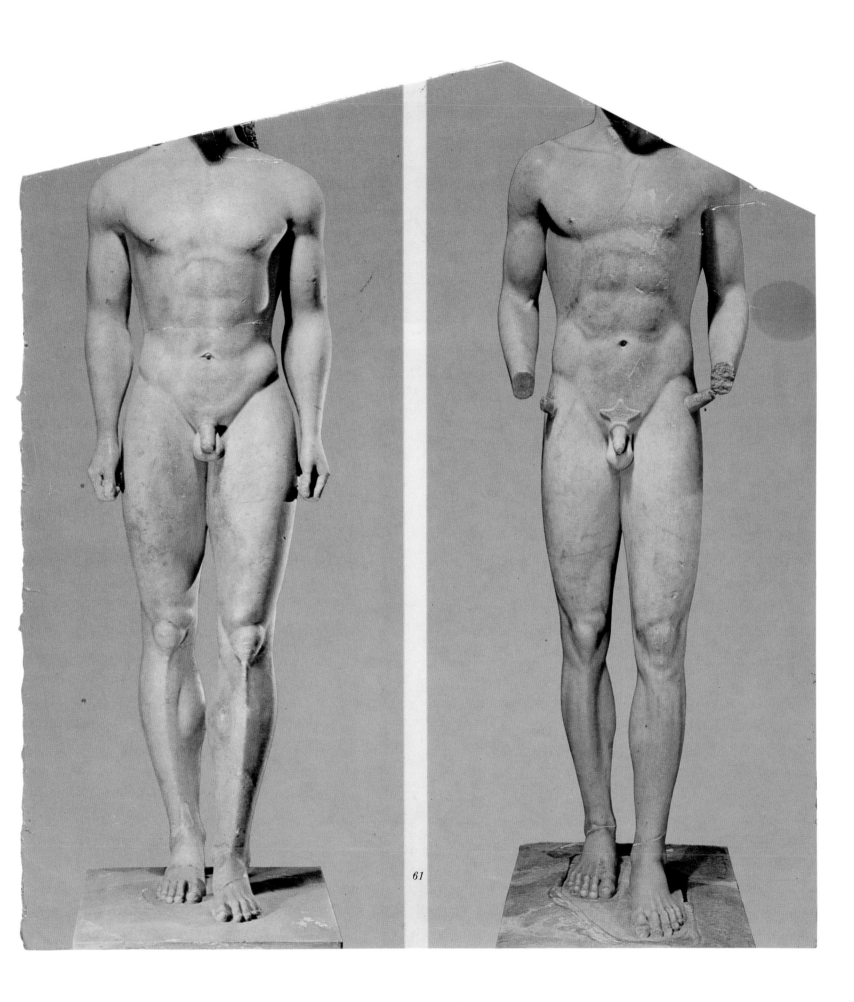

61

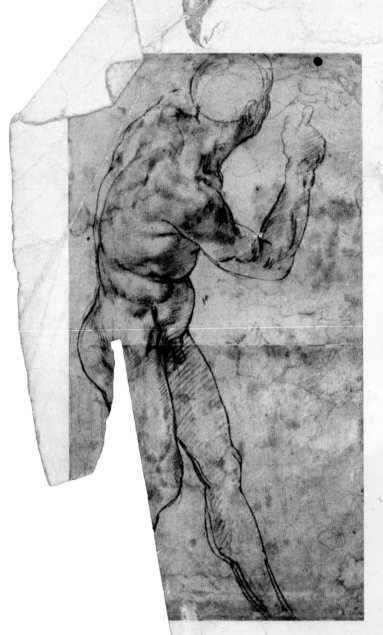

23. Apollonius, Son of Nestor:
BELVEDERE TORSO. 150 B.C. Marble, height 62 $^5/_8$"
Vatican Museum, Rome

nude for THE BATTLE OF CASCINÀ
. Drawing, black chalk,
$^1/_4$". *Teyler Museum, Haarlem*

noves what can only be described
form and line. Forms protrude,
ibing locks of hair, eyebrows,
beard, are actually cut into the
perceptible degree. Much later,
Benedetto Varchi in 1549,
acterize sculpture as the art c
of "putting on," which
nfinished statues one c
, or carving, very
mplete save for
d by the rou

the blocked-in marble. There is no in
as in the usual unfinished work of a
brought to about the same con
same moment. One can wa
lessly driving the profil
freeing it from the ma
and living silhouett
tor's vision of th
around it. No
sharp that
and poli

In

"

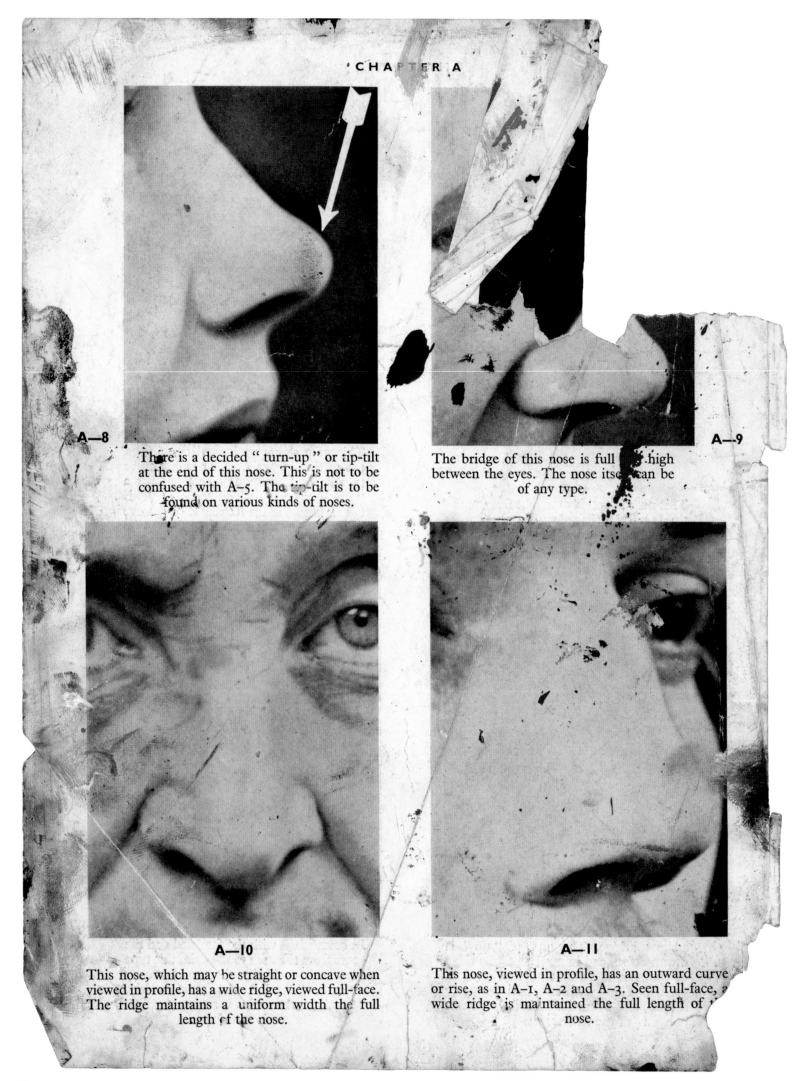

A—8

There is a decided " turn-up " or tip-tilt at the end of this nose. This is not to be confused with A–5. The tip-tilt is to be found on various kinds of noses.

A—9

The bridge of this nose is full and high between the eyes. The nose itself can be of any type.

A—10

This nose, which may be straight or concave when viewed in profile, has a wide ridge, viewed full-face. The ridge maintains a uniform width the full length of the nose.

A—11

This nose, viewed in profile, has an outward curve or rise, as in A–1, A–2 and A–3. Seen full-face, a wide ridge is maintained the full length of the nose.

Eyebrows a
appearance o

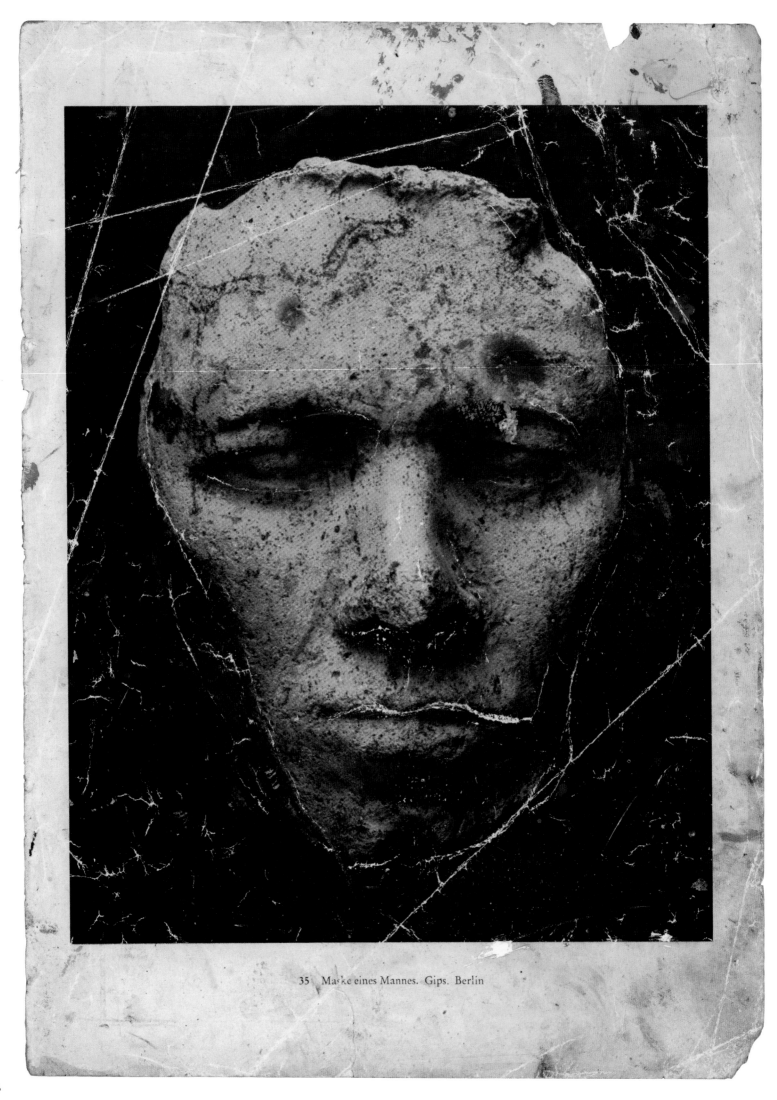

35 Maske eines Mannes. Gips. Berlin

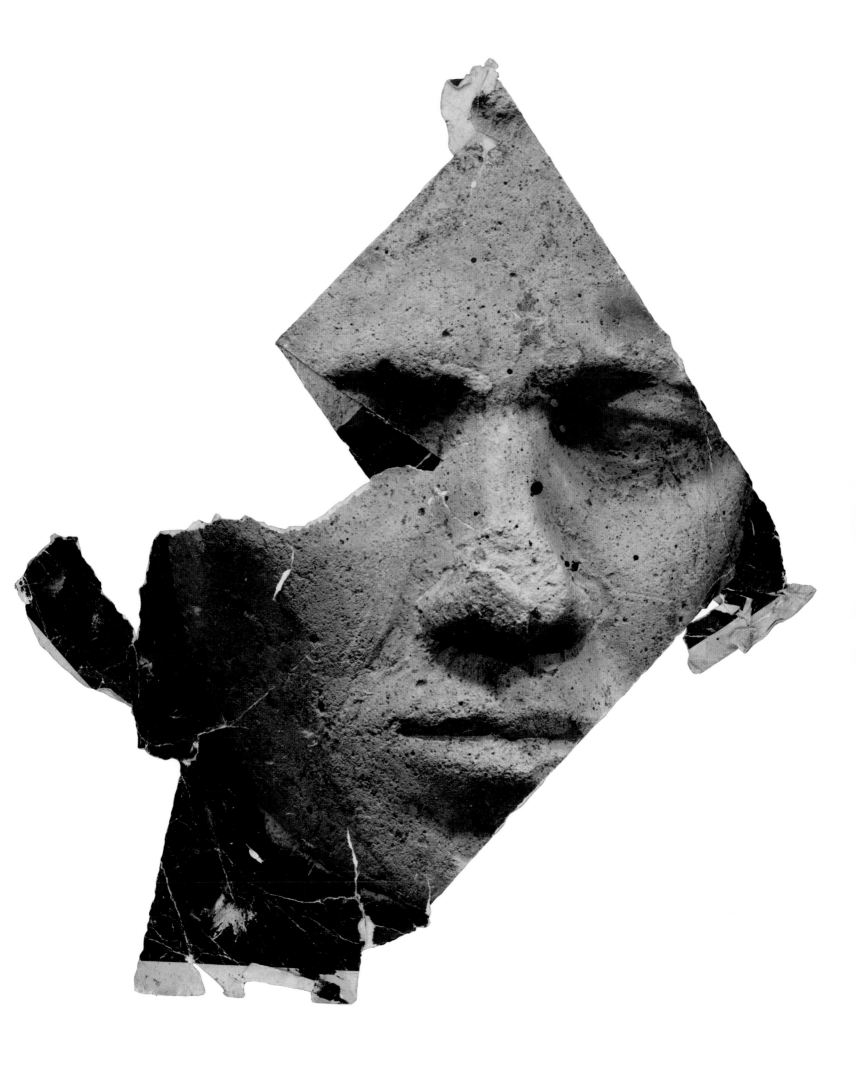

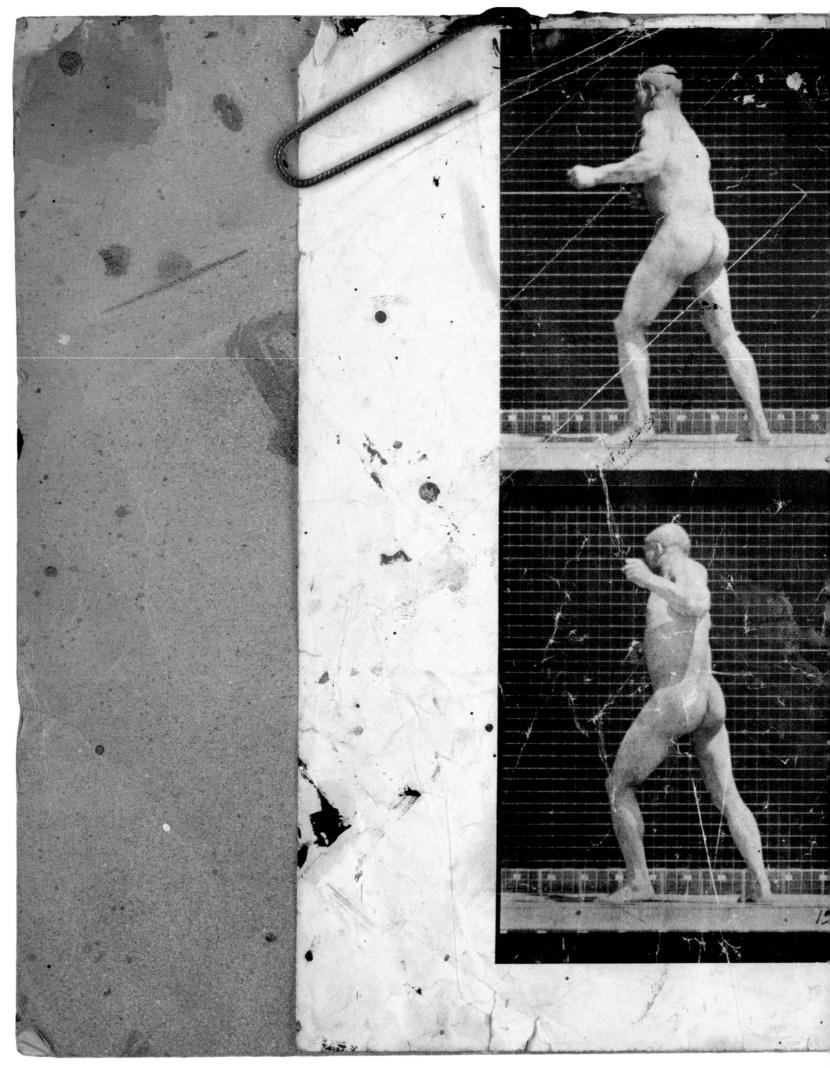

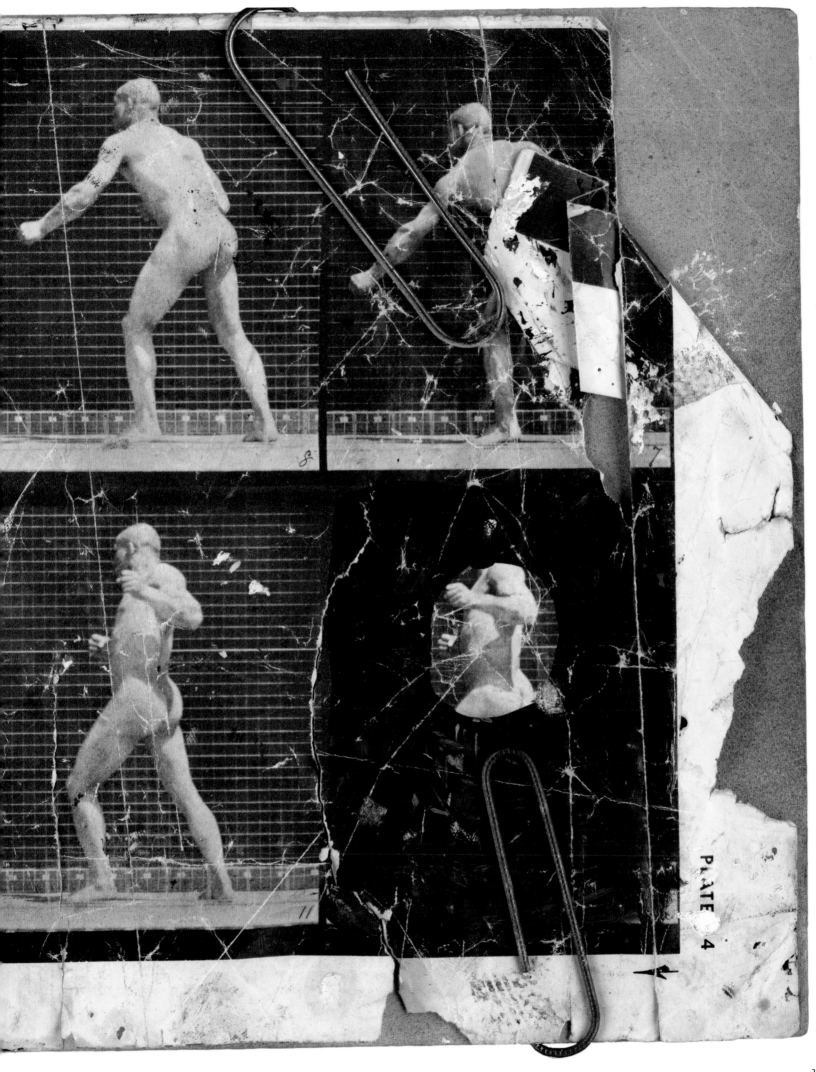

2

Conflict — Mass Media

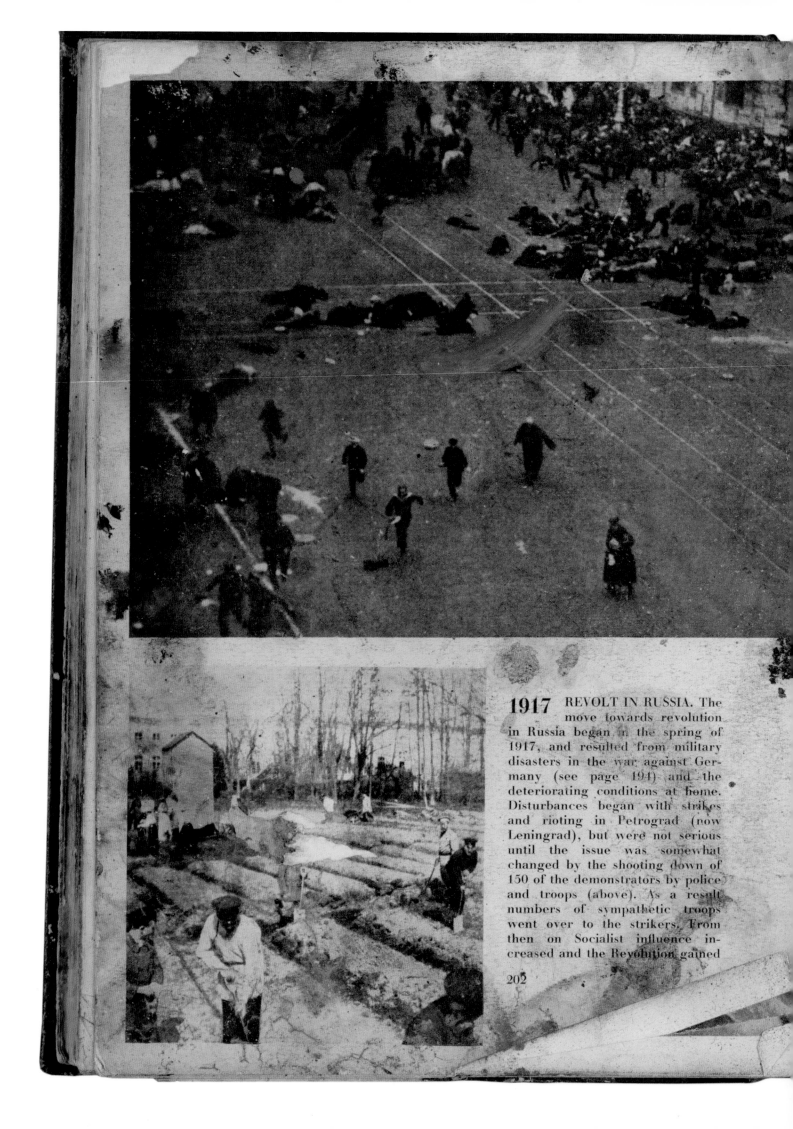

1917 REVOLT IN RUSSIA. The move towards revolution in Russia began in the spring of 1917, and resulted from military disasters in the war against Germany (see page 194) and the deteriorating conditions at home. Disturbances began with strikes and rioting in Petrograd (now Leningrad), but were not serious until the issue was somewhat changed by the shooting down of 150 of the demonstrators by police and troops (above). As a result numbers of sympathetic troops went over to the strikers. From then on Socialist influence increased and the Revolution gained

202

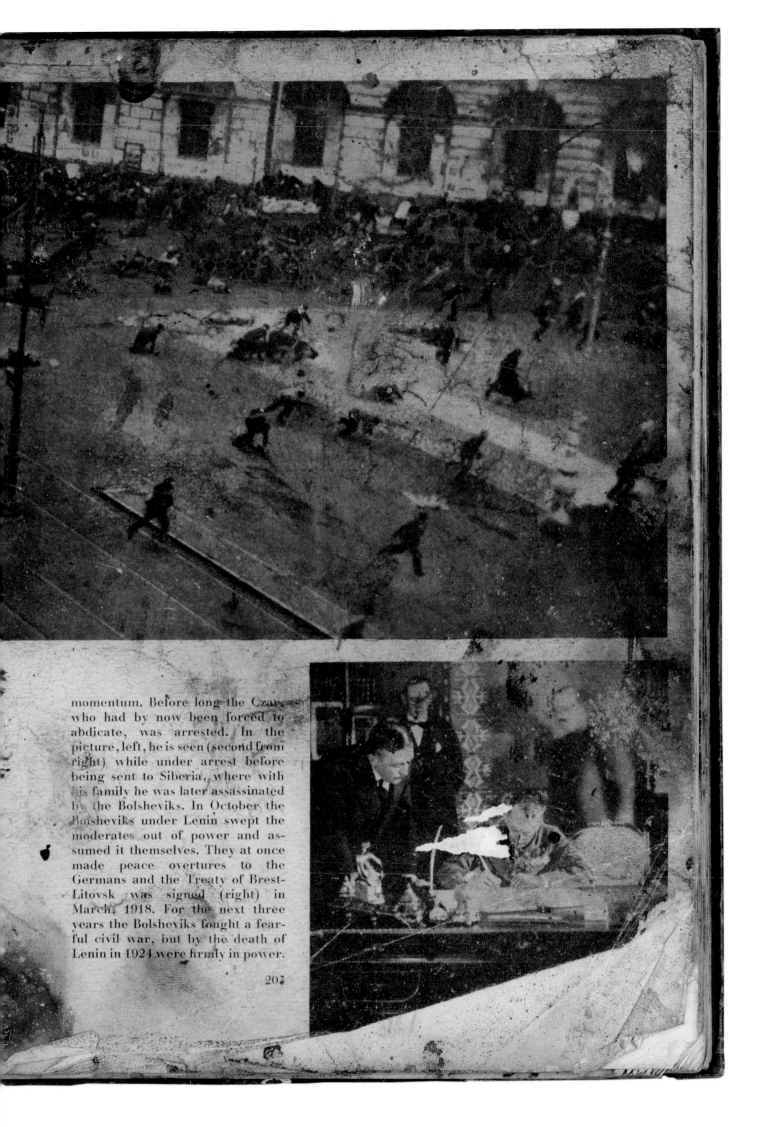

momentum. Before long the Czar, who had by now been forced to abdicate, was arrested. In the picture, left, he is seen (second from right) while under arrest before being sent to Siberia, where with his family he was later assassinated by the Bolsheviks. In October the Bolsheviks under Lenin swept the moderates out of power and assumed it themselves. They at once made peace overtures to the Germans and the Treaty of Brest-Litovsk was signed (right) in March, 1918. For the next three years the Bolsheviks fought a fearful civil war, but by the death of Lenin in 1924 were firmly in power.

203

pilot changed plates by reaching out, pulling a lever, and pushing it forward again. Lieutenant Sanders describes it: *The aeroplane is travelling but slowly against a strong head wind . . . The reduced speed on the outward journey is of great assistance to the pilot in getting his exposures accurate, and when he turns westward again, having reached the farthest point that he wishes to photograph, his machine is whirled back to our side of the trench before the enemy gunners can correct their aim.*

(But this was an exceptional day. Normally the wind blew from the west, wafting our machines towards the lines and Germany, but hindering their return.)

The flyers strafed front-line trenches and rearward supply columns. They dropped bombs by day and, increasingly, by night. They did whatever an imaginative staff, barely convinced that men really could at last fly, asked them to. (Baker, in March 1918: *Had to go up on a comic stunt this morning. I had to fly low over the German trenches to attract the fire of their machine-gunners. As soon as they opened on me, our gunners turned on to them and blew them up . . .*)

Gradually it became clear that these "comic stunts" and "priceless flips" depended for their success on a measure of dominance in the sky. Hence were born the long-range bomber and the true fighter, then called the Scout. The bombers never really reached strategic depth – though they were poised to do so, with the big Handley Page, when the war ended. The Scouts formed the habits, and the spirit, that won the Battle of Britain.

Trenchard, the R.F.C. chief in France, insisted that Scouts should not be used as close escort to bombers or Corps planes. That was a defensive mentality. They were to carry the fight to the enemy, attacking deep over the lines, destroying enemy Scouts wherever they found them. This policy left our Corps planes unprotected, and accounted for the very high scores of the German aces, above all of Richthofen – who could sit back, wait for the British to come to them, and then choose as their prey the weak, the new boy, the straggler, the lost and strayed, while refusing battle with the strong, and those in good formation or an advantageous tactical position; but it gave the Royal Flying Corps the mastery of the air. Here is how they used it (this is Lieutenant Mayberry of 56 Squadron describing his actions on July 31, 1917, the first day of the battle of Pilckem Ridge):

. . . Crossed the lines over Ypres at 500 feet just underneath very thick clouds. Got into the smoke from the artillery barrage and found it impossible to see ahead at all. . . . Dived down to about 30 feet and flew straight along the road to Gheluwe . . . Two E.A. (enemy aircraft) *Scouts appeared from over Courtrai and attacked me. . . . From Bisseghem I went north-east and immediately saw Henle aerodrome . . . Circling round the aerodrome the only sign of activity I could see was one man lighting two smoke fires. This man looked at me but did not seem to take any particular*

60

The impression left by an airman
falling from a Zeppelin

61

★ Les prisonniers, d'heure en heure, sont de plus en plus nombreux. On les parque au coin d'un immeuble. Sans réaction, passifs, même sans tristesse, pour eux, la guerre est finie.

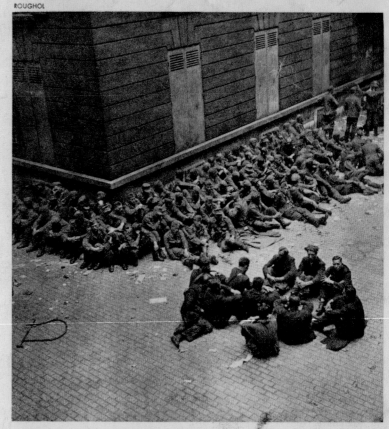

★ La mort fauche partout, les femmes aussi bien que les hommes. Cette dame âgée a été touchée à mort quand elle allait chercher son pain. Pour manger pendant l'insurrection, il fallait souvent payer de sa vie.

★ On a vu souvent, pendant la semaine glorieuse, ce spectacle qui témoignait d'un tranquille courage : un F.F.I. patrouillant seul dans les rues d'où il était guetté, à chaque fenêtre, par les mitraillettes.

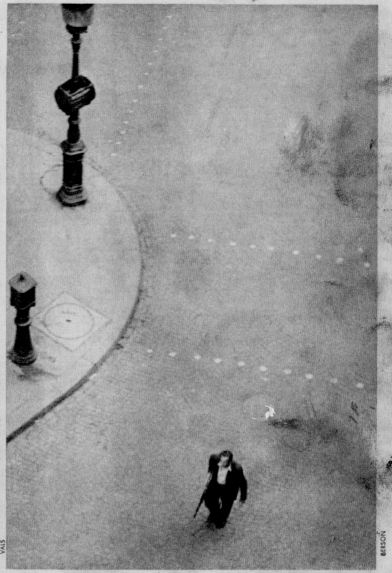

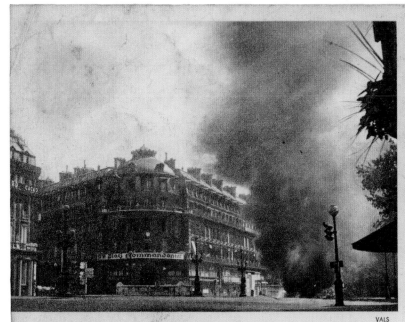

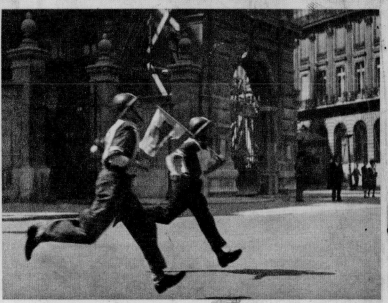

★ 1. – Trente minutes de combat photographiées par Pierre Vals : A 14 heures, le 25 août, les chars de Leclerc et les F.F.I. sont dans la rue du 4-Septembre

et dans l'avenue de l'Opéra. Leurs premières salves ont incendié une voiture allemande. 2. – En plein combat, les jeunes gens de la défense passive se rendent au péril de leur vie, comme ils l'ont toujours fait, au secours des blessés, qu'ils soient

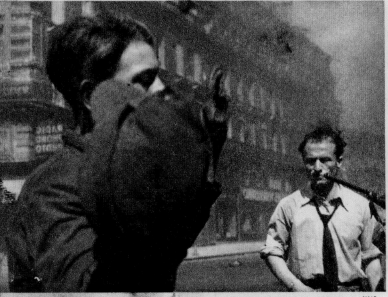

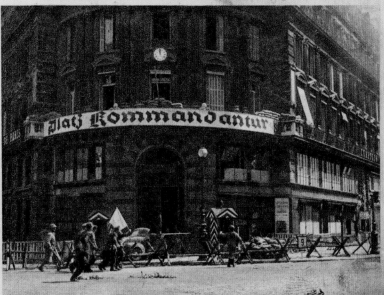

français ou allemands. 3. – Dans les fumées de la bataille, le premier Allemand de l'Opéra se rend aux F.F.I. 4. – Leur drapeau blanc est une serviette accrochée à un manche à balai. Ils sortent de la Kommandantur, contournent les barbelés

et vont se rendre. 5. – Ce même groupe, précédé d'un soldat de Leclerc se dirige vers le détachement stationné rue Daunou. 6. – La foule qui s'était mise à l'abri commence à apparaître. En tête marche celui qui, il y a un instant, portait le drapeau blanc.

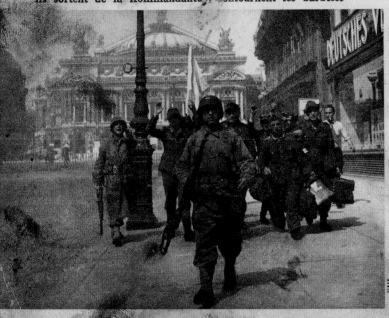

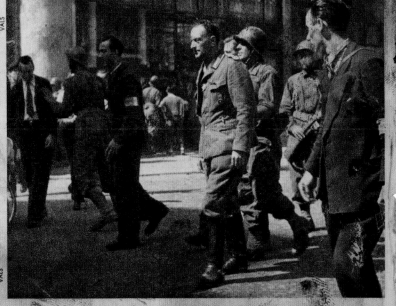

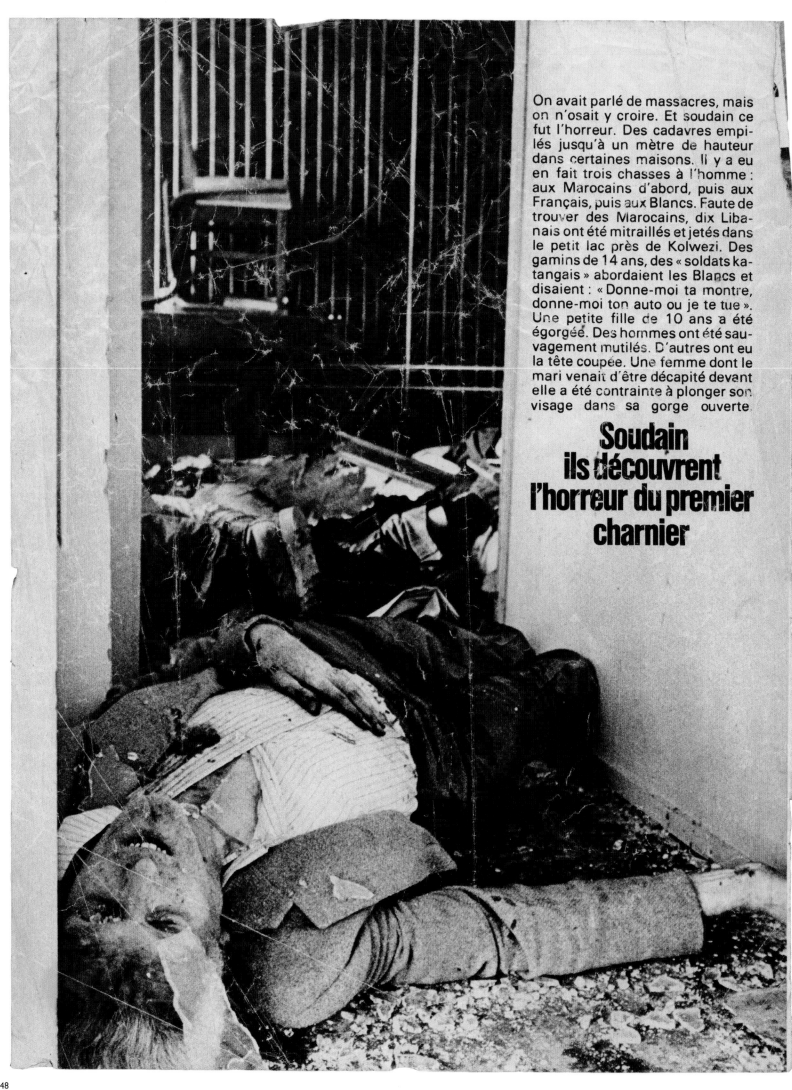

On avait parlé de massacres, mais on n'osait y croire. Et soudain ce fut l'horreur. Des cadavres empilés jusqu'à un mètre de hauteur dans certaines maisons. Il y a eu en fait trois chasses à l'homme : aux Marocains d'abord, puis aux Français, puis aux Blancs. Faute de trouver des Marocains, dix Libanais ont été mitraillés et jetés dans le petit lac près de Kolwezi. Des gamins de 14 ans, des « soldats katangais » abordaient les Blancs et disaient : « Donne-moi ta montre, donne-moi ton auto ou je te tue ». Une petite fille de 10 ans a été égorgée. Des hommes ont été sauvagement mutilés. D'autres ont eu la tête coupée. Une femme dont le mari venait d'être décapité devant elle a été contrainte à plonger son visage dans sa gorge ouverte.

Soudain ils découvrent l'horreur du premier charnier

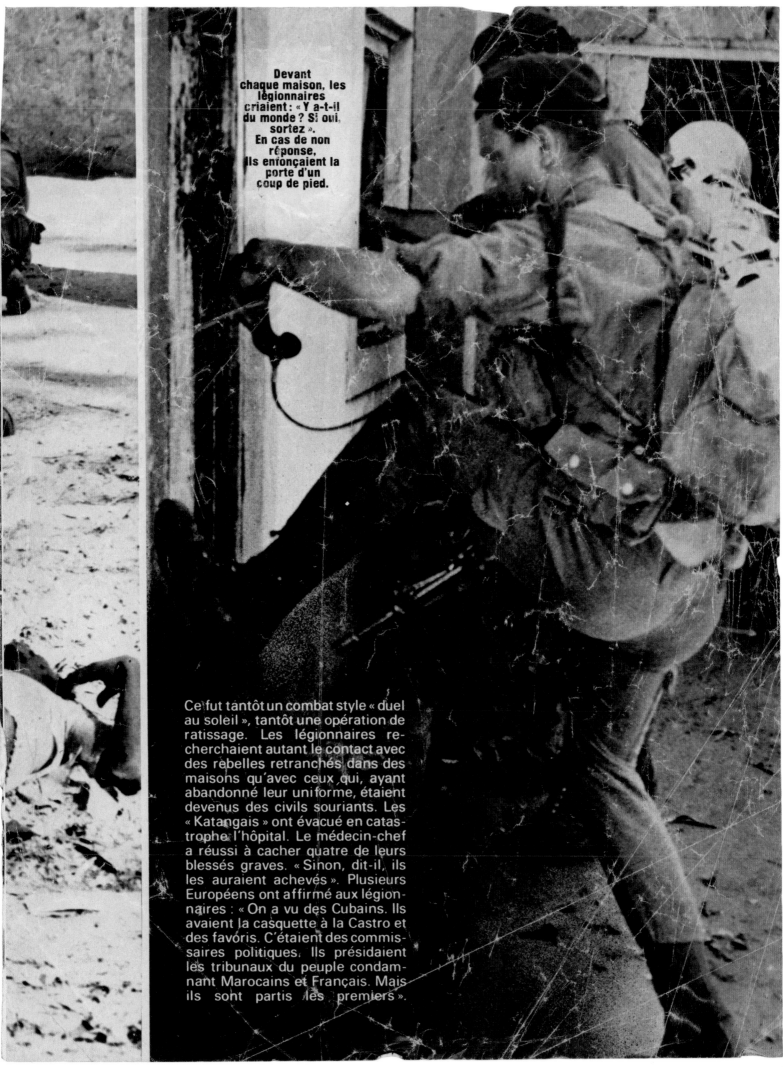

Devant chaque maison, les légionnaires criaient : « Y a-t-il du monde ? Si oui, sortez ». En cas de non réponse, ils enfonçaient la porte d'un coup de pied.

Ce fut tantôt un combat style « duel au soleil », tantôt une opération de ratissage. Les légionnaires recherchaient autant le contact avec des rebelles retranchés dans des maisons qu'avec ceux qui, ayant abandonné leur uniforme, étaient devenus des civils souriants. Les « Katangais » ont évacué en catastrophe l'hôpital. Le médecin-chef a réussi à cacher quatre de leurs blessés graves. « Sinon, dit-il, ils les auraient achevés ». Plusieurs Européens ont affirmé aux légionnaires : « On a vu des Cubains. Ils avaient la casquette à la Castro et des favoris. C'étaient des commissaires politiques. Ils présidaient les tribunaux du peuple condamnant Marocains et Français. Mais ils sont partis les premiers ».

These official photographs of two of 12 women still detained in hospital after the bomb explosion in a Belfast electricity board office on Wednesday were released to the press yesterday with their permission and the consent of their relatives. At the same time the Northern Ireland Hospitals Authority issued the statement reproduced in full below.

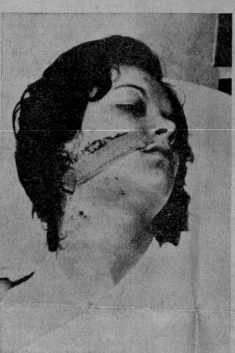

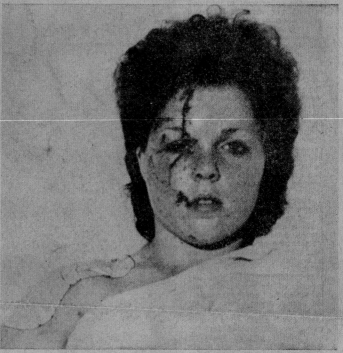

en

gning
ster

Minister of State,
has emphasized
senior Scotland
who advocated
ent for criminals
g a campaign to
policy change on

ied to Mr Merlyn
MP for Leeds,
told the Home
eek that he would
ommons the inter-
he policemen pub-
e Times.

les told Mr Rees
r would be put be-
Maudling when he
om his holiday in
xt week, The Home
uld also have a full
details of the cir-
of The Times inter-

ples said in his letter:
have seen the state-
equently issued by the
oner. This makes it
the reporter, in refer-
he interview as in the
the two officers 'the
e in a campaign to force
change of policy on
nt', misinterpreted the

recognize, and have
that as serving members
Metropolitan Police they
in a position to take any
ttitude. I think this helps
he matter in perspective."
Police Federation said
ay that the gun had be-
art of the standard equip-
of the robber because the
s of crime have become
r and the risk less.
rticle in the federation's
ine Police said that a few
ago criminals who carried
were shunned by others.
hen the death penalty was
Parliament sought to
e menace of the gunmen
ening penalties for fire-
offences. Long sentences
ose taking part in armed
y have become common.
And yet the crime rate
es to leap upwards.
ese thugs know that if
these circum-
a long

'Twelve female victims of the explosion are still in Belfast hospitals, eight at the Royal Victoria and four at the City. The majority of them are in their late teens or early twenties.

Surgeons who treated the patients say that when admitted all were in a state of severe shock. One of the girls had a lung lacerated severely when her chest was pierced by a piece of metal. She required an immediate operation.

Another girl is suffering from severe lacerations and skin loss to her leg which will cause a severe degree of scarring. Most of the girls have facial and head lacerations. These will result in permanent scarring.

Two girls have skull fractures as well as damage to their facial bones. Many of the injuries will result in permanent disfigurement. No doubt in some cases there will be mental ill effects. This is the tragedy of it all.'

Provisionals admit causing office blast

From Christopher Warman
Dublin, Aug. 27

The Provisional wing of the IRA in Dublin today admitted responsibility for the explosion at the Northern Ireland Electricity Board headquarters in Belfast on Wednesday.

A statement said: "The leadership of the Republican movement sincerely regrets the loss of life and injury to persons caused by Wednesday's explosion. We wish it to be known that a reasonable warning was iven to evacuate civilian nnel from the building and had been acted upon ilian casualties ed.
full

blame and responsibility on the British Government and the Stormont regime who by their oppressive actions, including the repeated use of internment with out trial, over the past 50 years, have brought about the present tragic circumstances.

The Provisionals also rejected the claim by the official wing, who had earlier claimed responsibility for the recent murder of two British soldiers in Belfast. "Now they are trying to claim credit for successful operations against the British Army as part of an unscrupulous attempt to exploit the tragedy at the electricity board offices."

Belfast police tonight rejected the Provisional's statement and reemphasized that occupants in

the building were only given a 90 sec warning.
Staff reporters write from Belfast: The Northern Ireland Government is likely to be completely unresponsive to Mr Harold Wilson's call for tripartite talks between Mr Heath, Mr Faulkner and Mr Lynch, Prime Minister of the Irish Republic, to consider Ulster's future.

Mr Faulkner is likely to be equally unattracted to Mr Wilson's enthusiasm for a meeting in Britain of all the political parties concerned.

The stance of the main parliamentary opposition here the Social Democratic an Labour Party and t Nationalist Party, that Storm should be abolished toge with their civil disobed

campaign, made such ing impossible, it wa

A similar attitud from Mr Heath

Opposition their camp rents in ment w

Me boy A

of a ton of gelig

the IRA was behind
out 8.30

Pr
call

Four fires
at Weeley
Frinton fireme
they had twice ret
to be called back
put out blazing s
By pop fans,
beaten out by police
Mr Alec Bareham
spokesman, said: "W
fire headquarters
a tender on site permanen
said it would serve no u
pose so it is no good
plaining."
One blaze started
stove set some straw
went up in seco
student said

SUNDAY wekly reiew

JULY 25 1976

Lord Moran

Shoulder: Desmond Morton

...on (circled) with, from left... Sarah Churchill, Winston Churchill, Admiral of the...

...consciously believed that C... ...was the only man who cou... ...country in a war... ...ow, and therefo... ...d should be d... ...ently-discred...

RCHILL: THE SP

...churchill ...ld lead ...against ...re that ...me to fit ...ited poli- ...n of power. ...became an ...terial adviser ...Any study ...dership, ...es in ...out

Writing to Thompson, Morton portrays a "crackpot strategist" capable of "depths of selfish brutality," who was simply afraid of "any person whose personal character was such that he (Churchill) could not avoid, most unwillingly, feeling respect for that person." Churchill was not, after all, a serious politician. Morton wrote to Thompson: "I doubt if the idea of ruling in order to serve the people of his country was ever clear to him." Morton wrote these letters to Thompson between 1960 and 1962 ...it a condition that th... ...not be quoted in ...borough. They ...hardly ha... ...ther Pe... ...u to...

The latter is ...irect evidence ...ave discussed ...the question ...dily asserted ...be true ...danger

MORTON ...CMG. ...C.B., ...Cajor Sir Desmond, ...Cames, Officer de... ...Royal 1891; educ... ...officer Military ...Artillery Royal... Camp ...Industr... ...Prof. Economic... ...onal Assistant to P... ...4046. ...vice. Unmarried; ...

...difficult to ...n your

John Duke as th... ...tache. Why? Fir... ...famous ancestor ...(I know of sev... ...in John Sp... ...which Wi... ...would suppr... ...the greate... ...thir ...gen... ...Se'n ...sticky ...of the ...of us...

51

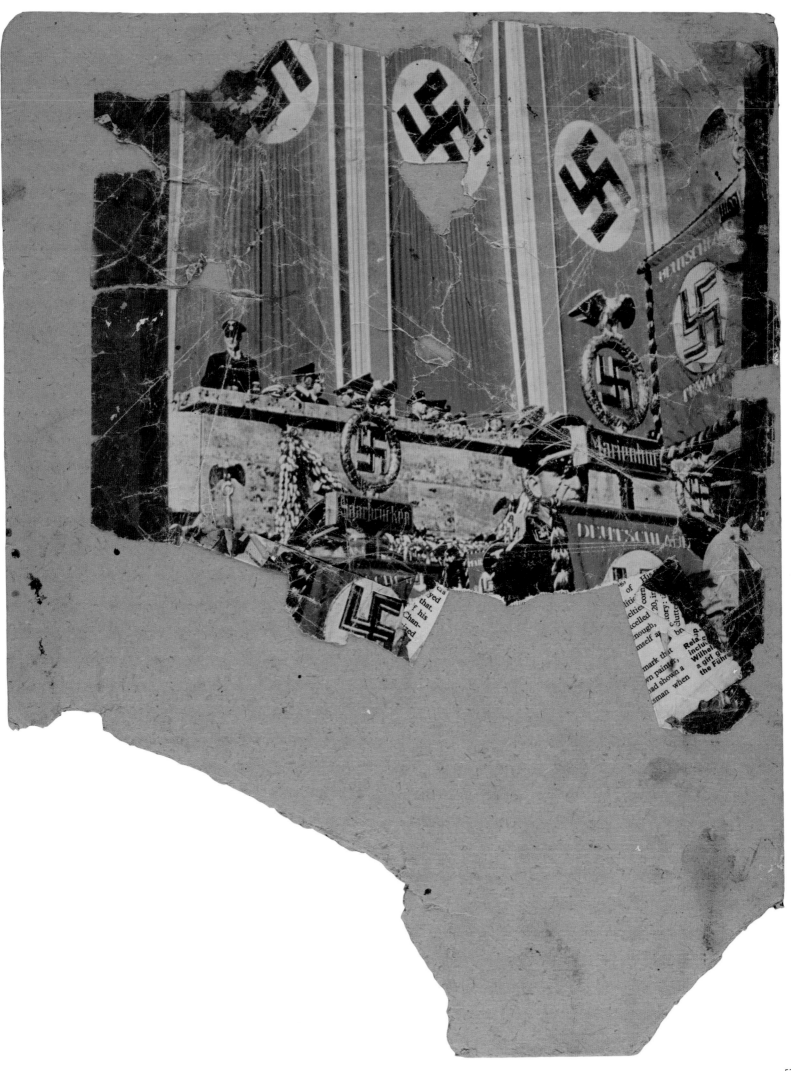

53

FEMME COUPÉE EN MORCEAUX (AFFAIRE DE MEKNÈS)
Collection du D^r Locard (Laboratoire de Police de Lyon).

mineures de la même accentuation des instincts digestifs.

J'ai connu un jeune dégénéré, d'ailleurs fils de magistrat et étudiant en droit, qui se vantait comme d'un haut exploit de virilité, d'avoir mordu le sein de sa maîtresse au cours de ses élans érotiques, « au point qu'elle avait dû se faire soigner à l'hôpital ». Il était, par ailleurs, homosexuel passif.

De tels cas mettent en lumière le rôle des instincts digestifs du mode dentaire dans la genèse des crimes. Mais l'autre modalité digestive, que nous avons appelée intestinale, peut aussi intervenir. On la reconnaît au fait que les crimes qu'elle inspire, au lieu d'être simplement brutaux et sanguinaires, tournent à un raffinement de cruauté. Ici, le désir de dominer par la peur, d'humilier et de souiller la victime, devient prépondérant.

Bourreaux et tortionnaires

LE mode intestinal inspire les bourreaux et les tortionnaires dont le type est fourni par les cas extraordinairement nombreux de parents qui martyrisent leurs enfants. Point n'est besoin de donner d'exemple : à la moyenne de deux ou trois fois par semaine, les journaux rapportent un cas nouveau. Toutes les horreurs des tortures du moyen âge ou des supplices chinois sont réinventées par le zèle criminel de ces parents.

Les causes instinctives de cette cruauté sont les suivantes : le sacrifice à la progéniture, aboutissement des instincts sexuels, ne peut se développer chez des individus dont le sens social a été préalablement faussé et la tendance normale à la tendresse ne peut que se renverser. En effet, le fait d'élever des enfants impose des obligations et des peines et lorsque rien ne peut compenser celles-ci sur le plan affectif, l'enfant devient l'objet de haine. Par ailleurs, les individus qui ont souffert dans leur enfance d'une jalousie intense à l'égard d'un frère ou d'une sœur plus jeunes, retrouvent tout à coup dans le petit être auquel il faudrait se sacrifier quelque peu, *l'image*, le souvenir de celui qu'ils ont haï à une époque où l'individu humain est essentiellement féroce. Ensuite, l'enfant représente, dans le sentiment des parents, une synthèse des amours qui l'ont engendré et lorsque ces amours les ont déçus, ils s'en prennent à lui. Ils se vengent du partenaire sexuel sur ce que celui-ci leur a donné. Ces petites animosités ne sont pas rares dans les meilleures familles : elles se traduisent alors en injustices systématiques à l'égard de l'enfant. Elles dégénèrent d'autant plus en persécutions criminelles que les parents, tarés dans leur évolution instinctive, n'ont pu atteindre à l'altruisme des sentiments sexuels bien épanouis. Enfin, pour ces individus arriérés aux stades possessifs et captatifs de l'affectivité, l'enfant, fait de leur propre chair et à leur image, sollicite leur

sentiment de propriété, très aiguisé, sans parvenir à toucher leur sentiment de solidarité ou de dévouement resté trop embryonnaire. Ils sont donc amenés à exercer sur lui une domination tyrannique dépourvue de toute tendresse et de toute pitié. Ajoutons que l'enfant se trouve livré sans défense au pouvoir absolu de ses parents, que les autres parents auront toujours de la répugnance à dénoncer leurs abus et les pouvoirs publics à les poursuivre ; ajoutons qu'il nous reste de cet odieux droit romain (qui est la consécration des pouvoirs du plus fort) l'idée que l'ordre familial, base de l'ordre social, doit être fondé sur la subordination totale des inférieurs aux supérieurs et que la défense du faible est une atteinte à l'édifice social. Nous comprendrons ainsi pourquoi les parents bourreaux sont si nombreux et pourquoi les tribunaux leur sont si indulgents. La loi autorise aux parents des actes qui seraient punissables en d'autres circonstances ; elle reconnaît au père le droit de corriger et de séquestrer ses enfants et il n'en coûte qu'une légère amende ou une infime condamnation avec sursis, pour laisser un enfant périr faute de soins ou pour le

torturer jusqu'à ce que mort s'ensuive ; ceci n'est pas un danger, estime-t-on, pour l'ordre public.

Les empoisonneurs

LES crimes du poison sont d'origine italienne. Catherine de Médicis était la reine du poison. Il y eut une recrudescence d'empoisonnements sous Louis XIV. Il est infiniment probable que le choix de ce moyen meurtrier, en dehors des circonstances de commodité qu'il peut présenter, affecte quelques rapports, sur le plan inconscient, avec les instincts digestifs. On donne le mauvais café à ceux dont on veut hériter, c'est-à-dire à ceux dont on veut retirer le pain de la bouche : il serait intéressant de chercher quelles obscures jalousies de nursery ont pu fixer la vocation des empoisonneurs. Je n'ai pas d'expérience sur ce point, mais je sais que ceux qui tentent de se suicider par le poison (ce qui est en somme un empoisonnement criminel réfléchi sur eux-mêmes) présentent souvent des traces, au fond de leur inconscient, d'une insatisfaction alimentaire du premier âge.

DESSIN DE GEORGES GROSZ

3

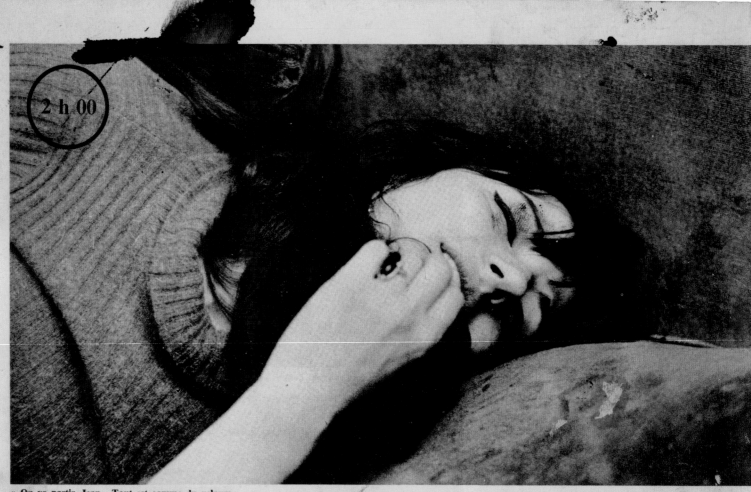

« On va partir, Jean... Tout est comme du velours... »

« Les fleurs sont belles, violettes, tout est violet ! »

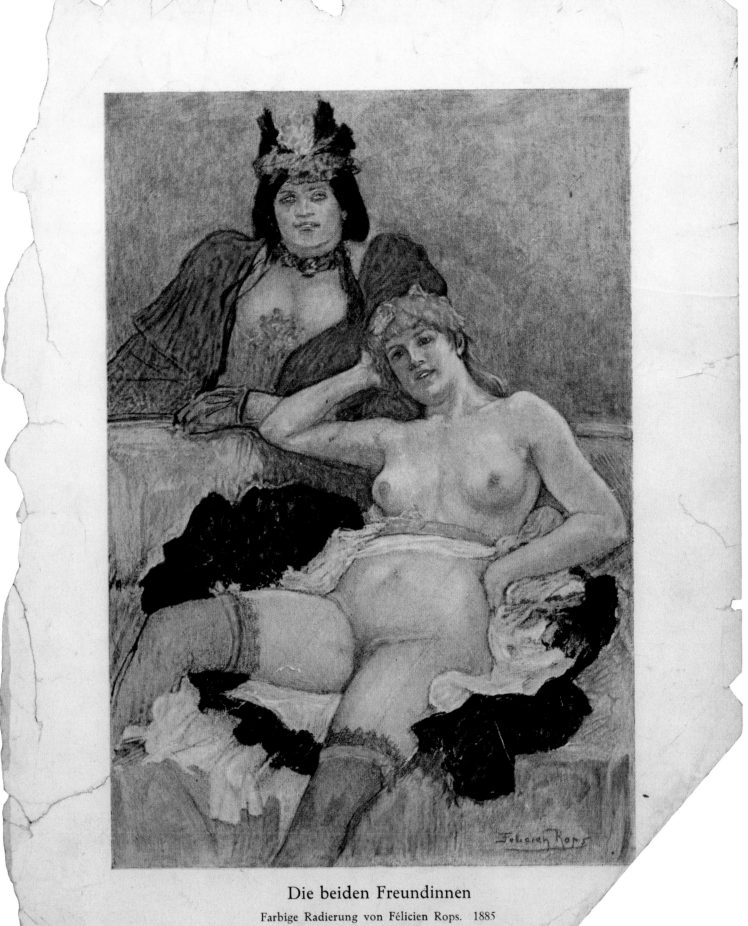

Die beiden Freundinnen

Farbige Radierung von Félicien Rops. 1885
Berliner Kupferstichkabinett

Beilage zu Eduard Fuchs, „Geschichte der erotischen Kunst II"

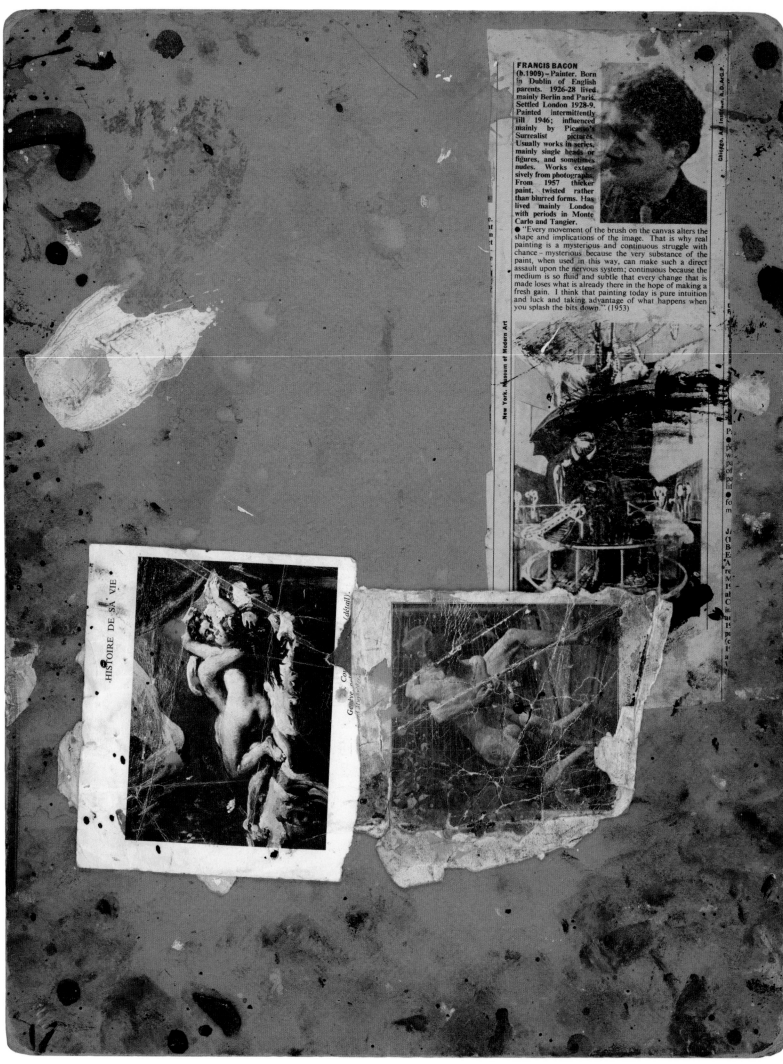

FRANCIS BACON
(b.1909) – Painter. Born in Dublin of English parents. 1926-28 lived mainly Berlin and Paris. Settled London 1928-9. Painted intermittently till 1946; influenced mainly by Picasso's Surrealist pictures. Usually works in series, mainly single heads or figures, and sometimes nudes. Works extensively from photographs. From 1957 thicker paint, twisted rather than blurred forms. Has lived mainly London with periods in Monte Carlo and Tangier.

● "Every movement of the brush on the canvas alters the shape and implications of the image. That is why real painting is a mysterious and continuous struggle with chance – mysterious because the very substance of the paint, when used in this way, can make such a direct assault upon the nervous system; continuous because the medium is so fluid and subtle that every change that is made loses what is already there in the hope of making a fresh gain. I think that painting today is pure intuition and luck and taking advantage of what happens when you splash the bits down." (1953)

HISTOIRE DE SA VIE

(détail).

STATISTIQUE DES ALIÉNÉS PASSÉS DES PRISONS A L'ASILE DE VILLEJUIF DE 1896 A 1904

MALADIES	Vagabondage	Scandales à l'Élysée	Refus de payer	Vol	Mendicité	Coups	Outrages à la pudeur	Assassinats	Outrages aux agents	Bris de clôtures	Ivresse	Expulsés	Divers	TOTAL
Paralysie générale..........	6		4	23	4	2				1	1	1	2	44
Démence sénile et organique.	10	2	1	9	2	3	2							29
Alcool et intoxications.......	2	2	1	8	2	1	1		1				1	19
Épilepsie et névrose.........						1			2		1			4
Débiles et imbéciles.........	43	6	2	28	10	10	7	6	13	2	2		6	135
Excités maniaques..........	1			4		1		1	1	3	1	1		13
Mélancoliques	2	2	2	2	1	3			1					13
Persécutés................	4					1								5
Démence précoce...........	10													10
Totaux............	78	12	10	74	19	22	10	7	18	6	5	2	9	272

On peut, d'après cela, estimer le nombre de demi-fous parmi les condamnés.

En fait, et à tout prendre, on peut dire que les prisons et les bagnes sont peuplés de fous, ce qui ne met pas à l'honneur le principe de la responsabilité légale, ni l'appréciation que les juges ont su en faire. Le cas des sœurs Papin est intéressant à ce sujet.

LES SŒURS PAPIN

CRISTINE PAPIN

Le 2 février 1933, Christine Papin, âgée de vingt-huit ans, et sa sœur Léa, âgée de vingt et un ans, depuis six ans placées comme bonnes à tout faire dans la famille Lancelin, au Mans, assassinèrent leur patronne et sa fille, celle-ci âgée de vingt-sept ans. Après s'être acharnées sur les corps, les mutilant, leur arrachant les yeux, les deux criminelles montèrent se coucher. C'est là, dans leur lit commun, où elles gisaient hébétées par la peur, que les trouvèrent ceux qui vinrent les arrêter.

Les sœurs Papin avaient connu depuis leur plus jeune âge la lente oppression du couvent. Elles n'en sortirent que pour être placées.

« *La vie chez les Lancelin*, dira plus tard Léa Papin au juge d'instruction, *était dure. On ne sortait jamais. Madame était hautaine et distante. Elle ne nous adressait la parole que pour nous faire des reproches. Toujours derrière notre dos, elle nous épiait sans cesse, comptait les morceaux de sucre qui restaient. Lorsque le ménage était terminé, le matin, Mme Lancelin mettait des gants blancs et passait ses mains sur les meubles pour se rendre compte si le nettoyage avait été fait soigneusement et s'il ne restait aucun grain de poussière. Si nous avions le malheur de casser la moindre des choses, elle nous le retenait immédiatement sur nos gages. Cela ne*

LÉA PAPIN
(*Photo Carrière*)

mode chemise 1962
loris gris «fumée»

Le CLUB CRÉATION
vous conseille
la gamme des coloris
gris «fumée»
qui s'harmonise
avec les

Pour être à la mode
faites confiance
aux chemisiers,
agréés par le CLUB
CRÉATION NYLFRANCE
chez qui vous voyez
ce signal lumineux
en vitrine.

club
création

OFF-HIGHWAY
TRUCKS
OF THE WORLD

INCLUDING
HIGHWAY LOCOMOTIVES
AND OUTBACK TRUCKING
IN AUSTRALIA

C. J. FRASER

80

83

81

84

86

82

85

64

MIDDLE TAR As defined by H.M. Government
H.M. Government Health Departments' WARNING:
CIGARETTES CAN SERIOUSLY DAMAGE YOUR HEALTH

D84 A DUTTON PAPERBACK ORIGINAL $2.45

$2.85 IN CANADA

FRED W. McDARRAH

INTRODUCTION BY THOMAS B. HESS

THE ARTIST'S WORLD

IN PICTURES

The HUMAN MACHINE

By GEORGE B. BRIDGMAN

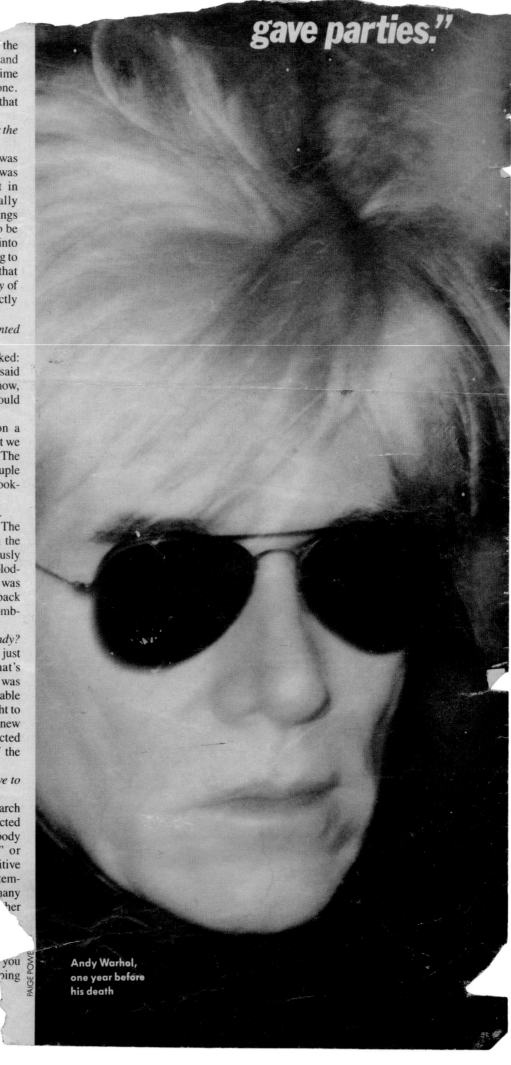

... of the
... and
... here, wa... time
... conscious th... ... one.
... had lost so m... ... that
... am anymore.

... think he changed a lot after the

... he never changed at all. It was
... Andy's nature to change. He was
...-track-minded and persistent in
... did that he never really
... of the remarkable things
... er he must have had to be
... , a crazy girl came into
... but I'm not going to
... not going to let that
... n't change *any* of
... He was exactly

... ? You rented

... me and asked:
... ge dance hall? You said
... hall and lost it. You know,
... nearby here. You could

... d it to me. It was on a
... decided on Tuesday that we
... and open on Friday. The
... mous business for a couple
... in a row until we got a book-
... fornia and closed it.

... d Jane Fonda used to be there.

... he did, but many people came. The
... put the Velvet Underground on the
... and really made Andy enormously
... us. The show was called the "Explod-
... Inevitable." Barbara Rubin was
... there was a photo, on the back
... an record album, of her comb-

... you miss most about Andy?

... t giant positiveness. He just
... atcha doing? Oh, that's
... gonna be great!" He was
... ve. And it's remarkable
... ould go out every night to
... nightclub. Nobody knew
... it. But he always expected
... come at the end of the
... t.

... stay home, he'd have to
... th you all night.

... ar missing that search
... He always expected
... and somebody
... illion," or
... a positive
... his tem-
... many
... her

... you
... ping

Andy Warhol,
one year before
his death

Plate 46 **Unknown photographer** Sarah Burge, 1883. Dr Barnardo's Homes (807)

The Monument

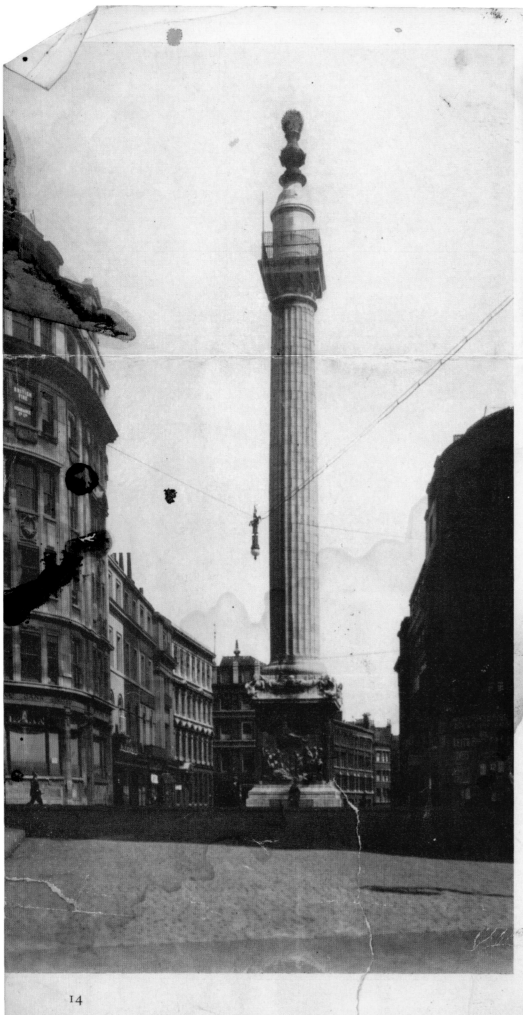

It is a steep climb up the 311 steps that spiral to the top of the Monument, Sir Christopher Wren's 1677 memorial to the Great Fire of London. About its foot, one 1967 block obtrudes into the unchanged curves of earlier offices. From the top, the view is again into Lower Thames Street, showing how Billingsgate Fish Market was extended in 1961. Opposite, there is now a gap where once was the Coal Exchange but alongside, the Custom House stands where one has stood for 500 years. The present block, with some rebuilding, dates back to 1817. Down-river, Tower Bridge hides its engineering marvels (each 1,000 ton drawbridge lifting for ships in a minute and a half) behind a medieval facade. It was completed in 1894. A footway across the top is now permanently closed.

14

DANS
LES RUES
DE
PARIS
au temps des fiacres

(Photo Adget)

LE COUP DE FUSIL SUR LE ZINC

par Claude BLANCHARD

Comme l'automobile en série dont il est une des conséquences, le bistro est un des triomphes de l'après-guerre.

En 1910, quand un bourgeois de petite bourse voulait régaler sa famille, il l'emmenait au « bouillon », dont les bonnes à coiffes empesées, les stores en macramé, les grandes salles déjà très illuminées, les panoramas de carafons et les plantes vertes dans l'escalier attiraient par la promesse du pigeon aux petits pois, de la blanquette à l'ancienne et des pommes Pont Neuf qui firent la fortune de feu Duval, le Boucicaut de la boustifaille. Ces établissements étaient respectables à souhait, pour la classe moyenne, qui eût cru déchoir en allant partager avec des déménageurs les plats solides à fond de « roux » qui remplissaient jusqu'au ras bord, pour quinze sous vin compris, les assiettes blanches des marchands de vins.

Relaxing in an armchair

Science Against Crime

Stuart Kind · Michael Overman

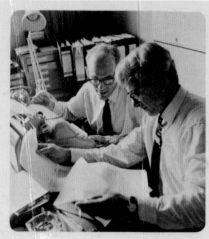

About the Authors

Stuart S. Kind (right) is an internationally known British forensic scientist. During his 20 years' experience in the biological aspects of forensic science, he has worked on some 3,000 cases and appeared in court as an expert witness more than 1,000 times. He is Editor of *The Journal of the Forensic Science Society* and a skilled amateur photographer. Before beginning his career as a scientist, he served in the War with the Royal Air Force.

Michael Overman (left) has written a number of books on technical subjects. After achieving the rank of Major in the Royal Engineers, he retired in 1947 for health reasons and became a journalist. He spent 16 years in India, where he founded and edited several successful publications. In 1963 he returned to England, where he now works in public relations and as a free-lance writer.

The Illustrated
LONDON NEWS

September

LONDON IN CRISIS

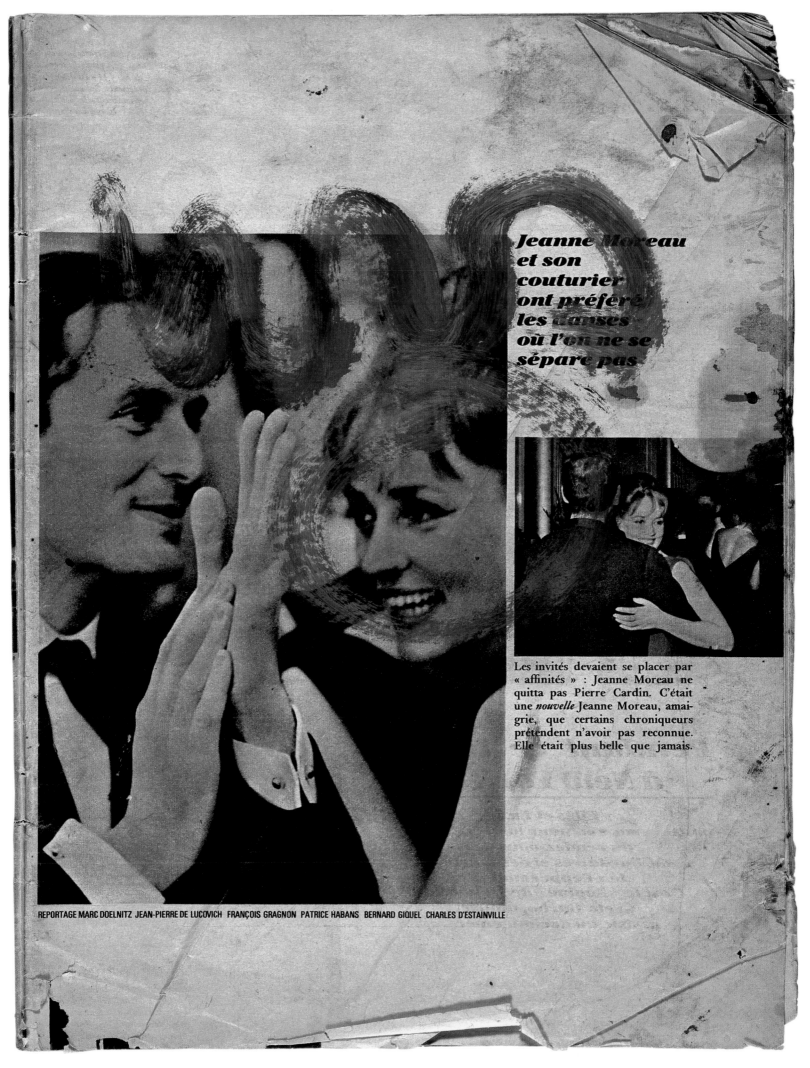

Jeanne Moreau et son couturier ont préféré les danses où l'on ne se sépare pas

Les invités devaient se placer par « affinités » : Jeanne Moreau ne quitta pas Pierre Cardin. C'était une *nouvelle* Jeanne Moreau, amaigrie, que certains chroniqueurs prétendent n'avoir pas reconnue. Elle était plus belle que jamais.

REPORTAGE MARC DOELNITZ JEAN-PIERRE DE LUCOVICH FRANÇOIS GRAGNON PATRICE HABANS BERNARD GIQUEL CHARLES D'ESTAINVILLE

QUI EST-ELLE ?
JOLIE ? PERVERSE ? INSOLENTE ?
JOSETTE EST
AU CENTRE DE TOUTES LES QUESTIONS

Josette coûtait 8 à 10 millions par an à son mari.
Petite fille mal grandie,
à l'humeur imprévisible, elle a endossé avec véhémence
sa part de responsabilité, mais nie
avoir été l'instigatrice du crime.
Les psychiatres lui donnent raison. Engoncée
dans sa robe noire, elle a laissé les
jurés perplexes devant son masque énigmatique.

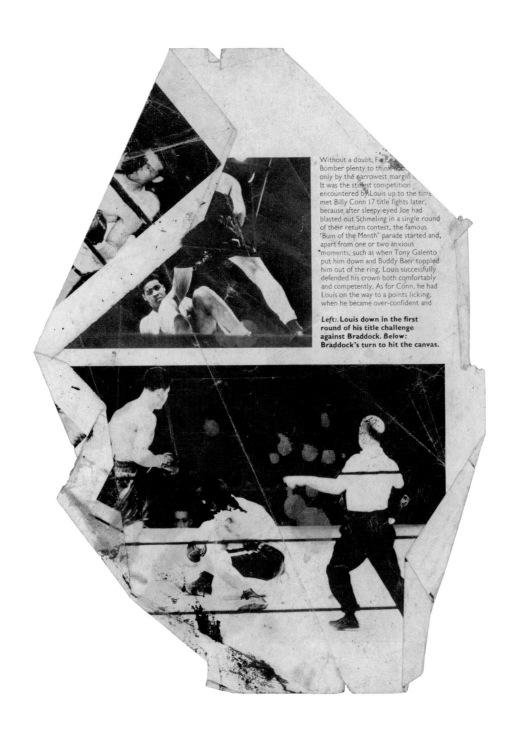

Without a doubt, Far East
Bomber plenty to think about
only by the narrowest margin
It was the stiffest competition
encountered by Louis up to the time
met Billy Conn 17 title fights later,
because after sleepy-eyed Joe had
blasted out Schmeling in a single round
of their return contest, the famous
'Bum of the Month' parade started and,
apart from one or two anxious
moments, such as when Tony Galento
put him down and Buddy Baer toppled
him out of the ring, Louis successfully
defended his crown both comfortably
and competently. As for Conn, he had
Louis on the way to a points licking,
when he became over-confident and

Left: **Louis down in the first round of his title challenge against Braddock.** *Below:* **Braddock's turn to hit the canvas.**

3

Action — Painting

former Northern Ireland
s given the job of explaining
American public. H

This page: USA defend against a Mexican attack
City in 1965 Opposite page: a battle of the giants in Ne
in 1966, as Inter-Milan (striped shir
n game that pulled in a crowd of
s in a country where soccer was
a few months before, when the Worl
ised fre gland, put the ga

243

TV, in fact, have
been healthy
ks for the right
e standard of
e Americans
g a match as
sticking one
e view that
dull
are used.
midfield,
alty-area
line for
behind
s. All

d in
ing
up
e

encourage attacking play, awarding extra points for goals scored.

Teams were awarded six points for a win, three for a draw, and none for losing; in addition, one extra point was given for each goal scored (by both winning and losing teams) up to a maximum of three. A team winning 2—0 (or 2—1) thus collected eight points; while a team winning by scoring three or more goals (e.g. 3—0, 7—0, 4—2) obtained the maximum of nine points. In the last example, the team losing 4—2 collected two points for its two goals.

Each of the NPSL teams played thirty-two games, meeting all other teams in the league (seven of them four times, two of them twice). For classification the league was divided into East and West sections, with the winners of the two sections meeting at the end of the season in early September. This two-game championship play-off was won by California Clippers, who beat Baltimore Bays.

If we apply this system to the 1966–7 season's top two English Divisions, some interesting statistics are revealed. For instance Newcastle and not Aston Villa would have been relegated from the First Division, Spurs and not Nottingham Forest would have been runners-up to Manchester United, and Wolves and not Coventry would have been Second Division champions. In each of these instances the team which benefits on the American system, scored the more goals, and also, to a purely neutral observer, each in fact seemed the more attractive side.

The NPSL's rivals in the meantime had been laying their plans to prevent the 'rebels' getting too much of a head-start. The North American Soccer League, or United Soccer Association as it

had the full sanction of the USSFA. a t ready to launch their own sides in a made foreign ir official backing they did not have promoting them, and so they

They pi ition games played by visiting some of the resented American cities. Star (Yugosl lars to stage a series involving Madrid (Spain) clubs. They called on Red (Hungary), West o Bilbao (Spain). Real tracht (West Germa ited (England), Vasas Rangers (Scotland), Land), Frankfurt Ein- fica (Portugal). iro (Brazil), Glasgow England) and Ben-

The clubs tied up in this in the spring of 1968, were ba with plans to open Cleveland, Dallas, Detroit, H oston, Chicago, New York, San Francisco and Wa Los Angeles, States, with Toronto and Vancouver on DC in the Cnada.

The United Soccer Association's aim was still to persuade the rebel American B y join them. They met unsuccessfully to try and st a merger. Jim Maguire, president of the affiliated bo said at the beginning of the 1967 summer, 'The last thing we want is a war. It would be much better for professional soccer in the States if we do not cut each other's throats.'

FIFA's president Sir Stanley Rous met representatives from both leagues, and was equally anxious that they should merge. He commented, 'It would be pleasing to us if these two leagues determined that it would be in their best interests to consolidate'. The exploratory talks on amalgamation led nowhere, however, and both leagues ran into spots of trouble.

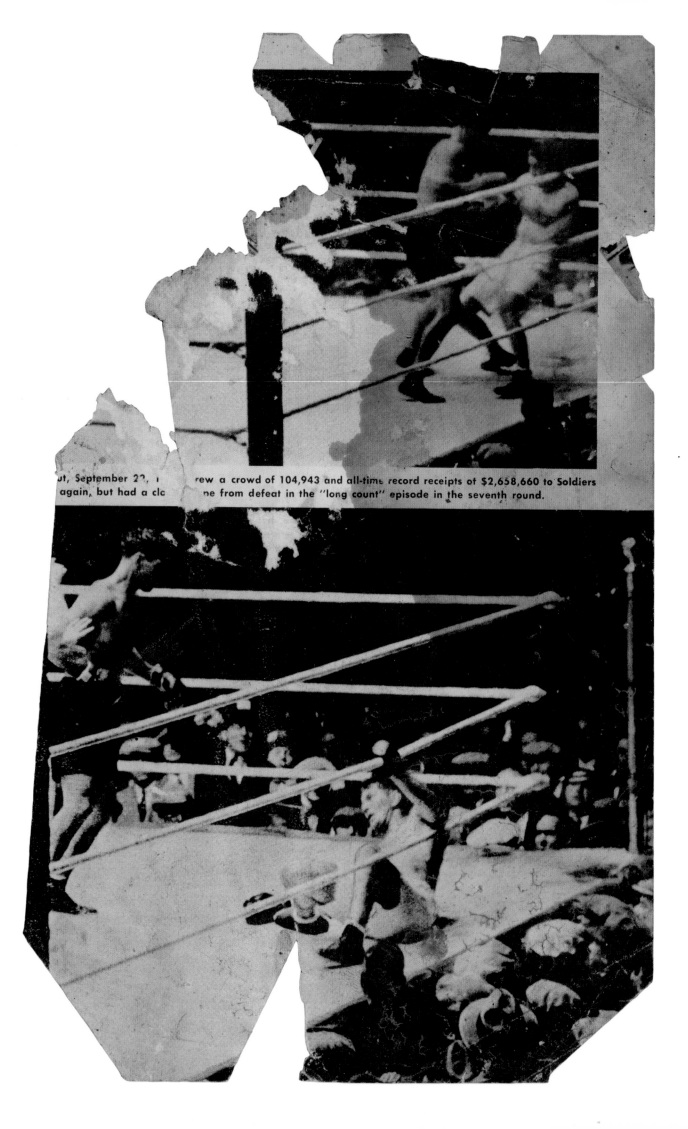

ut, September 2?, 1 rew a crowd of 104,943 and all-time record receipts of $2,658,660 to Soldiers again, but had a clc ne from defeat in the "long count" episode in the seventh round.

MIROIR DE L'ATHLETISME

Joe Louis in action. *Top left:* ... knocked out in the ... *Above:* Schmeling's ... as Lo...

176

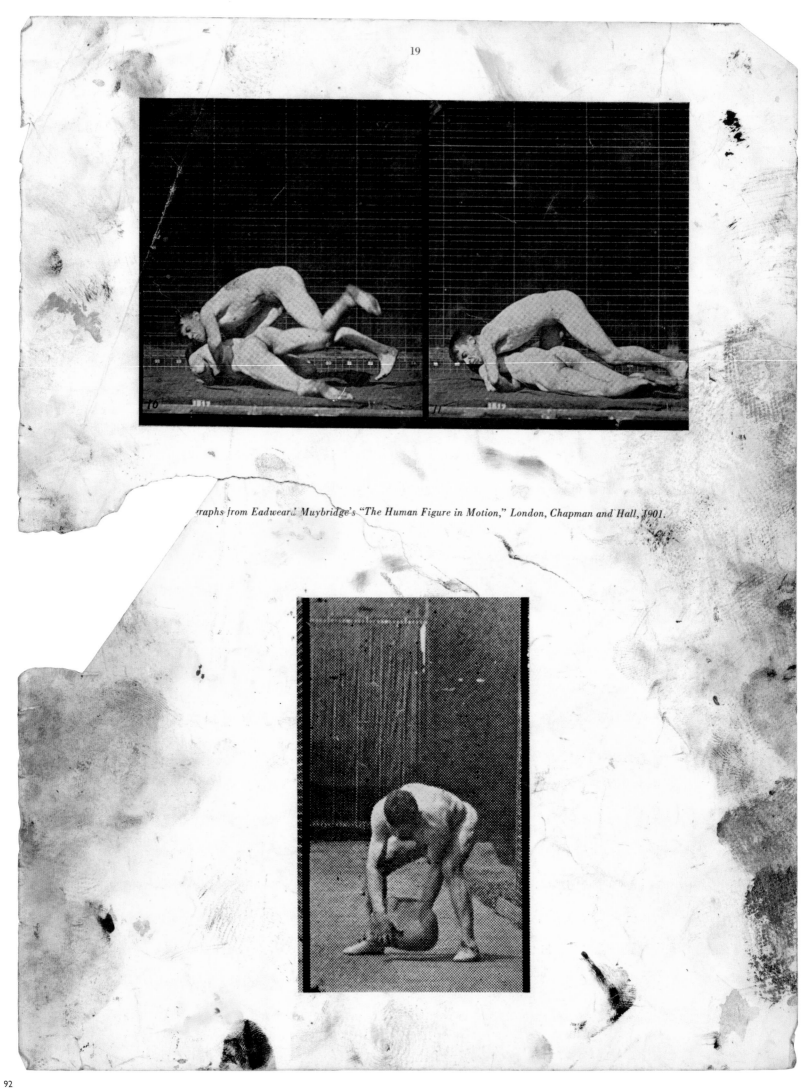

...raphs from Eadweard Muybridge's "The Human Figure in Motion," London, Chapman and Hall, 1901.

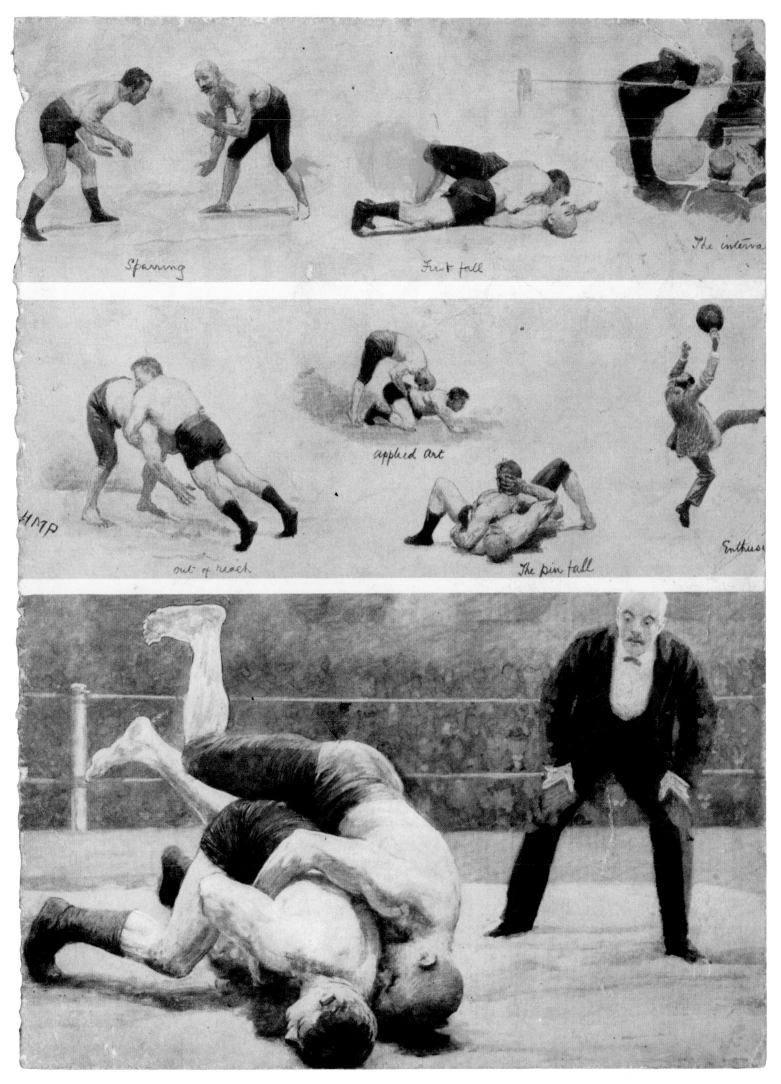

Sparring

First fall

The interva[l]

HMP

out of reach

applied art

The pin fall

Enthus[i]

93

2nd Test **India** v. **England** *Calcutta*

the Scottish footba book no.

EDITED BY HUGH TAYLOR

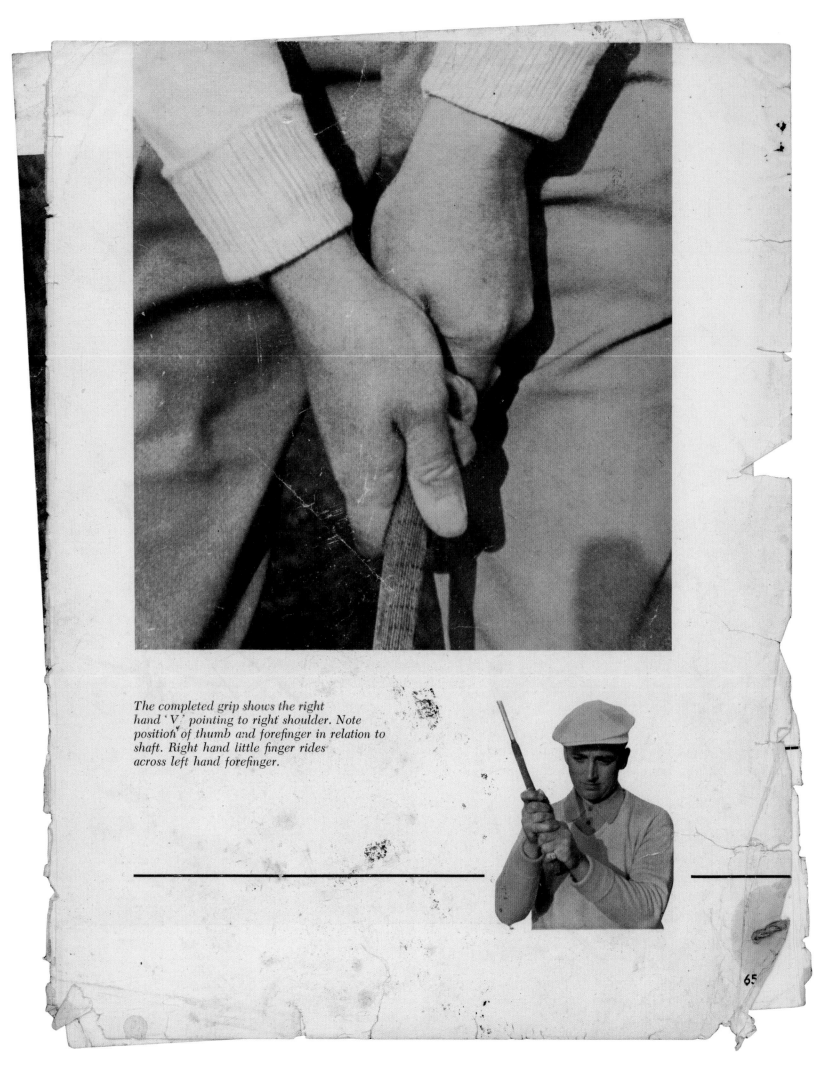

The completed grip shows the right hand 'V' pointing to right shoulder. Note position of thumb and forefinger in relation to shaft. Right hand little finger rides across left hand forefinger.

65

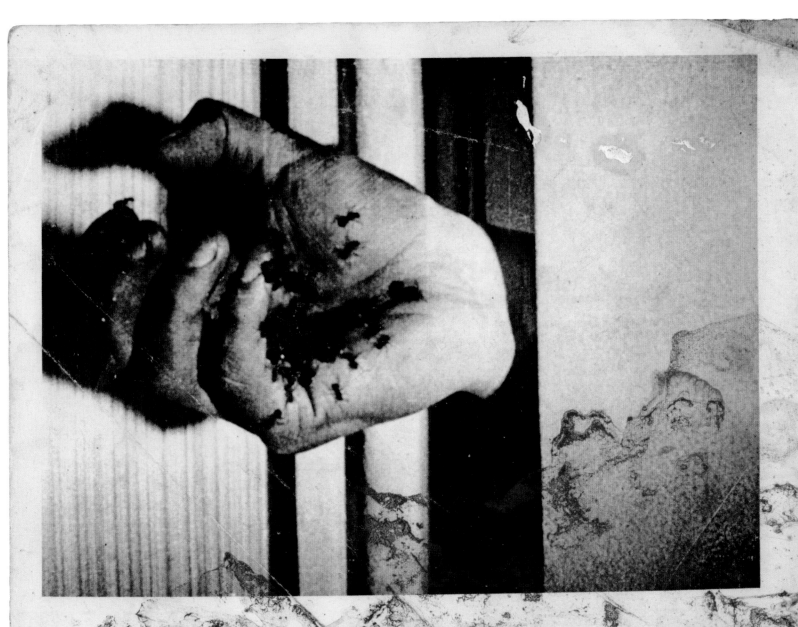

Buñuel was a member of the movement while in Europe, if rather on its margins.

Several Buñuel films show an interest in socio-political questions, and his work has a strong appeal to anarchist commentators, like Alan Lovell in Britain, and to Marxists of most shades of opinion, like the *Positif* team in France. 'Anarcho-Marxist' might not be a bad description of Buñuel's general orientation.

For some, Buñuel is primarily a Christian despite himself. He freely admits that he has been deeply influenced by his religious upbring-

Stills: Un Chien Andalou. *The rival world . . . the ants which are one of Buñuel's symbols for decay spread out over the wounded hand, while the too-prudent heroine keeps its owner at bay.*

ing, and Gabriel Figueroa, his cameraman on many films, has described him as an essentially 'religious' man. However, Luc Moullet's suggestion that Buñuel's blasphemies betray the depth of his religious involvement run into the corollary, which is rather appealing to the irreverent, that if you canonise Buñuel, why not Sade or Satan? Henri Agel is also an

10

Four cuts from the scene of the massacre
crowds on the Odessa Steps
masterpiece, 'The Battle

AMERICA

THE GIRL WHO STARTED THE 'IT' BU
Clara Bow helped to popularise sex films with a public
to the Victorian innocence of Mary Pickford and Lilli

had been
Gish char

3

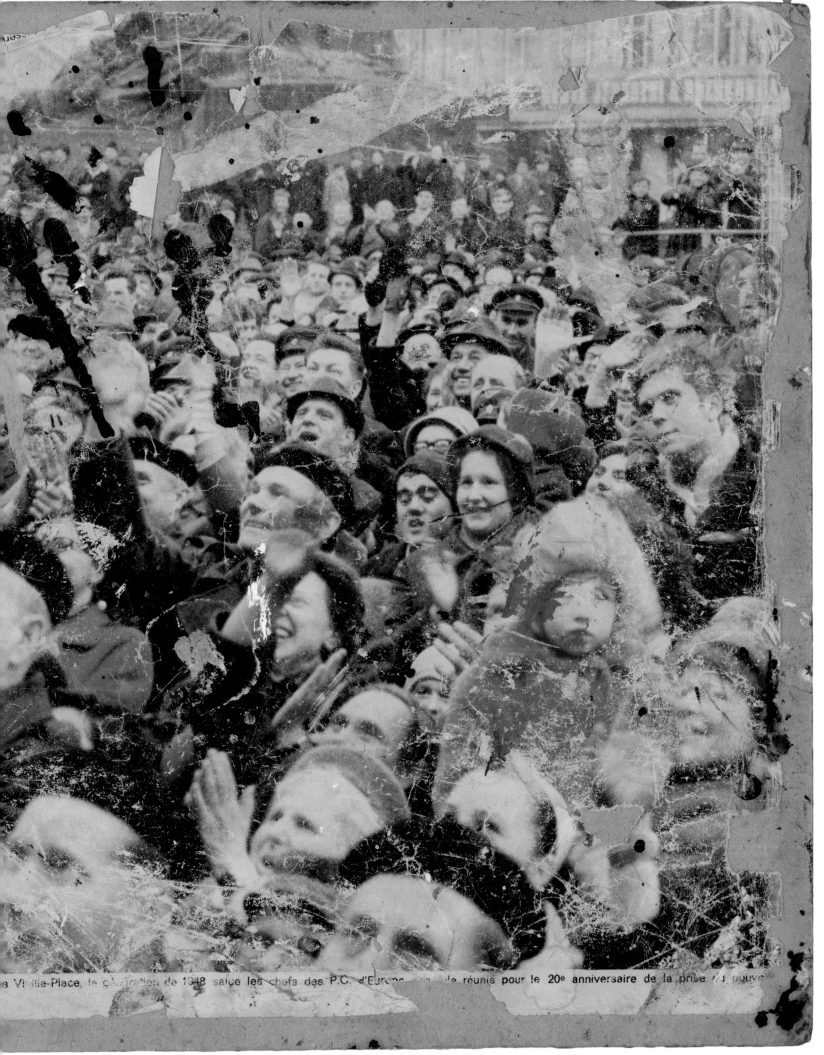

a Vieille-Place, le célébration de 1948 salue les chefs des P.C. d'Europe réunis pour le 20e anniversaire de la prise du pouvoir

187. LE JOUR SE LÈVE. MARCEL CARNÉ. 1939.

106

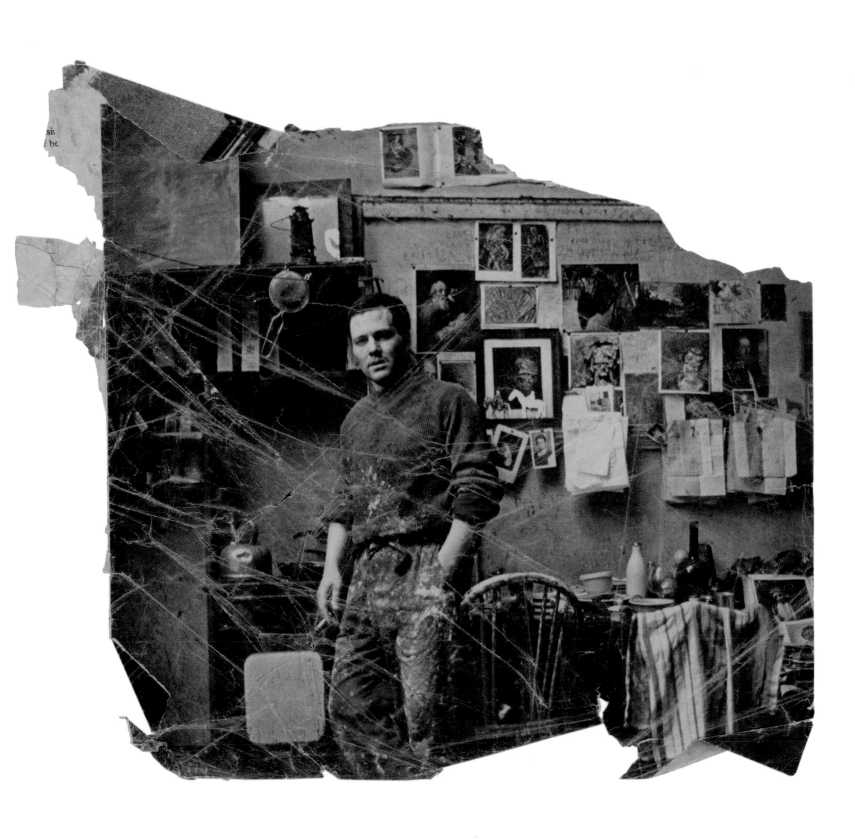

INDUSTRIAL DESIGN

JOHN HESKETT

BEFORE

With Amalgam Fillings

AFTER

With **ADAPTIC*** Universal Restorative © Johnson & Johnson LIMITED

Abb. 1. Max Koner in seinem Atelier.

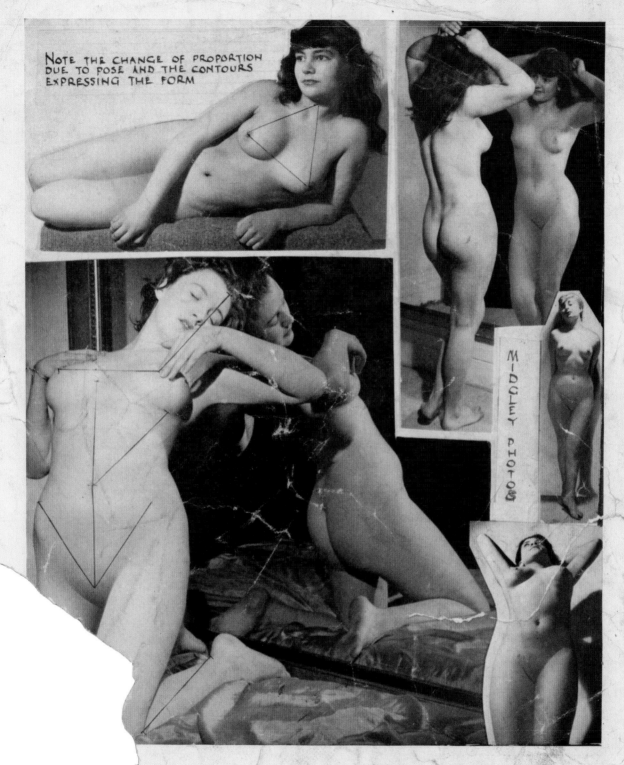

NOTE THE CHANGE OF PROPORTION DUE TO POSE AND THE CONTOURS EXPRESSING THE FORM

...te carefully fat areas on breasts, mid back, giuteal area, sub-trochanteric and sub-

...right silhouette expressing eloquently the sculptural forms of the upper and

...Note the navel-to-symphysis pubic measurements and how they relate over t...

...ers to discover additional similar measurements. Note also the iliac cres...

...right crest; also the foreshortening of the thoracic 'cage' and how the b...

...lie on it. Compare breasts bottom right to top left.

THE ARTIST'S WORLD IN PICTURES
FRED W. McDARRAH

This extraordinary and exciting volume pays tribute to the brilliant group of artists known nationally and internationally as the "New York School." In over 300 marvelous photographs and eighteen chapters Fred McDarrah has caught unerringly the look, aroma, feel and light of the artists in their studios, their paintings and sculpture, streets and galleries, parties and club meetings, their collectors, dealers and critics.

THE PAINTER AND THE PHOTOGRAPH

from Delacroix to Warhol / Van Deren Coke

(above left) Robert Delaunay.
Garden on the Champs de Mars.

(above right) André Schelcher and A. Omer-Decugis.
La Tour Eiffel.

(lower left) Eugène Delacroix.
Odalisque.

(lower right) Photographer unknown.
Seated nude.

Albuquerque / University of New Mexico Press

ISBN 0-8263-0197-5

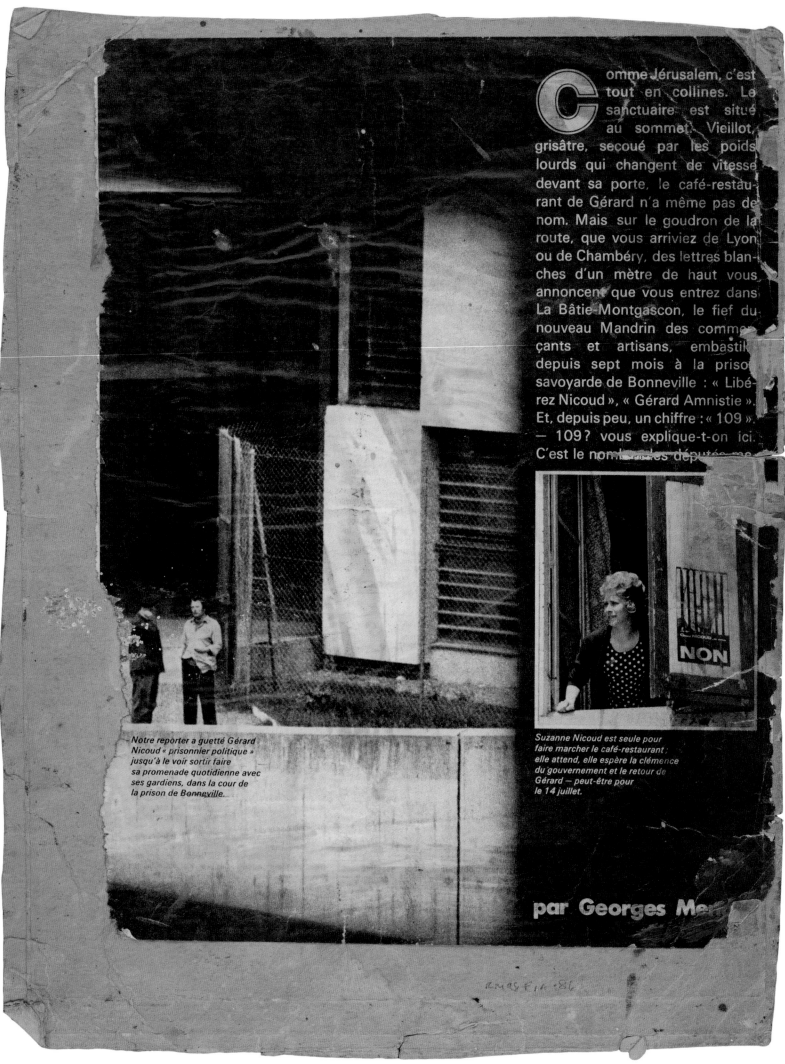

Comme Jérusalem, c'est tout en collines. Le sanctuaire est situé au sommet. Vieillot, grisâtre, secoué par les poids lourds qui changent de vitesse devant sa porte, le café-restaurant de Gérard n'a même pas de nom. Mais sur le goudron de la route, que vous arriviez de Lyon ou de Chambéry, des lettres blanches d'un mètre de haut vous annoncent que vous entrez dans La Bâtie-Montgascon, le fief du nouveau Mandrin des commerçants et artisans, embastillé depuis sept mois à la prison savoyarde de Bonneville : « Libérez Nicoud », « Gérard Amnistie ». Et, depuis peu, un chiffre : « 109 ». — 109 ? vous explique-t-on ici. C'est le nombre des députés me...

— Notre reporter a guetté Gérard Nicoud « prisonnier politique » jusqu'à le voir sortir faire sa promenade quotidienne avec ses gardiens, dans la cour de la prison de Bonneville.

Suzanne Nicoud est seule pour faire marcher le café-restaurant ; elle attend, elle espère la clémence du gouvernement et le retour de Gérard — peut-être pour le 14 juillet.

par Georges Me

Ad Reinhardt had a retrospective exhibition last sea... the Betty Parsons Gallery, showing twenty-five years of his abstract art. He was born in Buffalo in 1913, and went to Columbia University. He is a self-taught painter and exhibited with American Abstract Artists from 1939-1946.

173

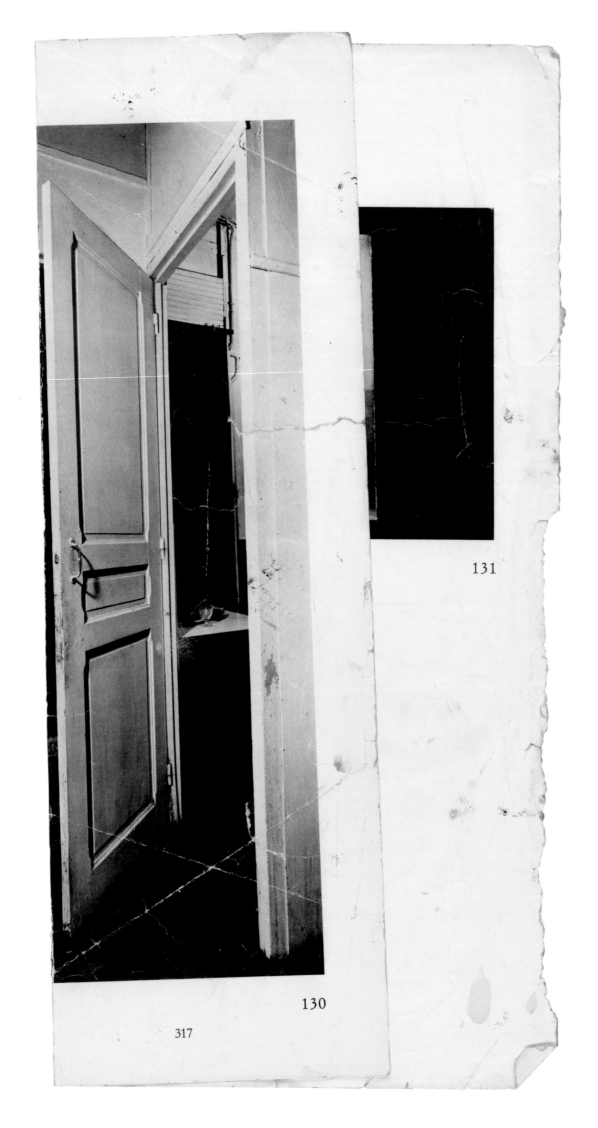

131

130

317

Fig. 261. O William Keck, 1939
Reflections and mirroring

MAI 1973
PRIX 4 F

39

RMAE FIA 73

PLATE SIXTEEN
JEANNE HEBUTERNE. 1919. Oil, 51″×32″
Collection Mr. and Mrs. Sidney F. Brody, Beverly Hills,
California

4

Science — Nature

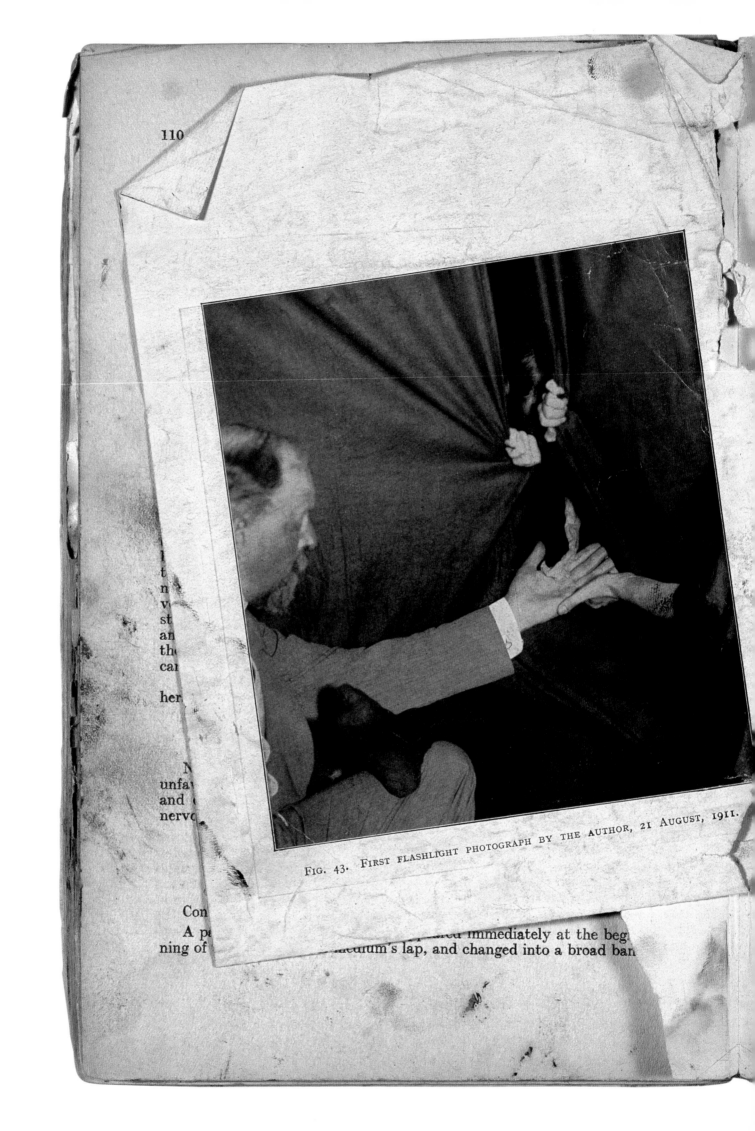

FIG. 43. FIRST FLASHLIGHT PHOTOGRAPH BY THE AUTHOR, 21 AUGUST, 1911.

I
t
n
v
st
an
the
ca

her

N
unfav
and
nervo

Con
A p immediately at the beg
ning of medium's lap, and changed into a broad ban

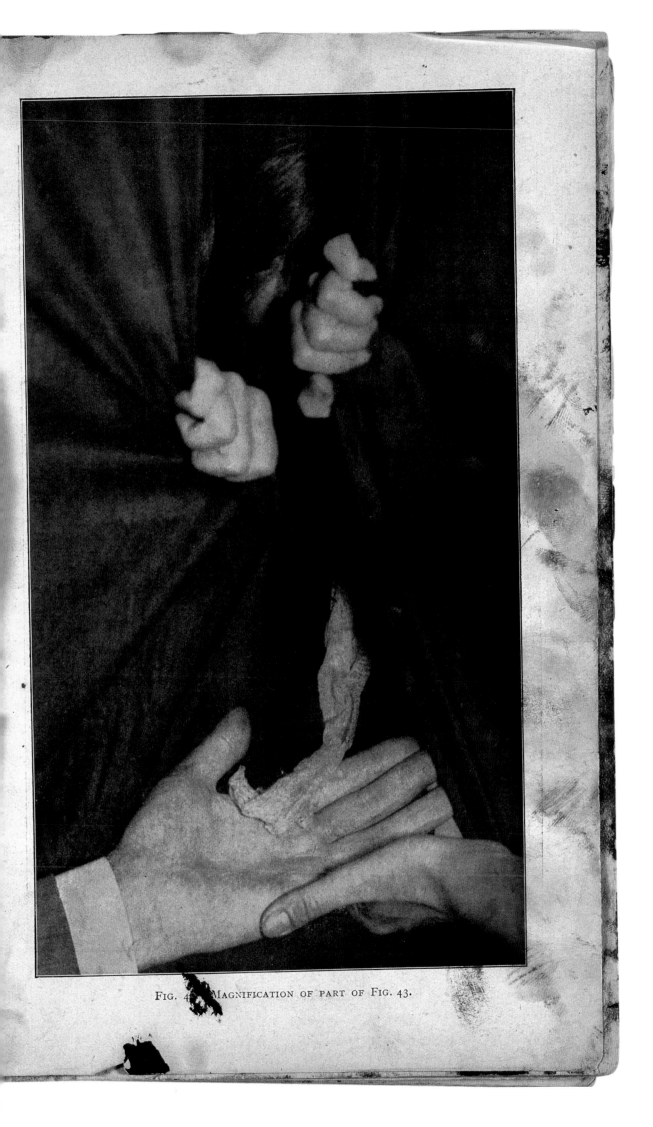

FIG. 4. MAGNIFICATION OF PART OF FIG. 43.

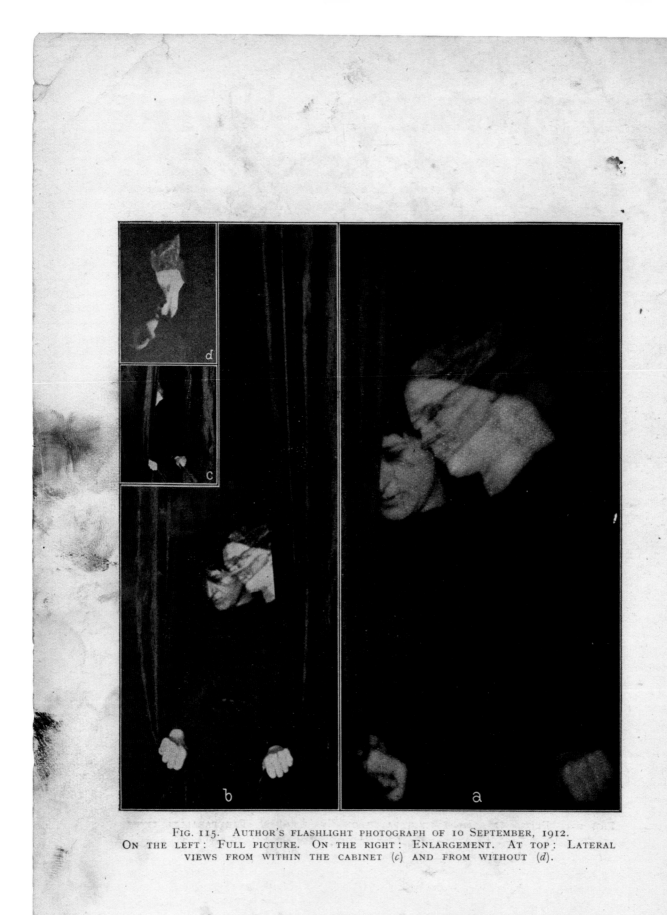

FIG. 115. AUTHOR'S FLASHLIGHT PHOTOGRAPH OF 10 SEPTEMBER, 1912.
ON THE LEFT: FULL PICTURE. ON THE RIGHT: ENLARGEMENT. AT TOP: LATERAL
VIEWS FROM WITHIN THE CABINET (c) AND FROM WITHOUT (d).

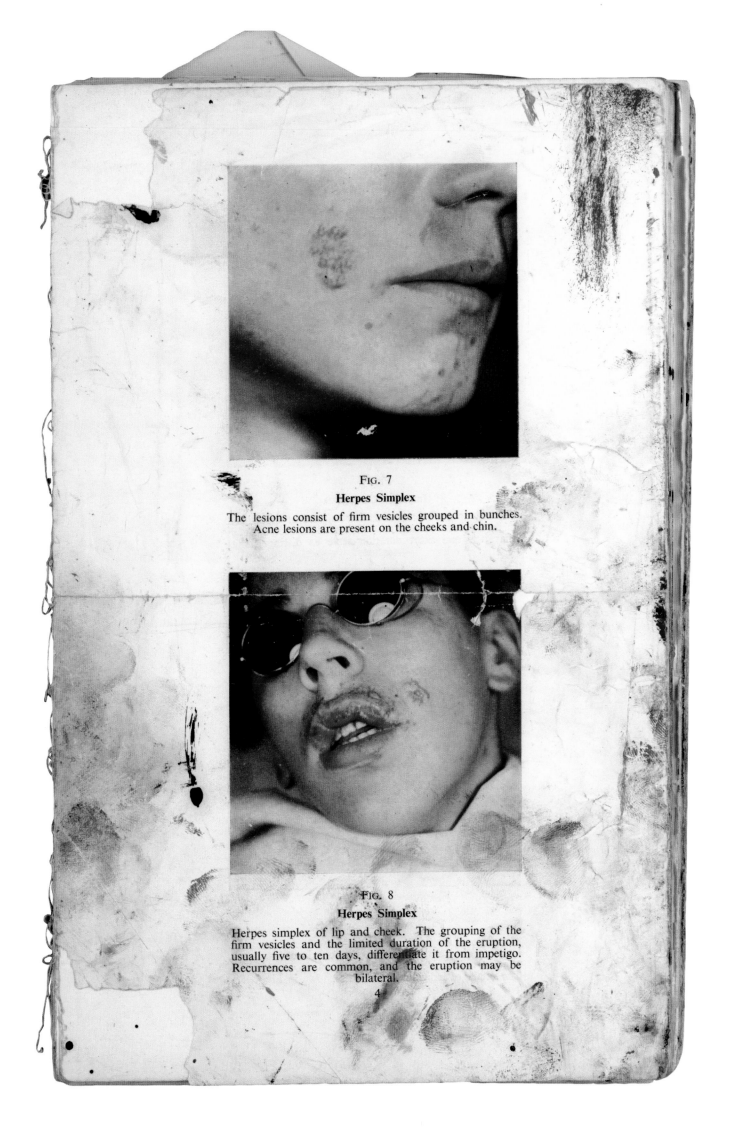

Fig. 7

Herpes Simplex

The lesions consist of firm vesicles grouped in bunches. Acne lesions are present on the cheeks and chin.

Fig. 8

Herpes Simplex

Herpes simplex of lip and cheek. The grouping of the firm vesicles and the limited duration of the eruption, usually five to ten days, differentiate it from impetigo. Recurrences are common, and the eruption may be bilateral.

4

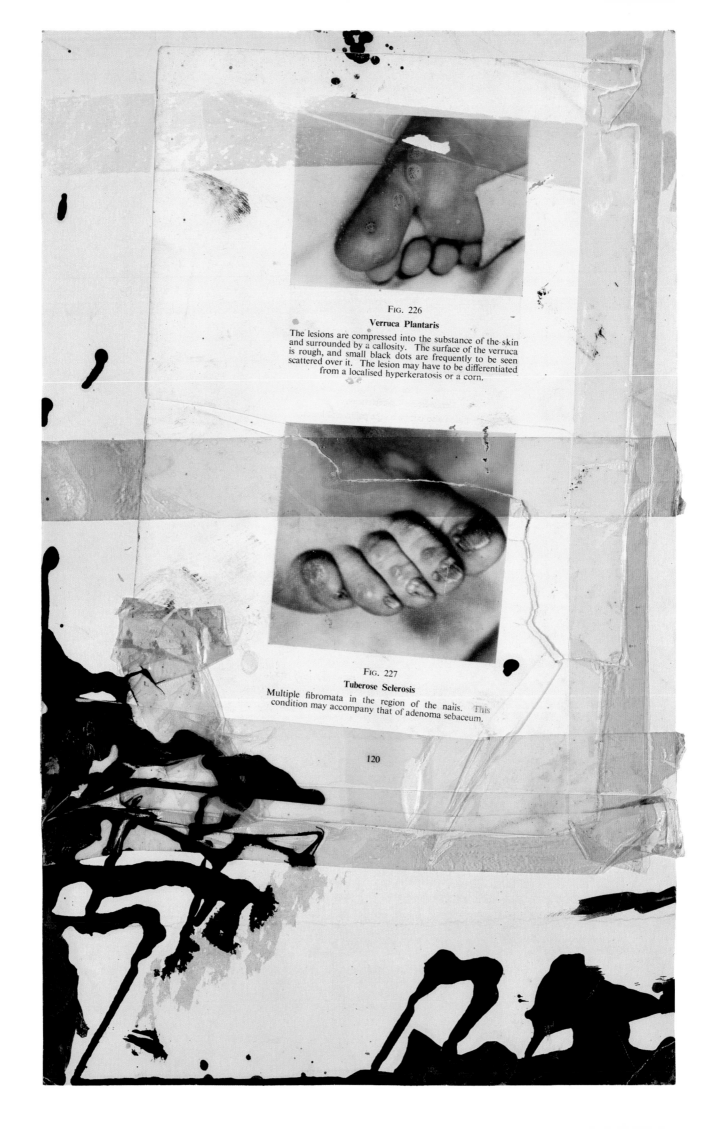

Fig. 226

Verruca Plantaris

The lesions are compressed into the substance of the skin and surrounded by a callosity. The surface of the verruca is rough, and small black dots are frequently to be seen scattered over it. The lesion may have to be differentiated from a localised hyperkeratosis or a corn.

Fig. 227

Tuberose Sclerosis

Multiple fibromata in the region of the nails. This condition may accompany that of adenoma sebaceum.

120

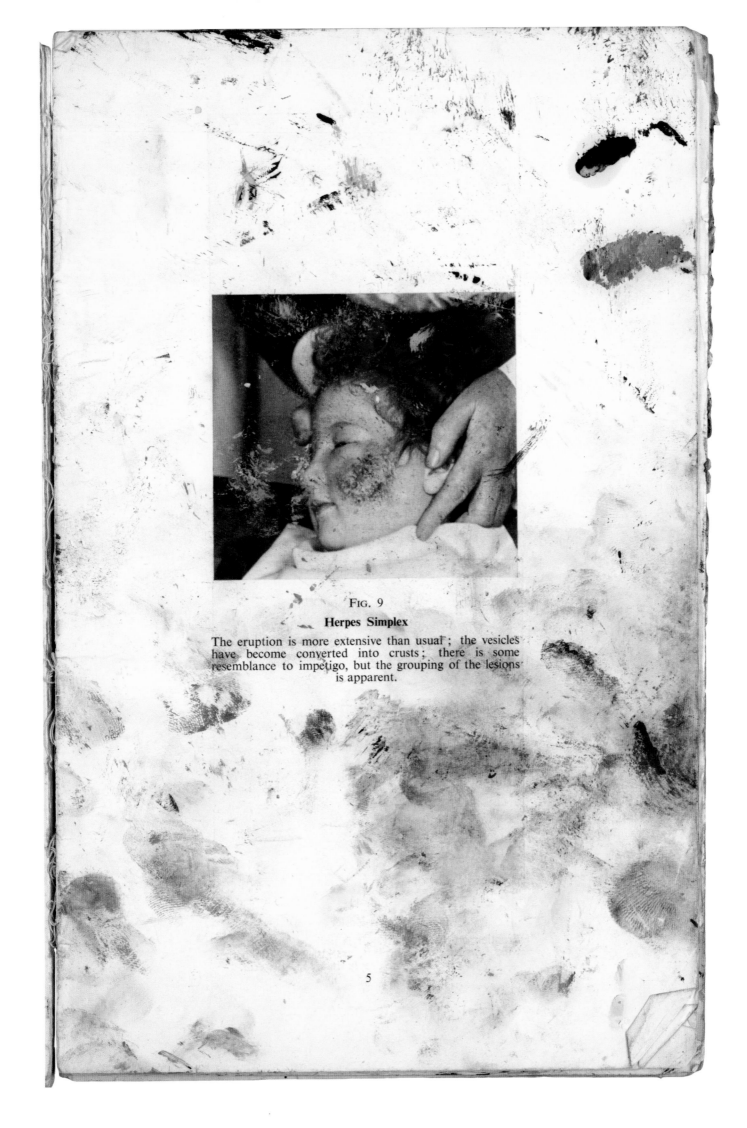

FIG. 9

Herpes Simplex

The eruption is more extensive than usual; the vesicles
have become converted into crusts; there is some
resemblance to impetigo, but the grouping of the lesions
is apparent.

5

MANDIBLE, TEMPORO-MANDIBULAR JOINTS

SHORT DISTANCE TECHNIQUE (*continued*)

(1134a) shows the film-cassette in the first position with the mouth closed; on withdrawing the cassette by two inches the second "at rest" exposure is made (1135) and on further withdrawal of the cassette by two inches the third exposure is made with the mouth open, similar to the open mouth position (1145) on page 303.

ᴺᴼᵀᴱ—For research purposes when positioning technique must be meticulous, one horizontal and two ᵃⁿᵈ fine wires may be embedded in the cassette holder ᵃᵗ each side of the exposure area to provide for the ᵒᶠ each set of exposures.

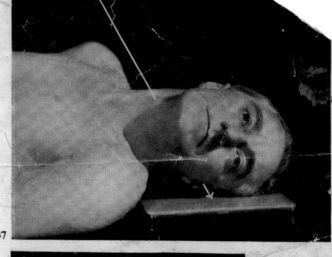

1137

SUPINE—TUBE ANGLED

patient supine, the neck is allowed to move ward the affected side so that the parietal esting on the cassette. The raised shoulder is on sandbags. This position is readily assumed tained by the patient.

ᴱ behind and below the angle of the jaw, with angled 30 degree ward the head. Each side is exposed separately with the jaw both open and closed.

(1137, 1138, 1139)

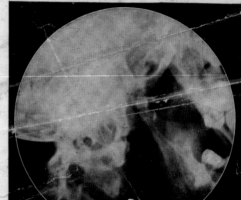

1138

kVp.	mAS	FFD	Film ILFORD	Screens ILFORD	Grid
60	5	30″	RED SEAL	FT	—

4. VARIABLE ANGLE-BOARD

On using the angle-board, adjusted to a 25-degree angle, the patient stands at the end of the couch and bending, rests the affected side of the head on the angle-board; the face is then turned approximately 10 degrees away from the film so that the temporo-mandibular joint may be projected clear of the cervical vertebrae and adjacent structures.

CENTRE posterior to and just below the angle of the mandible on the tube side.

(1138, 1139, 1140)

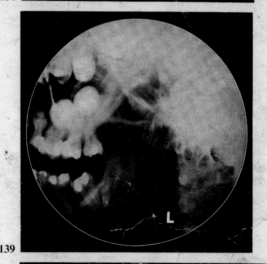

1139

CLOSED—OCCLUDED—OPEN—PROTRUDED

For a detailed examination of the temporo-mandibular joints, projections may also be taken with varied adjacency of the occlusal surfaces of the jaws, as summarized below.

It is unlikely that more than six exposures will be necessary for right and left sides, and these may be included

302

1140

2. SHORT DISTANCE TECHNIQUE

On reducing the focus-film distance to 12 inches, the joint remote from the film and thus nearest to the tube is diffused, whilst the joint adjacent to the film is clearly defined.

A modified craniostat attached to a cassette tunnel, with on the opposite side a fixture to hold the modified extension cone of the X-ray tube, enables the head to be placed and immobilized in the ideal position in relation to tube and film to produce the standard series of six radiographs required for the temporo-mandibular joints, three exposures on each side (1135, 1136).

The surface of the cassette tunnel is lined with lead with the exception of the exposure aperture in the lower part of the tunnel measuring 2×3 inches.

Plastic ear-plugs decentralized by half-an-inch are adjustable for right and left sides and provide for maintaining the position of the head in relation to the film—median-sagittal plane and anthropological base line parallel, and interorbital line perpendicular to the film (1134a).

The modified diaphragm with a 2-mm. aluminium filter and lead surrounded circular aperture one inch in diameter, fits into the craniostat at a caudal angle of 15 degrees, to be centred two inches above the EAM on the near tube side. When the patient is seated and with the ear-plugs fitted into the external auditory meatuses, three exposures are made in sequence on the lower one-half of the film (1134b) with the mouth *closed*, *at rest* and *open* and with the cassette adjusted appropriately by two inches for each exposure (1135). The ear-plugs and the position of the patient are then rotated and the position of the cassette is reversed to enable three similar exposures to be made of the opposite joint. The resulting radiograph shows the six exposures complete on a single $6\frac{1}{2} \times 8\frac{1}{2}$-inch film. The radiograph may be divided transversely and rejoined with plastic tape to enable the right and left joints to be viewed one below the other from the same aspect as in (1136).

At the focus-film distance of 12 inches the filter is most important and it should be noted that the difference between using a 1-mm. aluminium filter at 60 kVp and a 3 mm. aluminium filter at 70 kVp, is to reduce the dosage to the patient from 15 mr to 6 mr for each side of the face embracing three exposures. Using Standard film and High Definition screens at 60 kVp and 10 mA exposure is for $3\frac{1}{2}$ seconds (35 mAS).

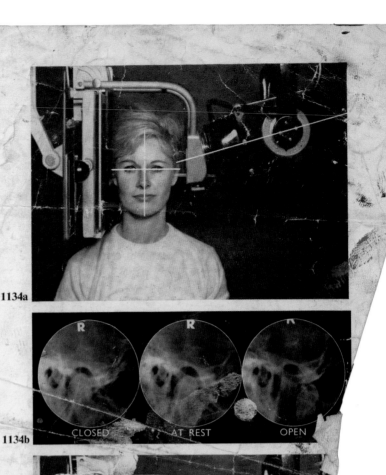

1134a

1134b

1135

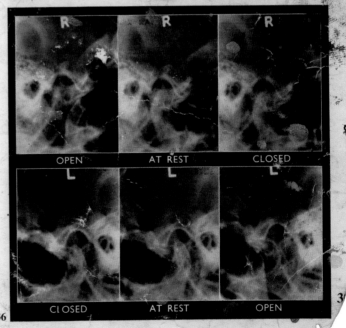

1136

appreciable time. Against a strong wind it would be easy to maintain a *ground* speed of *nil*, and it would be possible even with motionless wings. In still air, however, the ordinary gliding basis of flight is in abeyance, and altitude must be maintained by sheer vertical force of wingstroke, the bird being thus more nearly equivalent to a helicopter than to an aeroplane.

The aviators of to-day compete to establish records for speed, for endurance, and for altitude.

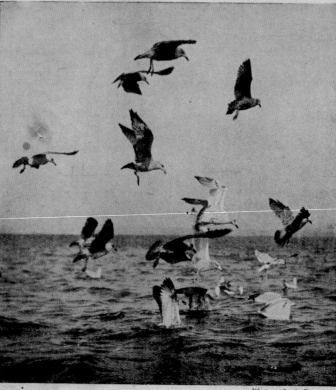

From "*Our Common Sea-Birds*" (*Country Life, Ltd.*). Photo : *J. C. Douglas.*

HERRING-GULLS (*LARUS ARGENTATUS*).

The Herring-Gull gets its name from its habit of following shoals of herrings. The Gulls will follow shoals of small fish swimming near the surface. They usually swoop down upon them on a flat curving course, not submerging the body but merely immersing the head and bill.

Speed and Altitude. How do birds stand in these respects? As regards speed, in the first place one must remember the difference between "ground speed" and "air speed." Both the aeroplane and the bird can, for a certain expenditure of power, attain a certain velocity in the body of air in which they are, but the velocity as measured from the ground may be a very different thing. Thus an aeroplane travelling at 100 miles per hour in a 20 miles per hour wind may seem from the ground to be going at 120 miles or at 80 miles per hour, accordingly as it flies with or against the air-stream ; so also, of course, with the bird. All our speed records of birds, except a few made from aeroplanes, are necessarily in terms of ground speed, and in many cases the particulars necessary for a wind correction are unhappily wanting.

What are some of the actual figures? The

available evidence has recently been summarised by Colonel Meinertzhagen, with special reference to speed during migration ; he concludes that a bird has an ordinary pace, which is the one used in migratory flight, and an accelerated pace of which it is capable for a short distance under stress of danger or in other special circumstances. Here are some of his figures : carrier-pigeons, 30–36 miles per hour (over 60 has been recorded, but possibly only with a strong favourable wind) ; crows, 31–45 ; small song-birds, 20–37 ; starlings, 38–49 ; ducks, 44–59 ; he also quotes the case of a flock of swifts flying at 6,000 feet above Mosul, in Mesopotamia, which in their ordinary flight easily outpaced the observer's aeroplane when it was doing 68 miles per hour. The air speed of this astonishing flyer is, when accelerated, probably well over 100 miles an hour.

As regards altitude, it seems that although birds have occasionally been recorded as high as 15,000 feet, they are indeed rarely met with above 5,000 feet, while the greater part of flight, including migration, probably takes place within 3,000 feet of the ground.

§ 5

The power of flight has given birds the key to one kind of habitat after another that might otherwise have proved to be too dangerous or

Illustration 18. The Ricochet

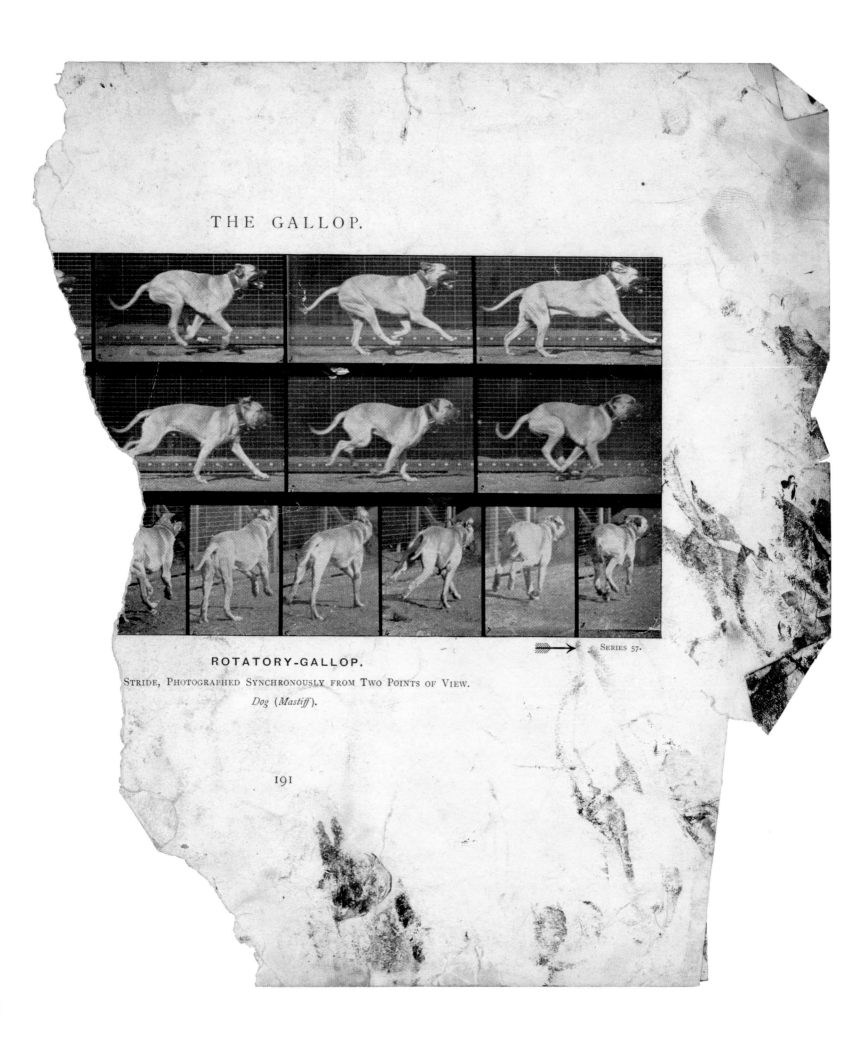

ROTATORY-GALLOP.

Series 57.

Stride, Photographed Synchronously from Two Points of View.

Dog (Mastiff).

191

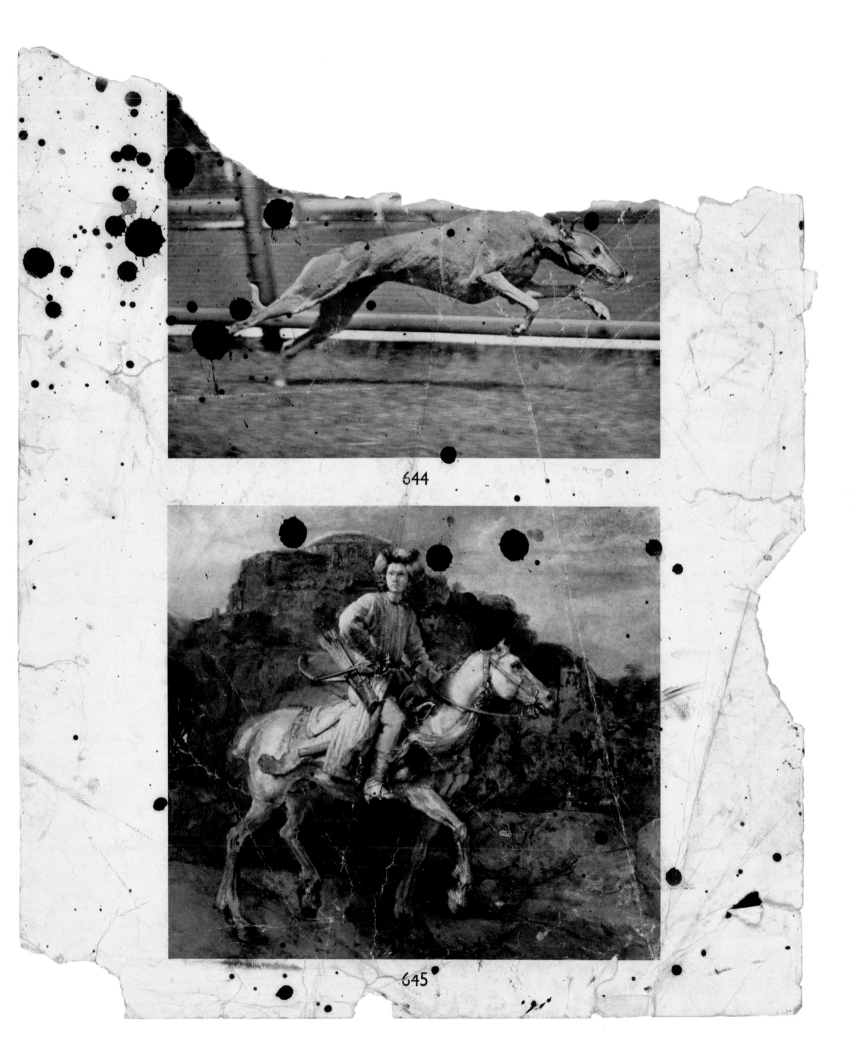

644

645

Oryx scratching its back with its sharply pointed horn. (Telephotograph.)

Pair of Oryx Beisa near the Guaso Myiro. (Telephotograph.)

Copyright: M. Maxwell.

FACE TO FACE WITH THE AFRICAN BUFFALO.

they are not, as has been said, intelligent as many other monkeys. They do not seem to be able to learn from experience, as was shown by Buckland's tame marmoset, which used to hang from a gas-bracket, and every now and again whisk its tail through the flame. It was still unconvinced of the folly of this behaviour when all the hair was burnt off the tail. They are commonly kept as pets by the natives of South America, and their feminine owners often allow them to nestle in their hair, from which refuge they emerge to catch a spider or two, and immediately return. The marmosets are among the few New World monkeys that breed in confinement. They have,

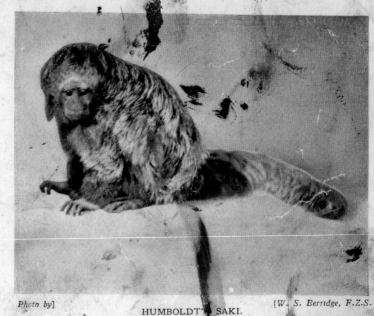

Photo by] [W. S. Berridge, F.Z.S.

HUMBOLDT'S SAKI.

This monkey is found in the valley of the Upper Amazon and is a timid, inoffensive creature. Its coat is long and thick, and in general colour is black tinged with grey.

at any rate in the case of the common grey species, two young at a birth—a very rare occurrence in other monkeys—and the male looks after these as well as the female.

In spite of all the varieties of temperament in the monkey tribe, from the genial little capuchins to the morose old-man baboons they nearly all have one thing in common—that is the monkey brain. The same curious restlessness, levity and want of concentration marks them all except the large anthropoid apes. Some of these have without doubt powers which the other monkeys do not possess. But in most of the rest, though the capacity for understanding exists, the wish to please, as a dog does, and the desire to remember and to act on what it has learnt seem entirely wanting. It must be remembered, however, that a dog is not a natural animal, but the descendant of a wild creature which has been brought into an unnatural state of dependence on us. Street dogs in the East readily make friends, but lack docility, as one would expect in animals used for untold generations to rely on themselves. There is no doubt that baboons might be trained to be useful animals, at any rate if they always served one master.

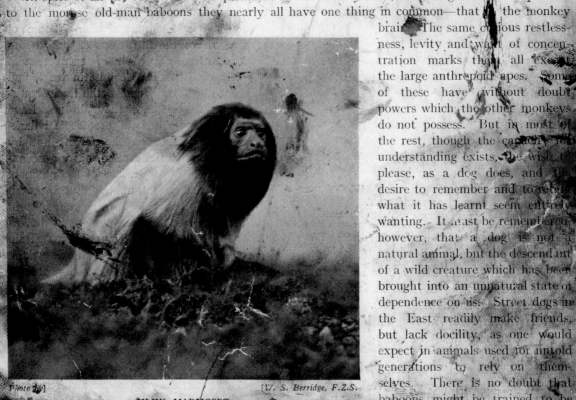

Photo by] [W. S. Berridge, F.Z.S.

SILKY MARMOSET.

This species is also known as the Lion Marmoset owing to the long mane of brown hair which hangs from its neck. It varies in colour from a golden yellow to an orange shade, and is a native of the forests of South-Eastern Brazil.

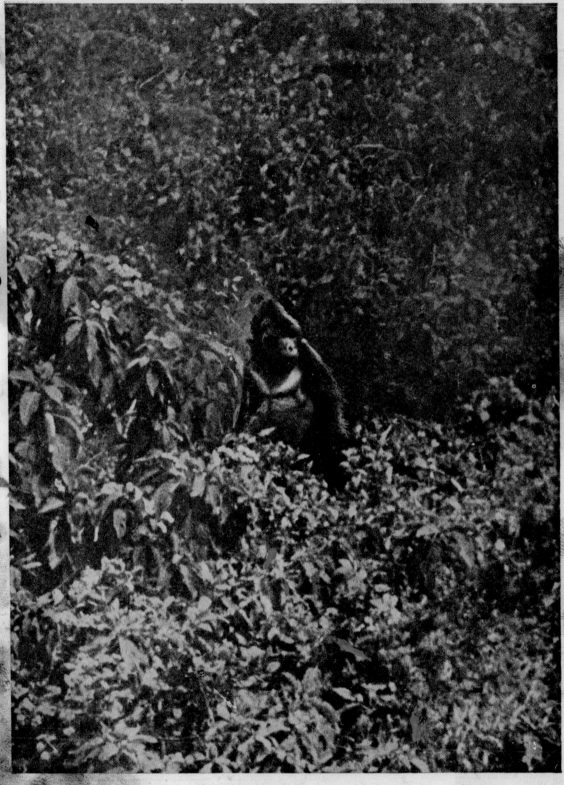

ROAMING THE FOREST

Largest of the man-like apes, the gorillas, inhabiting dense forests, are extremely difficult to study. The photograph seen above, secured by an explorer, is unique in that it shows a gorilla in its natural haunts in the Central African forestland.

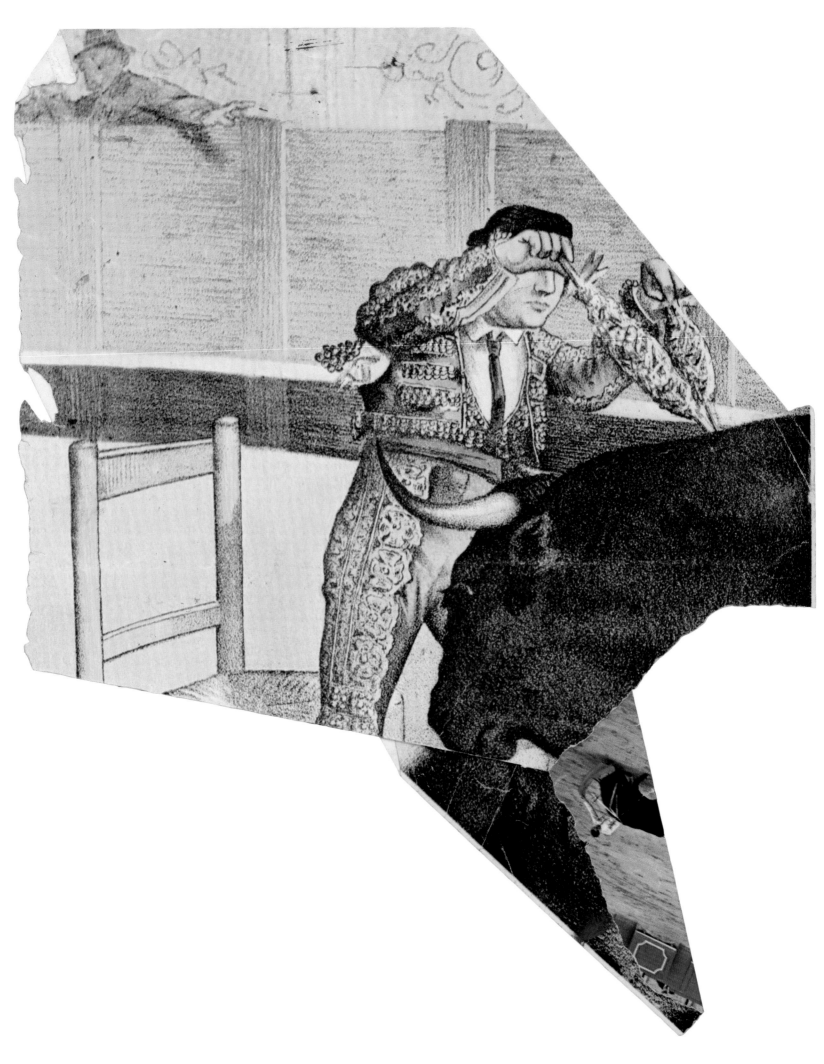

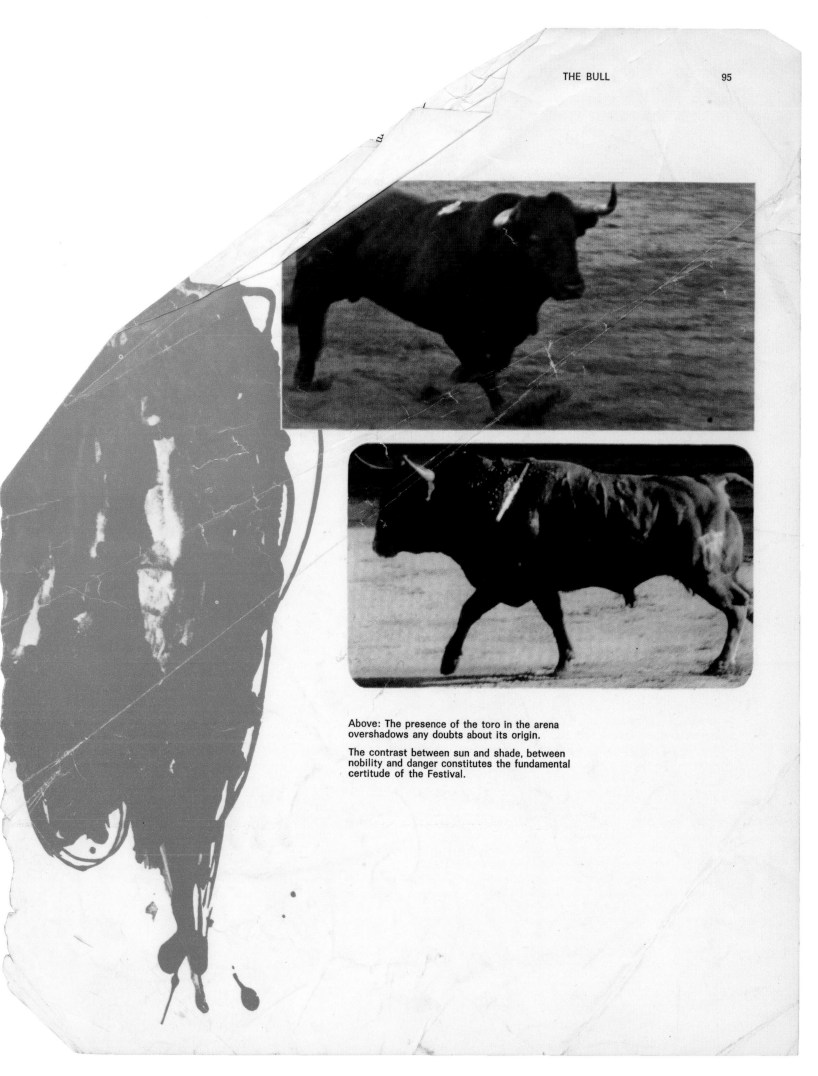

Above: The presence of the toro in the arena overshadows any doubts about its origin.

The contrast between sun and shade, between nobility and danger constitutes the fundamental certitude of the Festival.

The Swords Of Spain

The Swords Of Spain

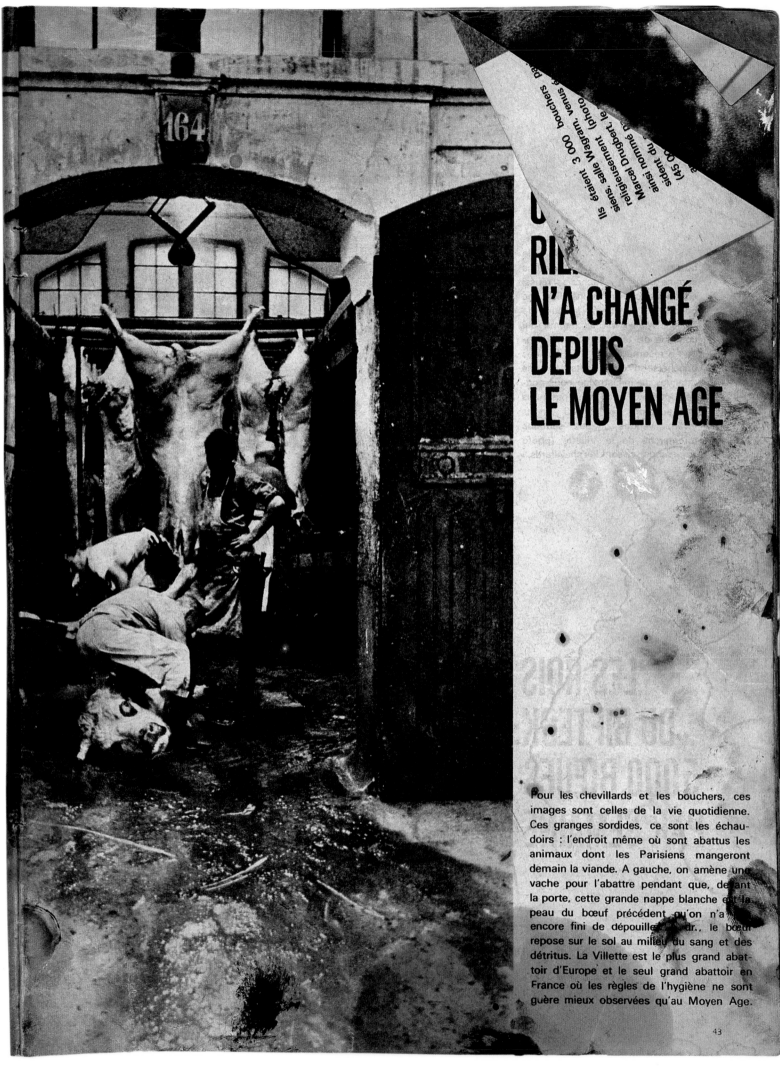

164

Ils étaient 3 000 bouchers ... siens, salle Wagram, (photo ... religieusement le ... Marcel Drugbert ... ainsi nommé ... sident du ... (45 c...

RIE... N'A CHANGÉ DEPUIS LE MOYEN AGE

Pour les chevillards et les bouchers, ces images sont celles de la vie quotidienne. Ces granges sordides, ce sont les échaudoirs : l'endroit même où sont abattus les animaux dont les Parisiens mangeront demain la viande. A gauche, on amène une vache pour l'abattre pendant que, devant la porte, cette grande nappe blanche est la peau du bœuf précédent qu'on n'a encore fini de dépouiller ... ar., le bœuf repose sur le sol au milieu du sang et des détritus. La Villette est le plus grand abattoir d'Europe et le seul grand abattoir en France où les règles de l'hygiène ne sont guère mieux observées qu'au Moyen Age.

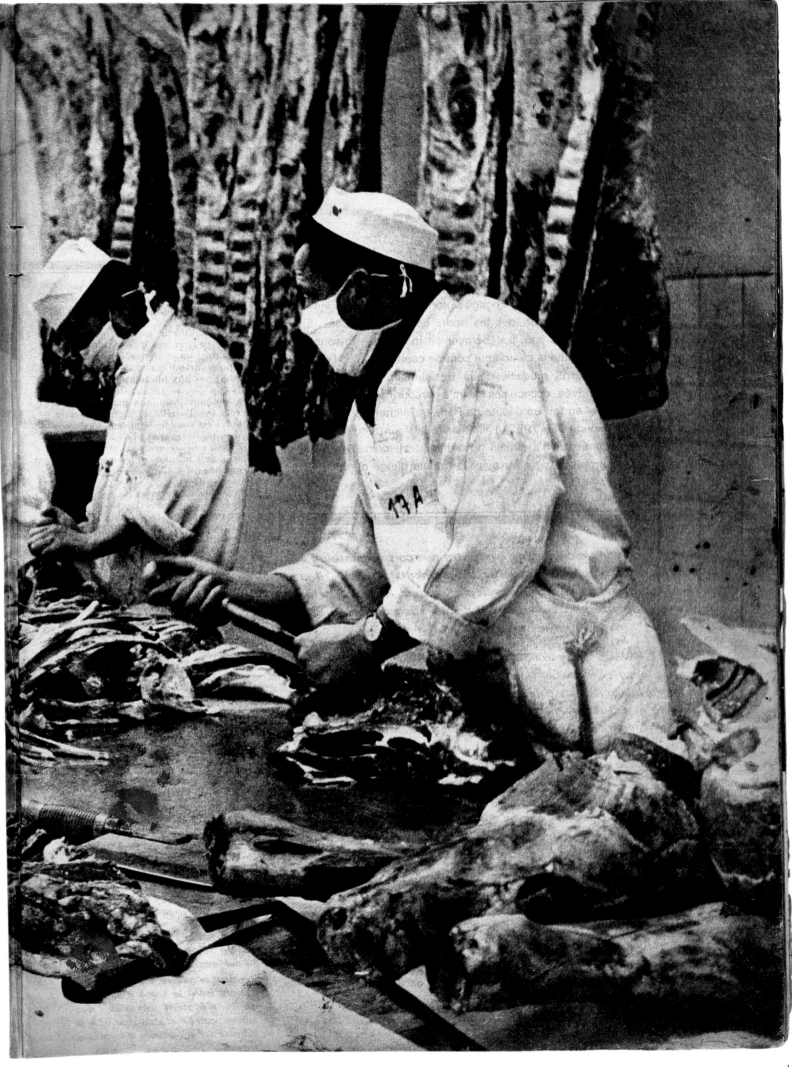

1—Roast Aitchbone of Beef. 2—Leg of Mutton. 3—Saddle of Mutton.
4—Roast Sirloin of Beef.

F

Poultry

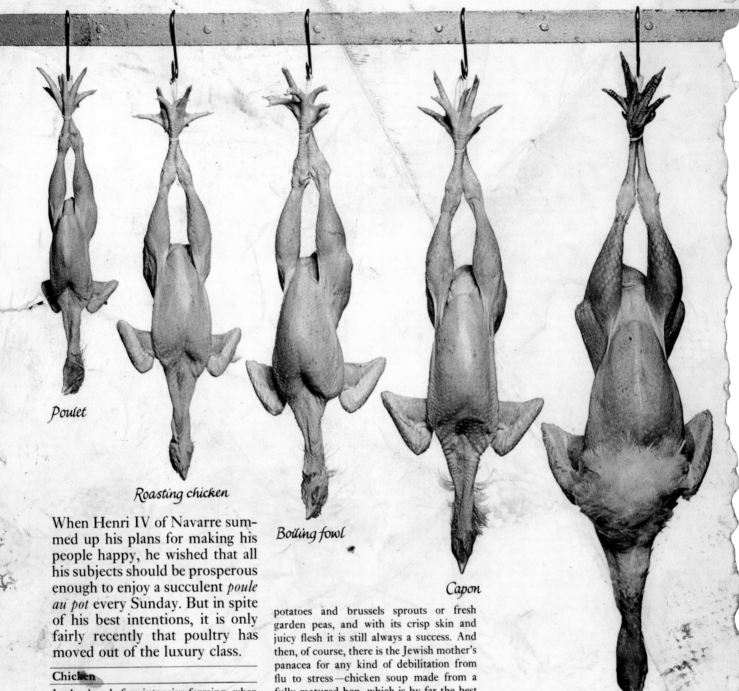

Poulet

Roasting chicken

Boiling fowl

Capon

Turkey

When Henri IV of Navarre summed up his plans for making his people happy, he wished that all his subjects should be prosperous enough to enjoy a succulent *poule au pot* every Sunday. But in spite of his best intentions, it is only fairly recently that poultry has moved out of the luxury class.

Chicken

In the days before intensive farming, when chicken was a rare Sunday treat, young farmyard fowls had to be specially fattened for the table. In France a young fowl would be roasted, an older bird, nicely stuffed and boiled with plenty of vegetables, would become *poule au pot*, and a large, heavy cockerel would go into a *coq au vin* with its heady smell of wine, onions, mushrooms and herbs. The backhähndl of Austria (a young roasted rooster) was accompanied by a paprika-sprinkled salad of cucumber cut transparently thin, while in England chicken was always stuffed and served roasted, surrounded by sausages, rolls of bacon, roast potatoes and brussels sprouts or fresh garden peas, and with its crisp skin and juicy flesh it is still always a success. And then, of course, there is the Jewish mother's panacea for any kind of debilitation from flu to stress—chicken soup made from a fully matured hen, which is by far the best provider of sustaining broth.

Today we eat chicken often and in a thousand and one ways. Unlike its ancestors, the battery-bred chicken is fattened so fast and killed so young that it does not have time to develop its full flavour. Sad though this is, a modern chicken responds to being enhanced and improved, and makes a good vehicle for a number of different flavours. Even so, it pays to begin with the best chicken you can find. Free-range birds undoubtedly have the best flavour because of the variety of their diet as they scratch happily for their living, and the fact that they have been able to run about in the sunshine gives them altogether more character. But even among the battery-reared supermarket poultry there are varying degrees of taste.

There is the fresh-chilled chicken, which may or may not be polythene-wrapped, which has been gutted and stored in freezing point. The giblets (not its own) are found neatly w You can cook it at on never do in the case of

84

to drag him off. The beast was driven away by the frantic shouting, but the unfortunate victim was beyond aid. The natives fear leopards more than lions. Leopards act like deadly gunmen stalking their prey alone. They do not command respect like the grand style and dignity of the lion, but are held in special abhorrence.

Next day, we reached the fringe of the forest, where Mt. Sirgoit was sighted. We struck across the plain in a north-westerly direction, towards the bush country where we expected to find the five-horned or Baringo giraffe. On the march, we sighted a large herd of zebra, amongst them a "toto." Our Somalis persuaded us to try to catch it. The animals allowed us to approach to within 150 feet, then they started off in a panic. After an exciting chase they were spreading out fan-shape and the little beast was luckily separated. But the chase was not yet over; the little chap was running like

8—CAMP IN A SMALL CLEARING IN ELGEYO FOREST.

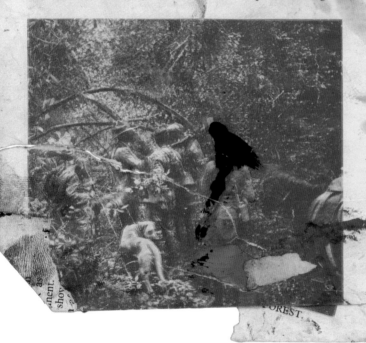

mac until at last Duali, one of ou
his horse, caught it by its tail
Duali hold the little captive
rein as an improvised halter
pitched barks, the "toto"
kept barking at the top of its
it thought of us, as if complacean
ree more mare terio
Mt. Elgon and the giraf
name of the five the giraff
with Raschid he porters
his h or

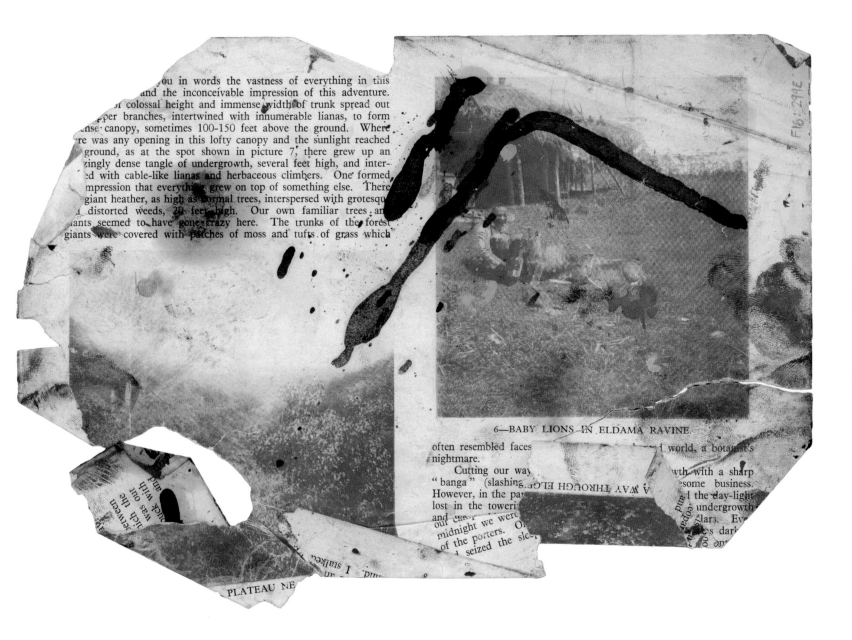

ou in words the vastness of everything in this
and the inconceivable impression of this adventure.
colossal height and immense width of trunk spread out
er branches, intertwined with innumerable lianas, to form
nse canopy, sometimes 100-150 feet above the ground. Where
re was any opening in this lofty canopy and the sunlight reached
ground, as at the spot shown in picture 7, there grew up an
zingly dense tangle of undergrowth, several feet high, and inter-
ed with cable-like lianas and herbaceous climbers. One formed
mpression that everything grew on top of something else. There
giant heather, as high as normal trees, interspersed with grotesqu
distorted weeds, 20 feet high. Our own familiar trees an
iants seemed to have gone crazy here. The trunks of the forest
giants were covered with patches of moss and tufts of grass which

6—BABY LIONS IN ELDAMA RAVINE.

often resembled faces world, a botanist's
nightmare.

Cutting our way wth with a sharp
" banga " (slashing esome business.
However, in the pa the day-light
lost in the toweri undergrowth
and midnight we wert lars. Ev
of the porters. O s dark
seized the sle

PLATEAU NE

151

21—CROSSING RIVER NZOIA IN DUG-OUT.

We had now reached the region north of 10,050 feet Mt. Debasien and as no more fresh tracks of big game were to be found there and our time was getting short, we decided to recross the Turkwell and to hunt along the eastern slopes of Mt. Elgon down to the Victoria Nyanza. For weeks we hunted round Mt. Elgon; as day succeeded day, we added to the list of our encounters with giraffe, rhino, topi, kongoni, antelope, warthog and a troup of lion. Justice cannot be done within this limited space to these adventures. At last, one morning, we left camp, moving towards the north Kavirondo district, to strike the Nzoia River, homeward-bound. The Kavirondo, representatives of which you see in picture 20, are strange people of great physical strength who prefer absolute nudity to the presence of even the scantiest garment. A six inch fringe, at the most, satisfies their modesty.

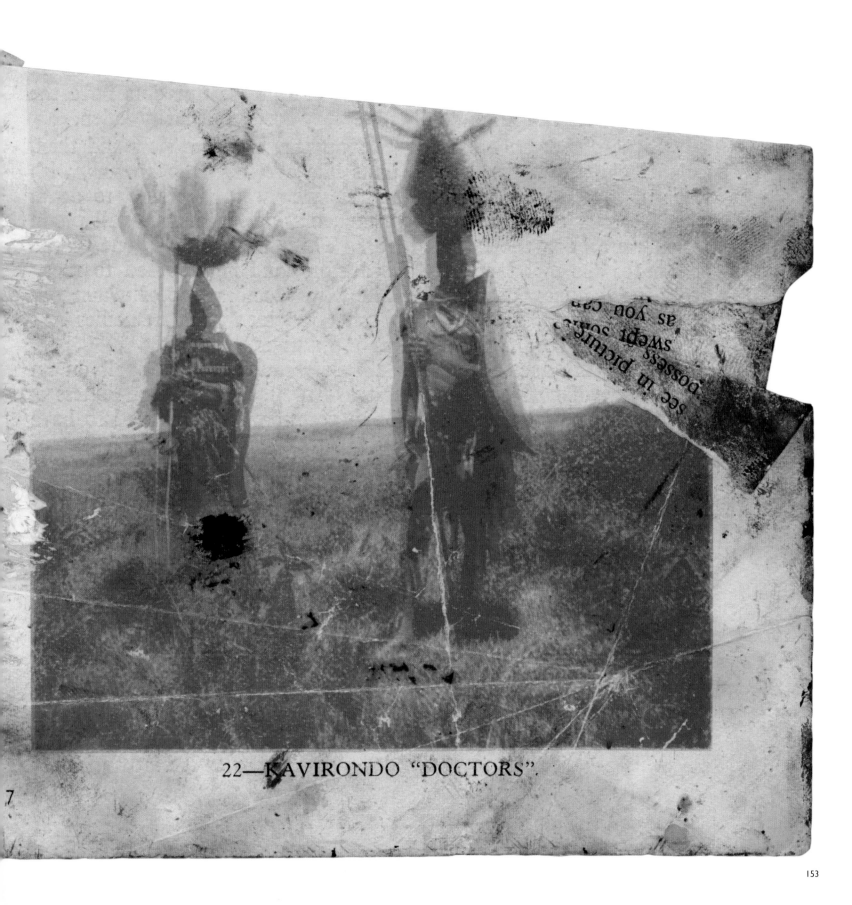

22—KAVIRONDO "DOCTORS".

5

Art — Photography — Art

105

LIST OF PICTURES

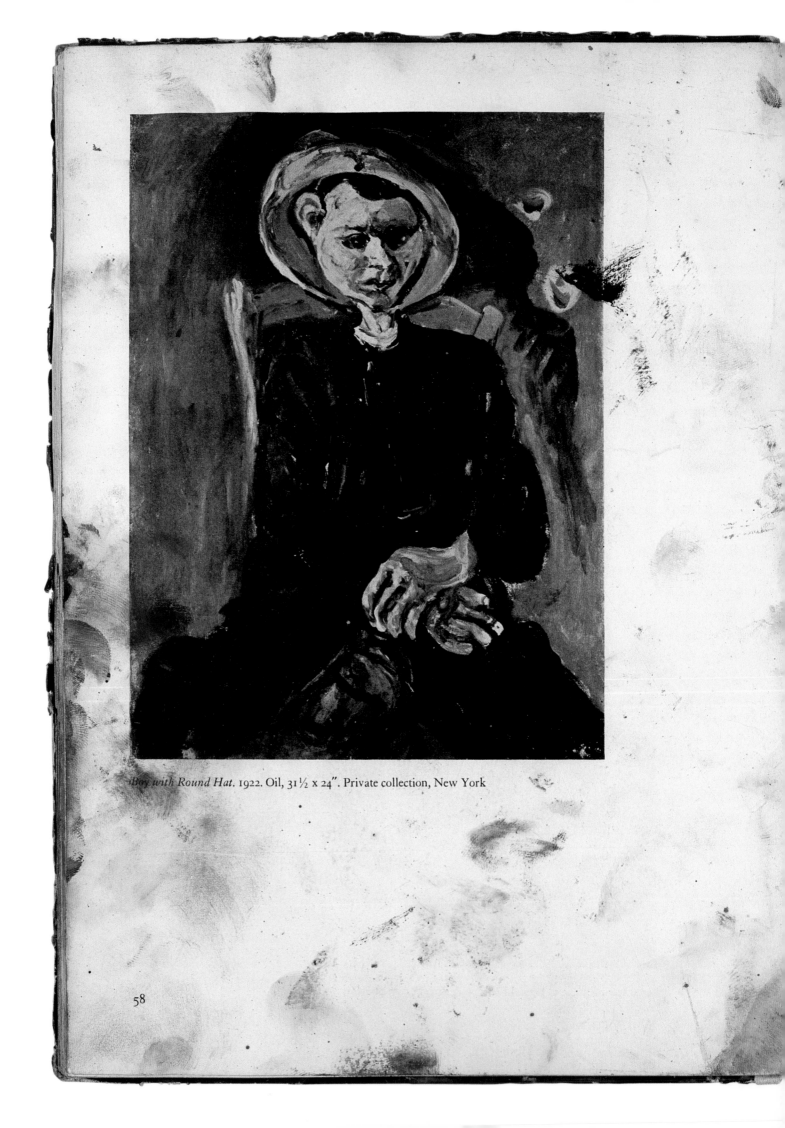

Boy with Round Hat. 1922. Oil, 31½ x 24". Private collection, New York

58

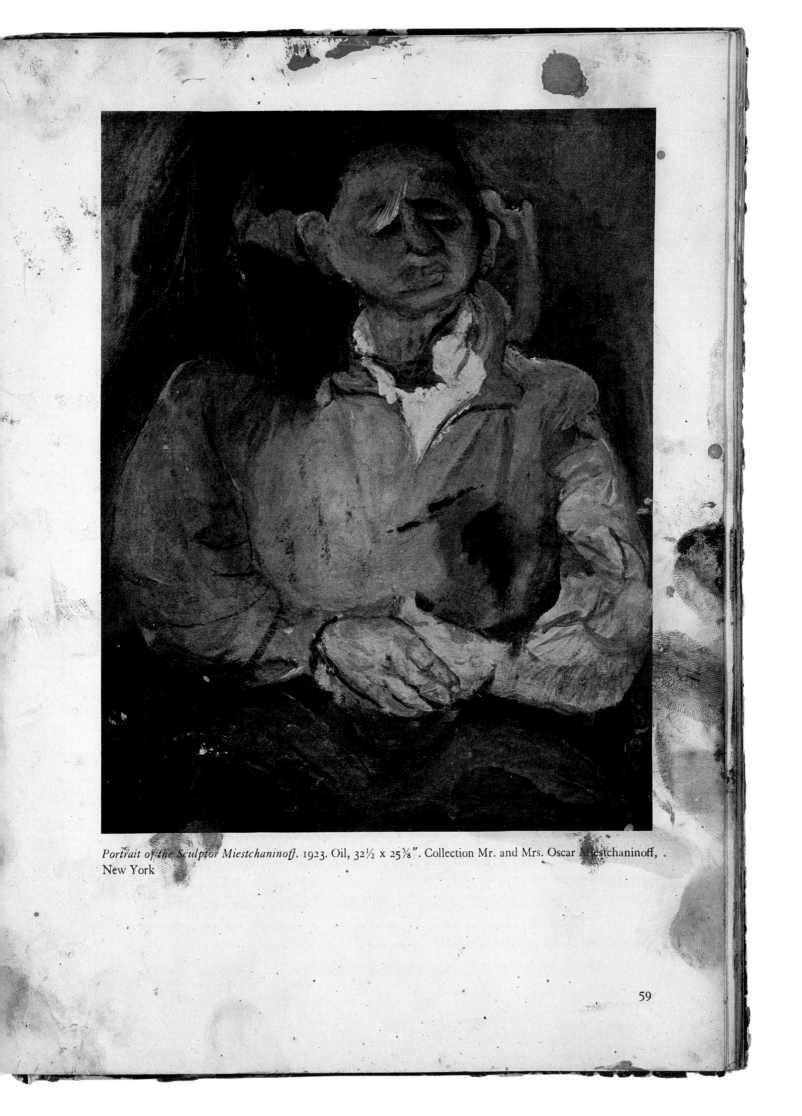

Portrait of the Sculptor Miestchaninoff. 1923. Oil, 32½ x 25⅝". Collection Mr. and Mrs. Oscar Miestchaninoff, New York

59

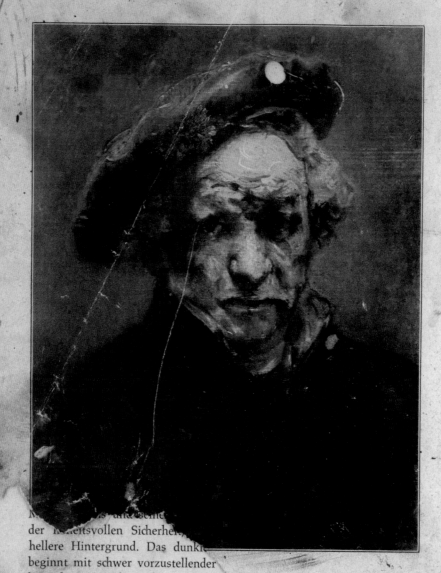

nun mit stärkerem An=
spruch der Gesamtge=
stalt. Es ist ein anderer
Bildtypus gewählt. Er ist
nicht neu. Die Hände
werden wieder gezeigt.
Die Londoner Galerie
erlaubt den bequemen
Vergleich mit einem weit
früheren Gemälde von
schließlich verwandter
Anlage, dem Selbstbild=
nis von 1640 (S. 64).
Damals hatte Rem=
brandt, vierunddreißig=
jährig, vor der großen
Wende gestanden. Eine
neue Gelassenheit hatte
er einer Grundform ab=
gewonnen, noch ein
Jahr zuvor in der Ra=
dierung von 1639 (S.
65), geradezu die Krö=
nung hochbarocken Be=
wegungsstiles, den Ab=
schluß des „öffentlich"
denkenden Rembrandt
bedeutet hatte. Nach
neuen Stürmen anderer
Art ist neue Gelassen=
heit errungen. Bis hin=
ein in die Hände, die
sich wie resigniert zu=
sammenfalten, ist sie
spürbar. Doch will uns

... und seine
der ...eitsvollen Sicherhei...
hellere Hintergrund. Das dunkl...
beginnt mit schwer vorzustellender
lösen kann: *so* also sieht Rembrandt ...ls der Gereifte erschien, jetzt fast jugendlich glatt vorkommen;
die Wahrheit ist nicht weniger dichte... Jahre ältere, ist ein *Greis!* Das ist lebensgeschichtlich das Selt=
bildnis der Uffizien (S. 101) schließt si... ragen nicht seine Schönheit um ihrer selber ..., wir fragen
telbar an. Die dunkle Macht des Auges... bwohl die Stirne glatter und faltenärmer b...lt ist als...
lichen Gesichtes über die Büste. Der Kop... och die Züge im ganzen schwammiger, ha...er, sie sind
Vortrag ist zugleich lockerer. Ein Reichtu... Augen und namentlich des Mundes ist wie von allen Ver=
schaften gießen konnte, ist vom Antlitz all... dfünfzig Jahre ist dieser Mann alt, aber ein überreiches
zelformen durch das Alter ist schonungslos... das ist ein *Greis!* Wie sehr jede scheinbare Äußerlichkeit
unerschütterlich wie eine verwitterte, aber und... eckung erweisen. Das New Yorker Bildnis bediente sich
des Gesichtes in der oberen Bildhälfte mitent... wahrhaft die stattliche „uneinnehmbare Festu..." des
Berg unterhalb der Feste. Der Hals freilich wird, rungen stolzen Kopfes. Im Londoner schmiegt sich
ist noch mehr *Abend* geworden. Noch entscheide... ganz dem Kopfe an: seine schlichte Endigung, ni...
eine Art dunkler und schwerer Landschaft, aus d... Die Stirne wird höher, da die Kopfbedeckung über
mal trägt Rembrandt das Barett. Es war ihm stets... sagt, erschütternder noch, da die Alterung des
zes; er läßt es in machtvoll ruhender Breite ausschwi... eine Preisgabe im alten Sinne mehr, kein Selbst=
rung an die früher so hochgewertete Geschmeidew... erstärkt nur den Ausdruck der seelischen Kraft,
gung des Stofflichen in das Auge. Alles Stoffliche ist... icht mehr ein Patriarch wie um 1658 — der
Selbstbildnis der Londoner National Gallery (S. 104) gibt...

100

war immer noch mehr Dichtung — er ist *der Maler*, auch wenn er nicht malend dargestellt ist. Gegen=
über dem hohen Anspruch des fertigen Gemäldes, den die große Londoner Leinewand erhebt, ist das
auf Holz gemalte kleine *Bild in Aix=en=Provence* eine echte Skizze (S. 102). Auch sie aber gibt den
Maler, und sogar so ausgesprochen, daß, wer hier Rembrandt nicht erkennte, gut an einen Maler
des 19. Jahrhunderts denken, ja, daß es uns wie mehr als Zufall erscheinen könnte, wenn wir dieses
Werk in der Provence, der Landschaft des Cézanne vorfinden. Mit wahrem furor germanicus hat
sich Rembrandt auf die kleine Bildfläche gestürzt. Als sei die fanatische Wut, mit der die alten Meister
unserer Plastik ihren Meißel bis in das Innere des Steines vorführten, als sei die kämpferische Wucht,
mit der Michelangelo den haßvoll geliebten Marmor anging, in dem späten Maler aufgeflammt —
mit wahren Meißelhieben des Pinsels stürzt er sich auf dieses Gegenüber, das er doch selber ist. Eine
Trotz=Stimmung muß ihn gepackt haben, vielleicht sogar eine grimmige Erinnerung an das Feuer der
längst vergangenen Jugend, ein Einspruch gegen die milde Selbstbescheidung des Londoner Bildnis=
ses, ein Einspruch womöglich gar gegen dieses *eine* Bild und sein Bekenntnis zur eigenen Alterung,
damit also abermals eine dialektische Selbstergänzung und Selbstberichtigung. Was dabei erscheint,
ist natürlich erst recht „der Alte". Die Augen liegen wie Raubtiere in ihren Höhlen, gleich zerklüfteten
Bergen ist die Stirne aufgerissen, der Mund droht wie eine Felsspalte, und alles ist bewegt und dann
doch aus quirlender Wogung wie durch jähen Zauberspruch erstarrt. Es ist der Zustand nach dem Aus=
bruch eines Vulkans.

Eine keck hingesetzte Zeichnung der *Albertina in Wien* (S. 93) hat verwandte Züge zum mindesten
in dem furchtbaren Ernst und in der Frontstellung des allein wichtig genommenen Kopfes.

Aber der Alte und Weise steht jetzt überall dahinter und darüber. Mit ergreifendem Ernst hat er dies,
1661, im Jahre des Claudius Civilis ausgesagt, ein Jahr vor der großartigen Tat der Staalmeesters, mit
dem *Selbstbildnis* der Sammlung de Bruyn in Spiez (S. 105). Es ist der lesende Rembrandt — zum
ersten Male. Er hat sich von den Blättern hinweggekehrt, wie von schwerem Nachdenken über=
fallen, und wendet uns ein Gesicht zu, so ernst und voller dunkler Trauer, wie wir ihn noch nie ge=
sehen. Der alte Faust! Die grauen Schwestern sind ihm nahe, und die nächste ist die *Sorge*. Tat=
sächlich „die Sorge" könnte man das Bild zu nennen versucht sein. Der überpersönliche Charakter
wäre damit angedeutet. Dennoch wäre die Bezeichnung nicht ausreichend, denn gerade dieses Bild

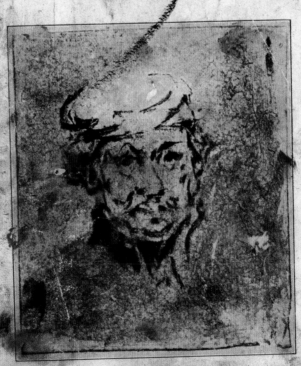

gehört *zugleich* zu der verstreut immer wie=
der auftauchenden Gruppe der ganz nahen
Selbstbeobachtungen und Selbsterforschun=
gen. An keinem anderen als Rembrandt, will
das sagen, hätte „die Sorge" so deutlich
dargestellt werden können; es ist doch die
eigene Sorge im *eigenen* Antlitz. Von den
sehr hochgezogenen Brauen her entspringen
neue Ströme von Faltenzügen, die ganze
Stirne ist eine Furchenlandschaft, ein Gottes=
acker von Merkmalen der Vergänglichkeit,
der Erfahrung und — immer wieder — der
Sorge. Wir kennen ihre grauen Schwestern:
Mangel, Schuld und Not. Wir hören schon
das „düstre Reimwort" Tod.

Und nun treten wir vor den Zeugnissen des
letzten, weisesten und tiefsten Alters. Ihr
Anblick will uns den Atem verschlagen, und
am liebsten möchten wir schweigen dürfen.
Zwei Bilder, die einzigen des ganzen letzten
Jahrsiebents, denen wir trauen dürfen, aber
welche Bilder! Sie fügen sich noch einmal,
ein letztes Mal, zu einem dialektischen Paare
zusammen. Noch einmal verlegen sie im

Zeichnung. Wien, Albertina

103

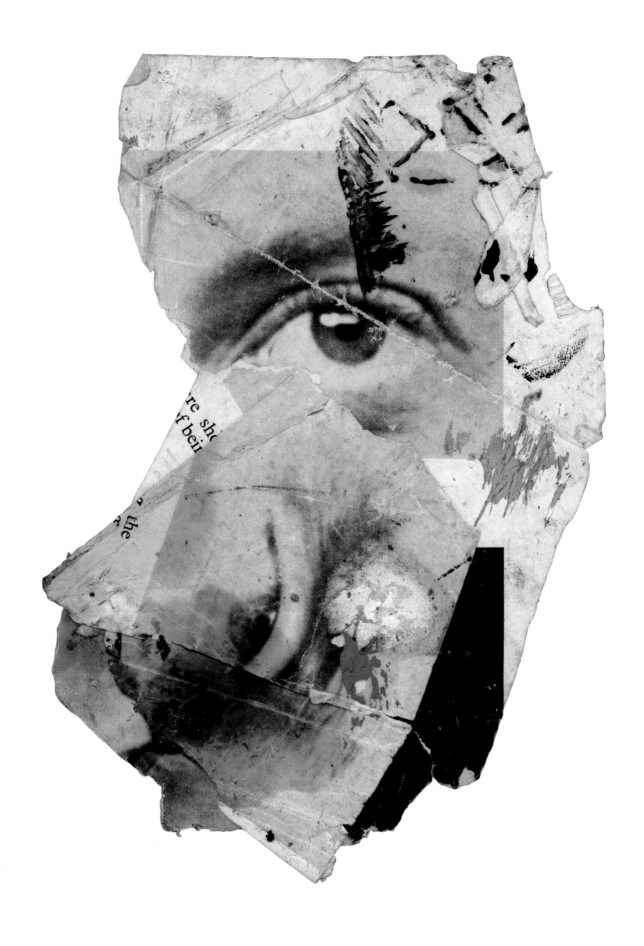

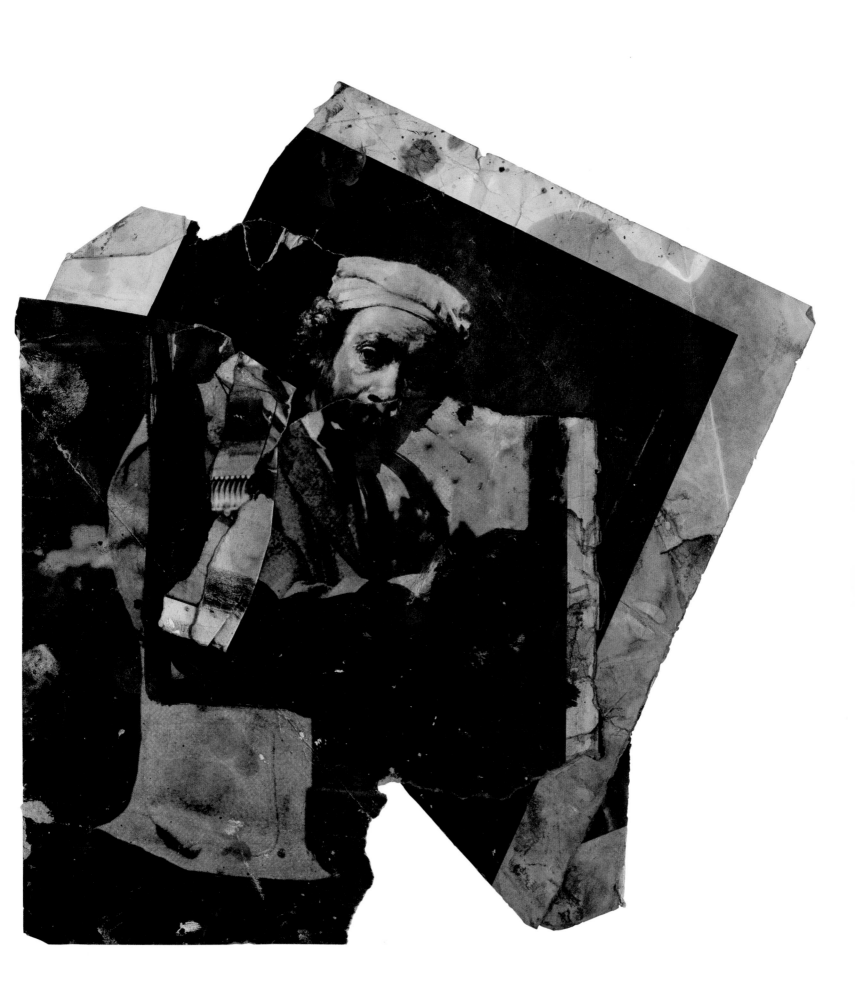

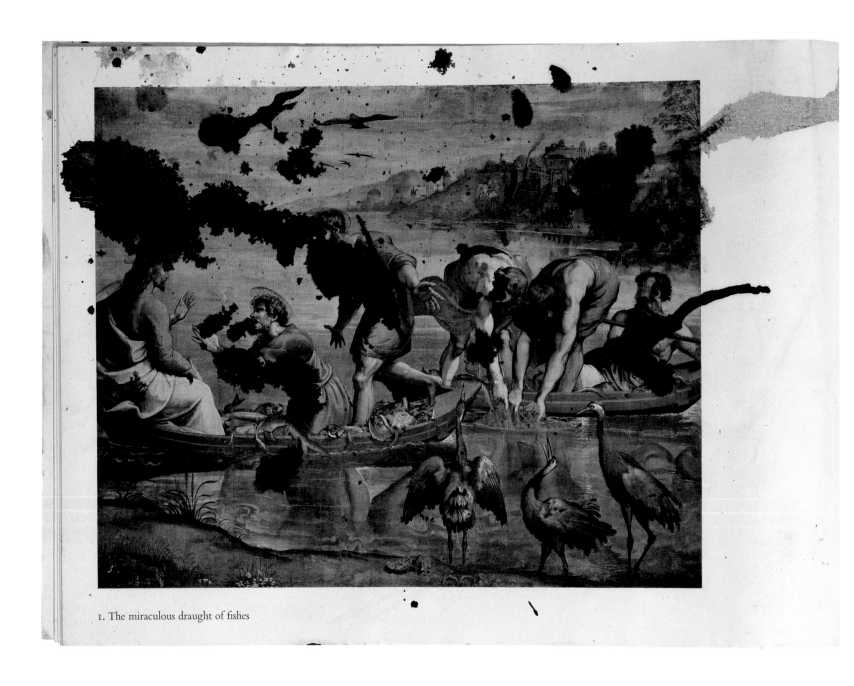

1. The miraculous draught of fishes

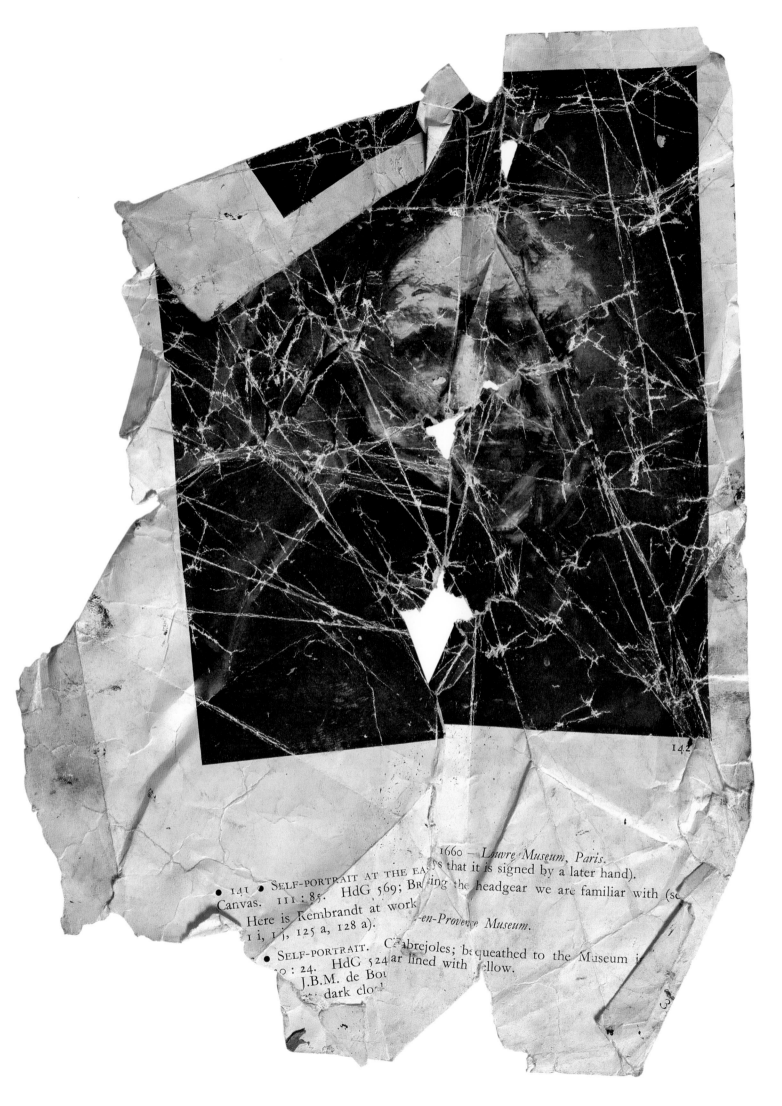

142

1660 – *Louvre Museum, Paris.*

• 141 • SELF-PORTRAIT AT THE EA... ...s that it is signed by a later hand).
Canvas. 111 : 85. HdG 569; Br... ...ing the headgear we are familiar with (se...
Here is Rembrandt at worken-Provence Museum.
...i, 1...), 125 a, 128 a).

• SELF-PORTRAIT. C... ...brejoles; bequeathed to the Museum i...
...0 : 24. HdG 524... ...ar lined with ...ellow.
J.B.M. de Bo...
...dark clo...

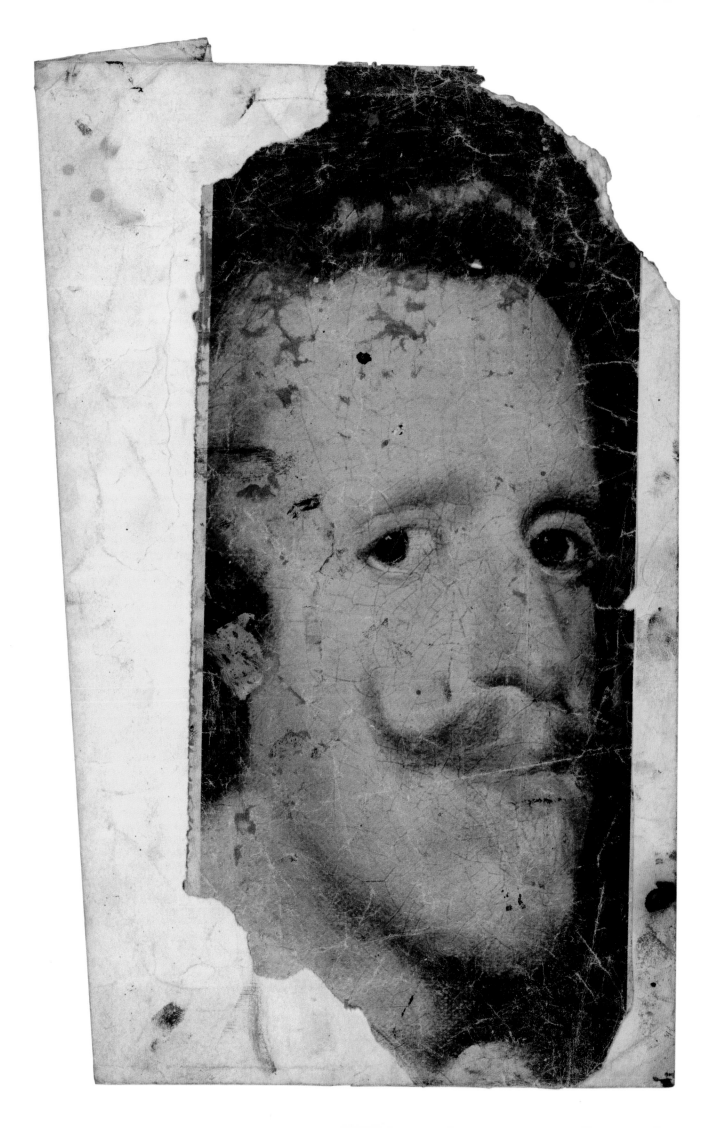

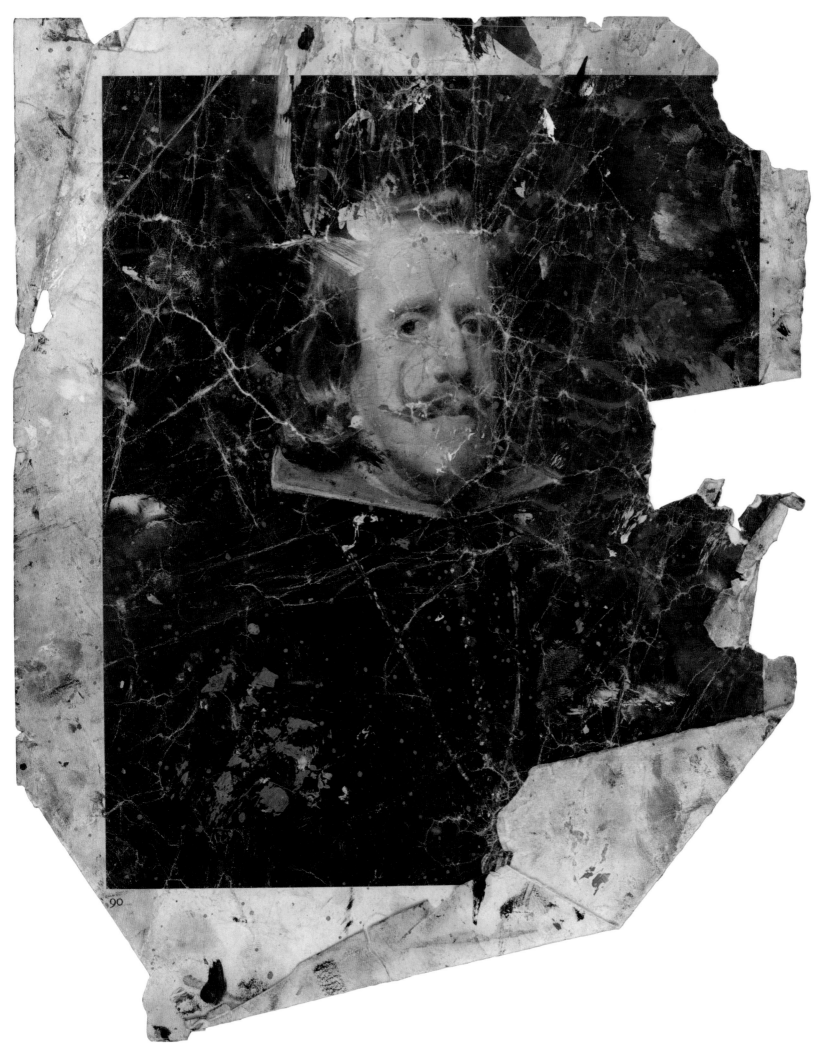

90

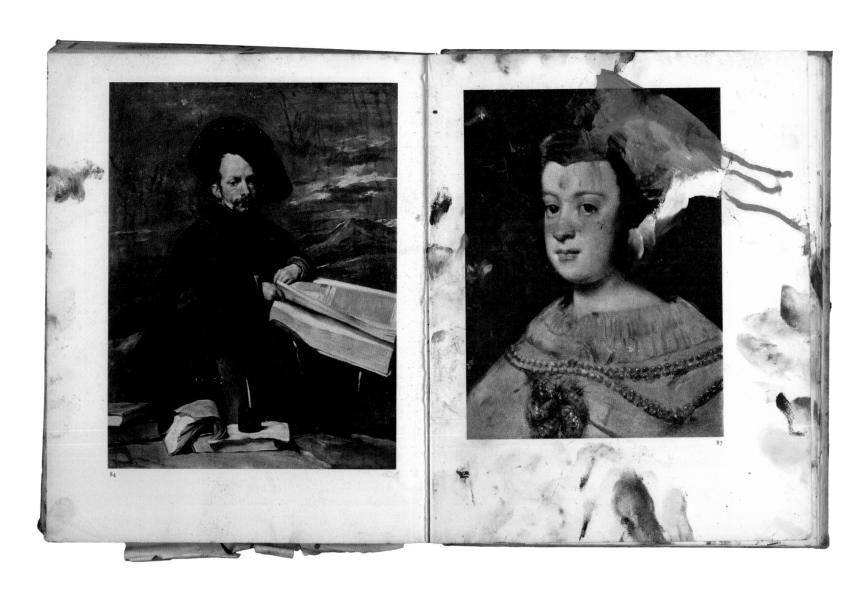

84

87

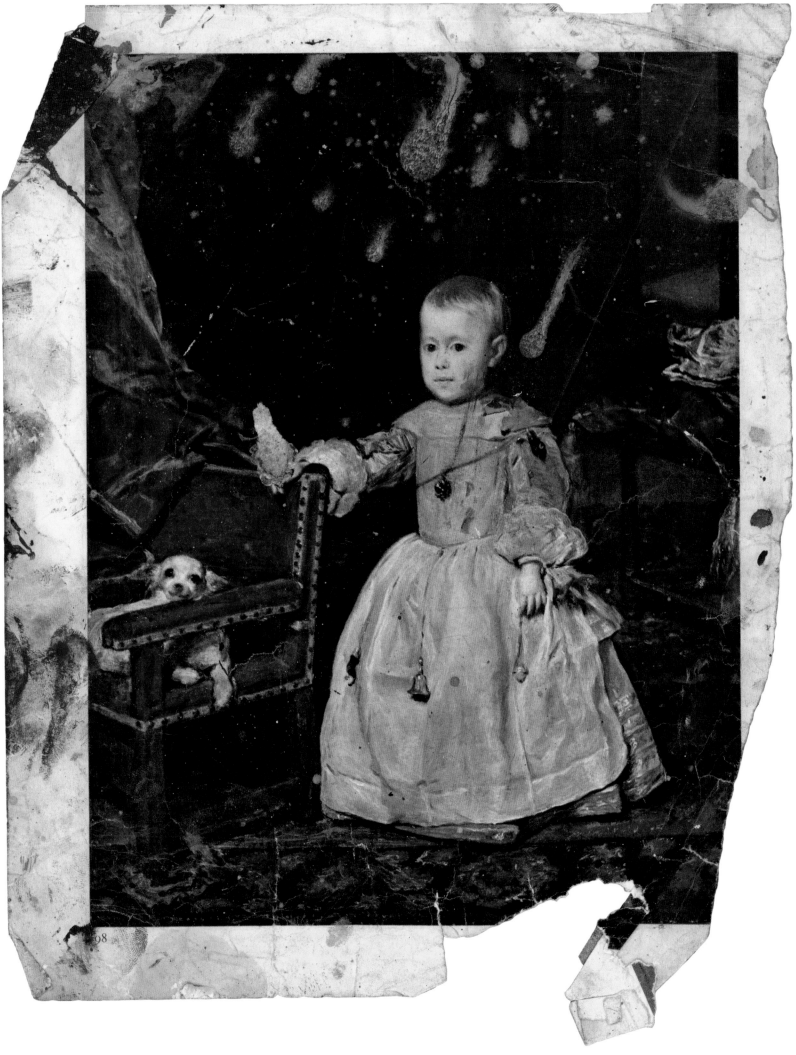

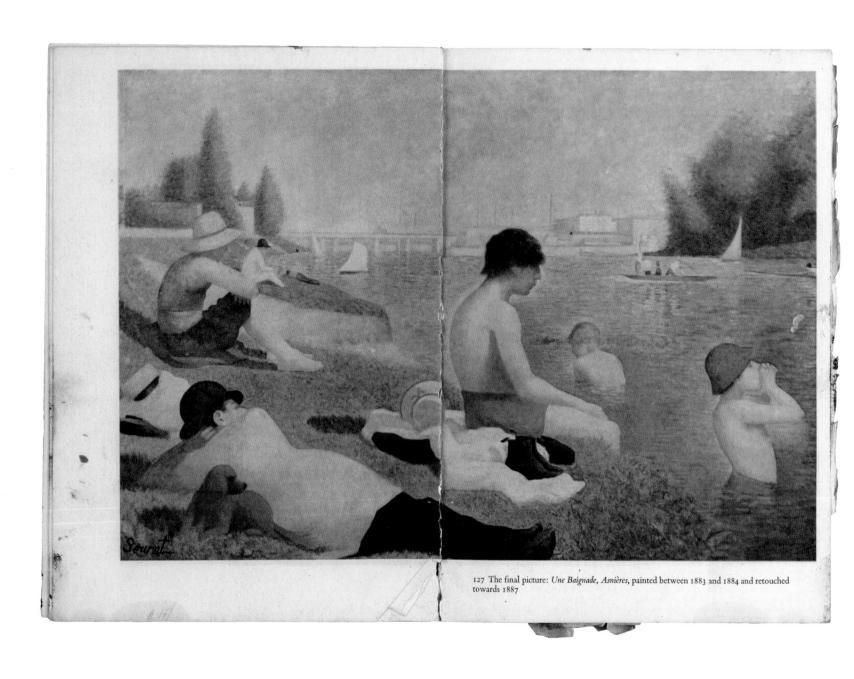

127 The final picture: *Une Baignade, Asnières*, painted between 1883 and 1884 and retouched towards 1887

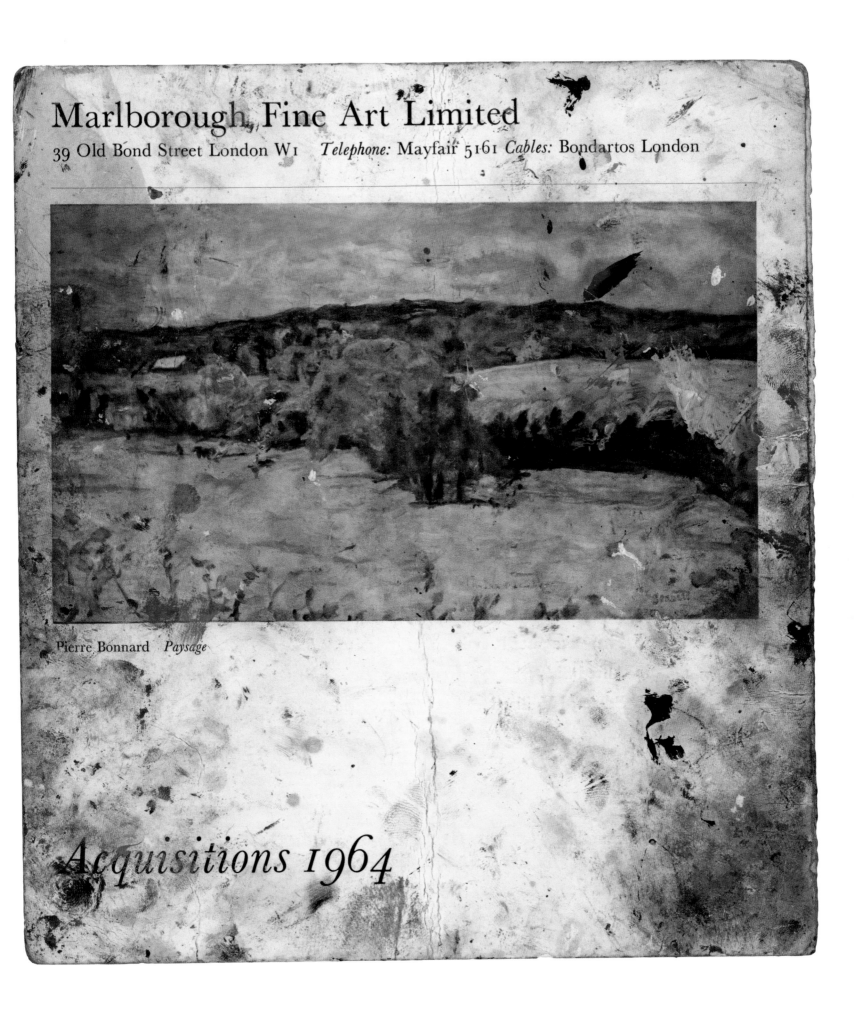

Marlborough Fine Art Limited

39 Old Bond Street London W1 *Telephone:* Mayfair 5161 *Cables:* Bondartos London

Pierre Bonnard *Paysage*

Acquisitions 1964

COUCHER DE SOLEIL DANS LES DUNES

Yvon

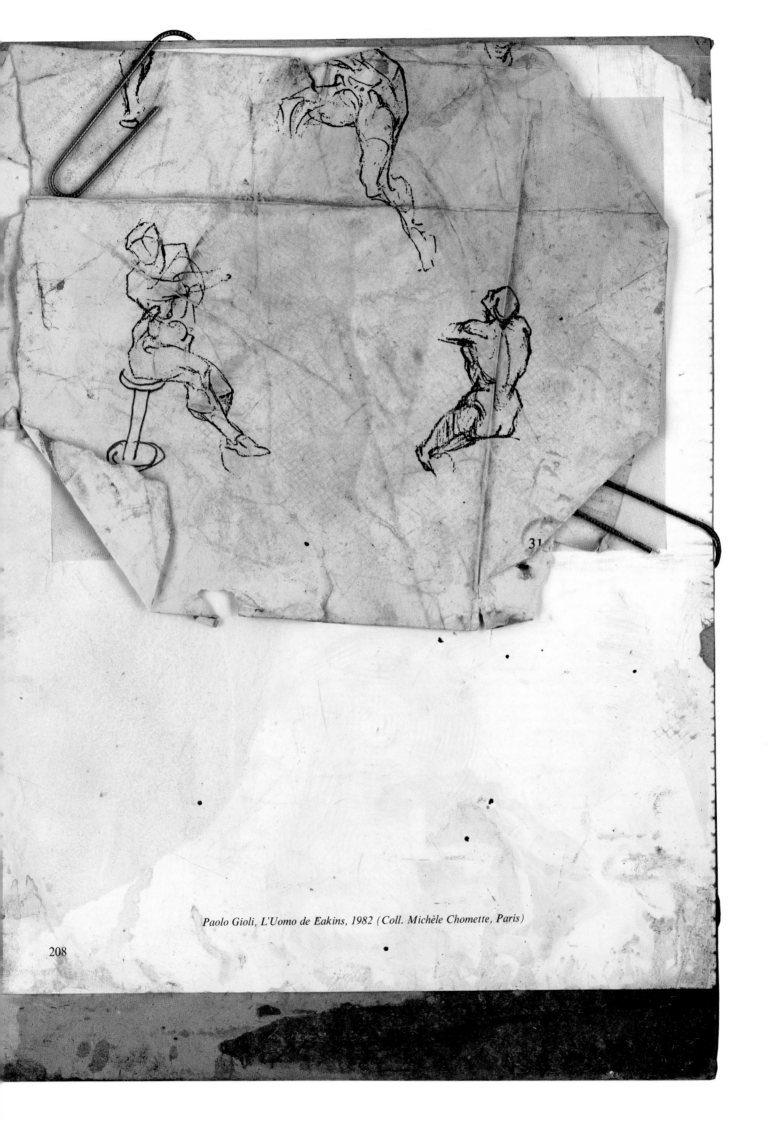

Paolo Gioli, L'Uomo de Eakins, 1982 (Coll. Michèle Chomette, Paris)

208

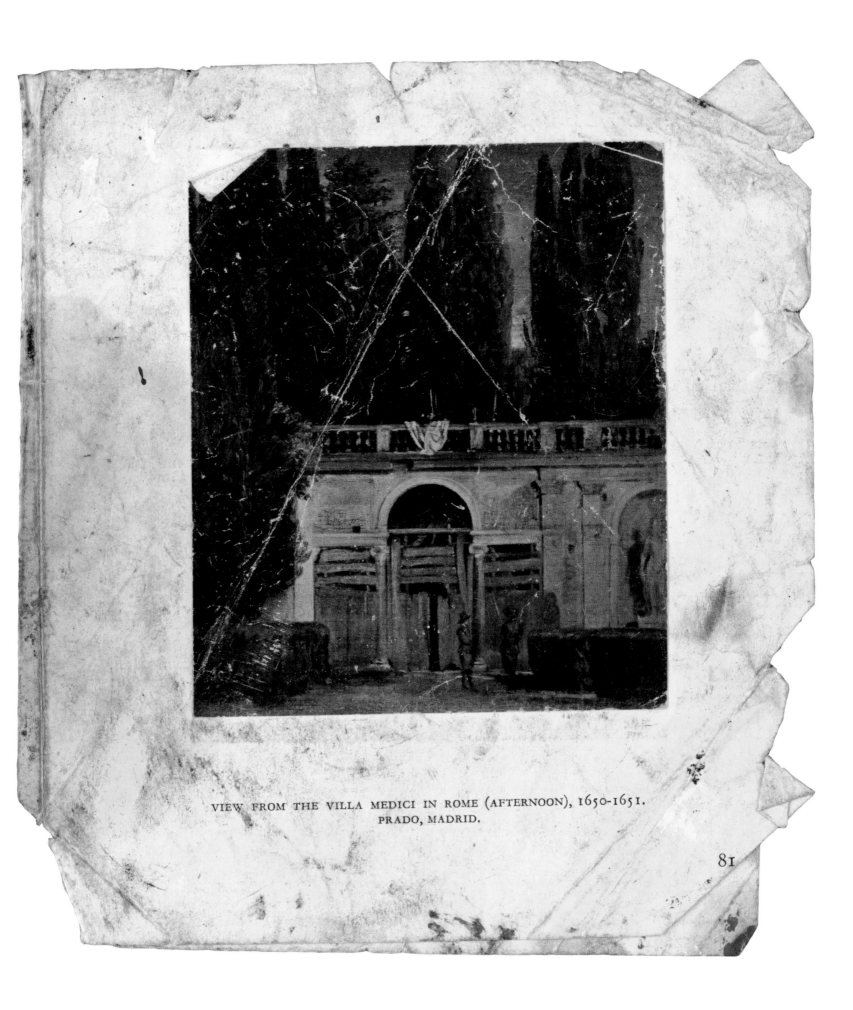

VIEW FROM THE VILLA MEDICI IN ROME (AFTERNOON), 1650-1651.
PRADO, MADRID.

181

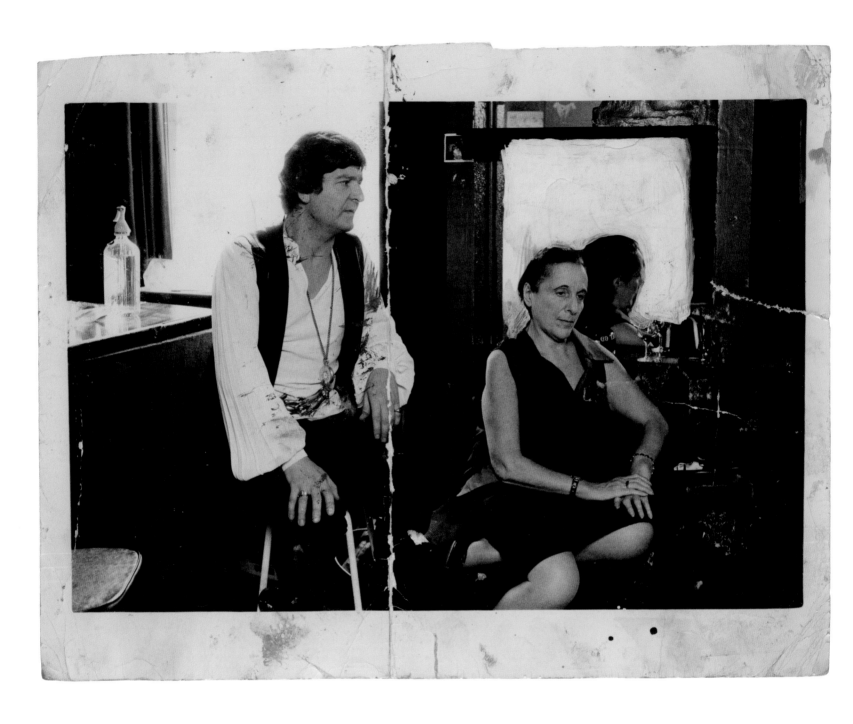

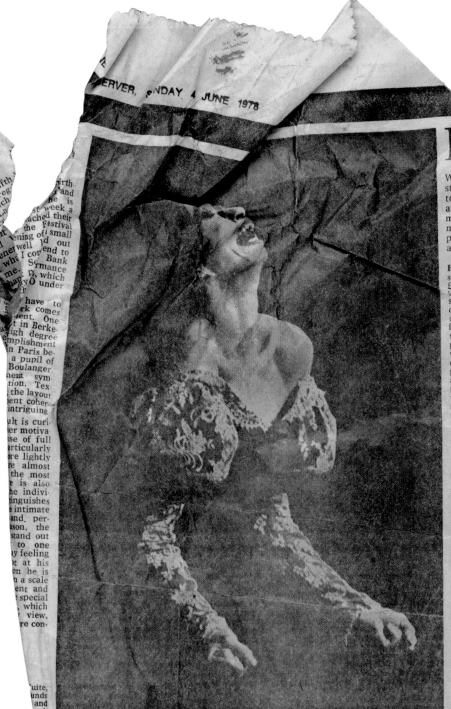

NOBBY CLARK

Marcia Haydée in ' Onegin.' More accomplished and moving than ever.

An eloquent tribute

Dance

ALEXANDER BLAND on visitors from Stuttgart and Caracas.

THE Stuttgart Ballet dedicated its opening programme at the Coliseum on Monday to Tamara Karsavina, whose death at 93 has carried away a dancer who in ballet circles came second only to Pavlova in renown and stood alone in esteem and affection. Like her partner Nijinsky, she was a supreme exponent of Diaghilev's ideas because she understood and shared them. The Young Girl of ' Le Spectre de la Rose ' has faded from view leaving the most fragrant of memories hanging forever on the air.

Another shade, that of Cranko, still fruitfully haunts the Stuttgart company, guiding the hand of its Director (and star) Marcia Haydée. His **Onegin** is an eloquent tribute to his

talents, probably the most perfect of all serious modern narrative ballets—there is hardly a minute of silent-film mugging, the whole tale is told in movement. Haydée's Tatiana was more accomplished and moving than ever; as Lensky, Egon Madsen was again an ardent slip of a young poet; Richard Cragun, though too outgoing to be a natural Onegin, danced and partnered superbly, and Lucia Montagnon made a happy debut as Olga.

It is a real tragedy for the

that with his ' Song of the Earth ' on its books, the loss is not tragic. He has not tried to offset the mellifluous flow of the score by ritual, but goes along with its sweetish flavour in episodes distantly evoking the Passion, the Virgin and other Christian motifs. There are moving moments, especially in the solos, but the mood is necessarily and consistently low-key and the effect, increased by Yolanda Sonnabend's lambently diaphanous setting, calls for adjectives like ' lyrical ' and ' ravishing '— not quite right for a Requiem.

Like the Stuttgart company, the **Internacional** de Caracas, which

WHILE records of the standard symphonic repertoire still an apparent market, it's music also profiting from affairs.

RCA's record Ferneyhough's string quart £3.99) is a because this sort of music quite recently never be record fact happened w would at best a partial and scrappy version taped from a cert. Now we have plete recording of a and difficult score, super played by the Berne Quart with a discriminating studio recording, all of which help make the process of getting to know this dense but in many ways beautiful music something less than the chore it would otherwise have been.

Of course, I don't suggest that good records of modern music are merely a sop for incompetent music critics. Perhaps one can't quite imagine an ordinary listener settling down to a nice quiet evening of Ferneyhough. But plenty of modern works do, surprisingly enough, make good listening of the half-an-ear type which is for most people the function of the gramophone.

The best purveyor of such music is **Luciano Berio**, and at least two of the works on a new London Sinfonietta record of his music (RL 12291, £3.99) fall in the category: the very early concertino, which predates Berio's seven Webern period, and recent ballet score whose delicate treatment board sonorities for illustrates Berio writing syntax music which

The other record, ' Points to Find ' are super manding is more a technically they are ent from brilliance of mances, und gives the city that u unknown of avant-

Another backgr a rec comp £2.9 we

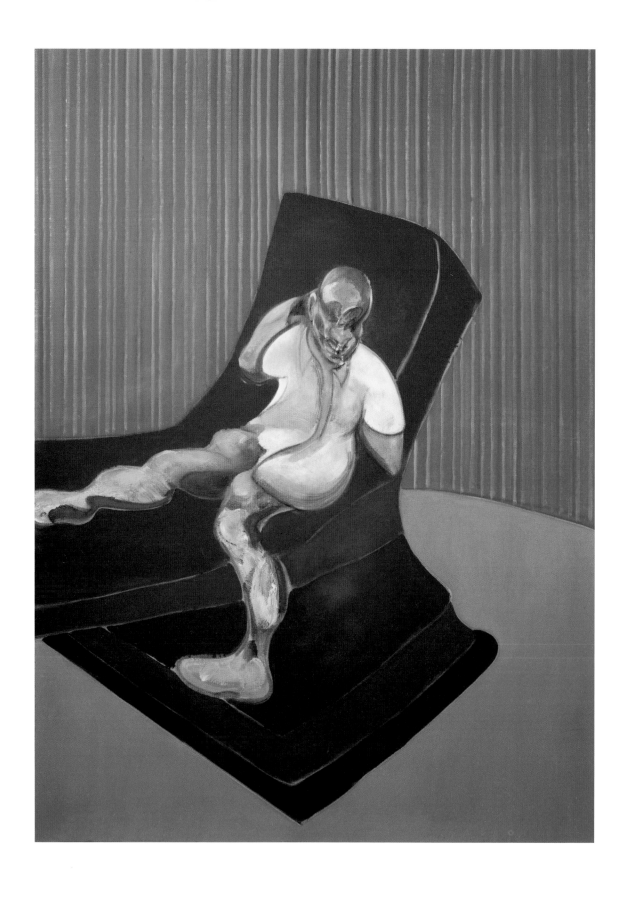

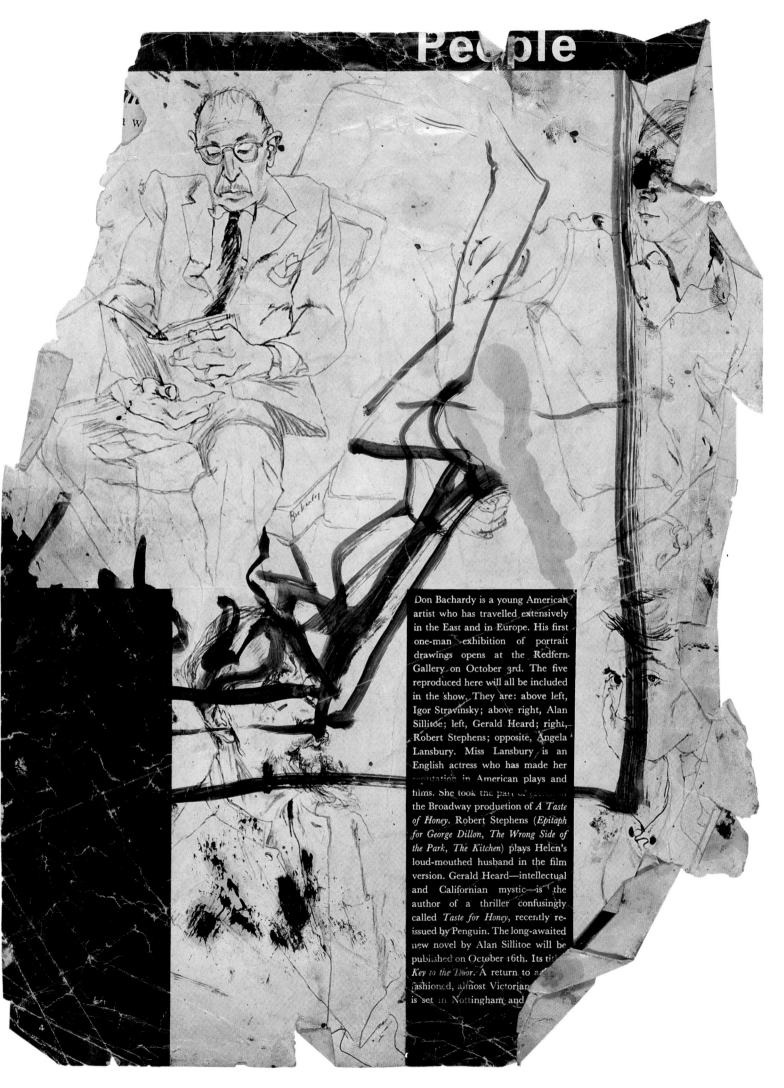

Don Bachardy is a young American artist who has travelled extensively in the East and in Europe. His first one-man exhibition of portrait drawings opens at the Redfern Gallery on October 3rd. The five reproduced here will all be included in the show. They are: above left, Igor Stravinsky; above right, Alan Sillitoe; left, Gerald Heard; right, Robert Stephens; opposite, Angela Lansbury. Miss Lansbury is an English actress who has made her reputation in American plays and films. She took the part of Helen in the Broadway production of *A Taste of Honey*. Robert Stephens (*Epitaph for George Dillon*, *The Wrong Side of the Park*, *The Kitchen*) plays Helen's loud-mouthed husband in the film version. Gerald Heard—intellectual and Californian mystic—is the author of a thriller confusingly called *Taste for Honey*, recently re-issued by Penguin. The long-awaited new novel by Alan Sillitoe will be published on October 16th. Its title *Key to the Door*. A return to an old-fashioned, almost Victorian is set in Nottingham and

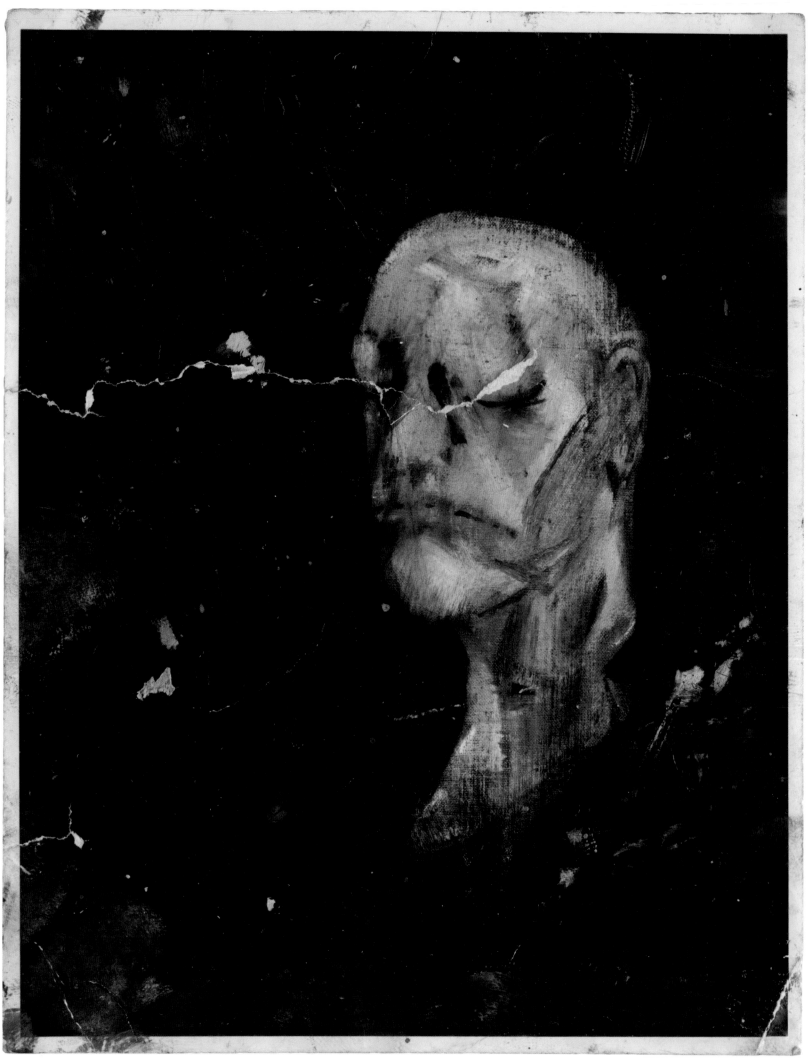

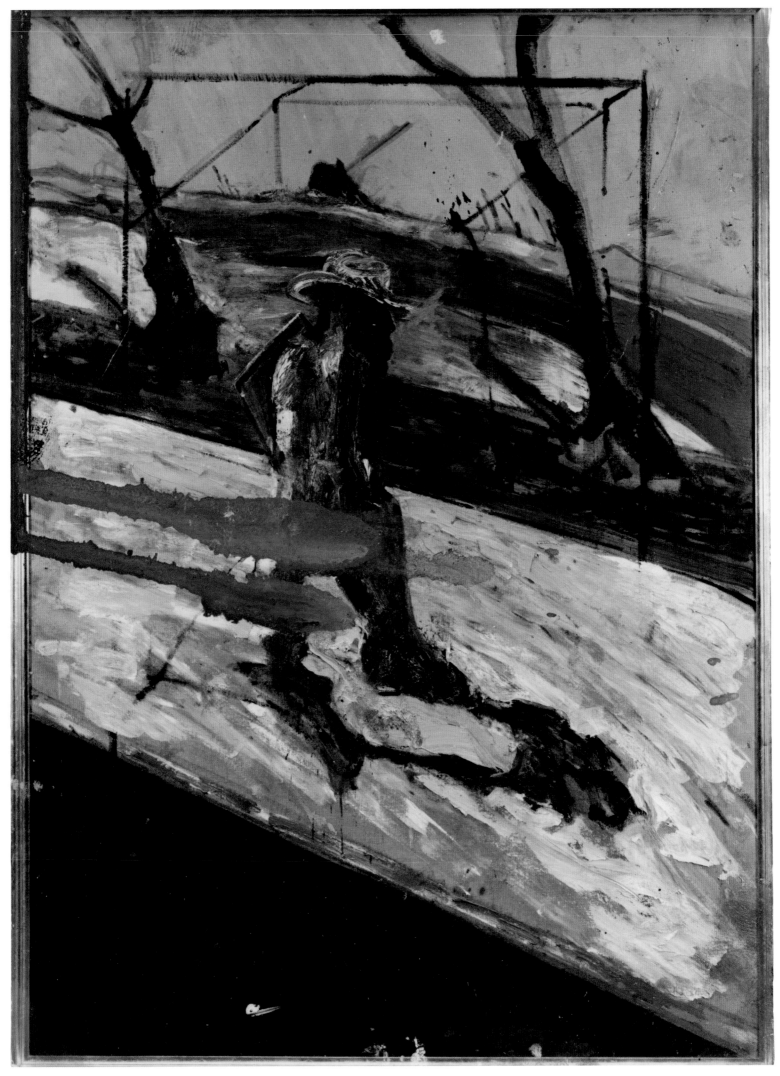

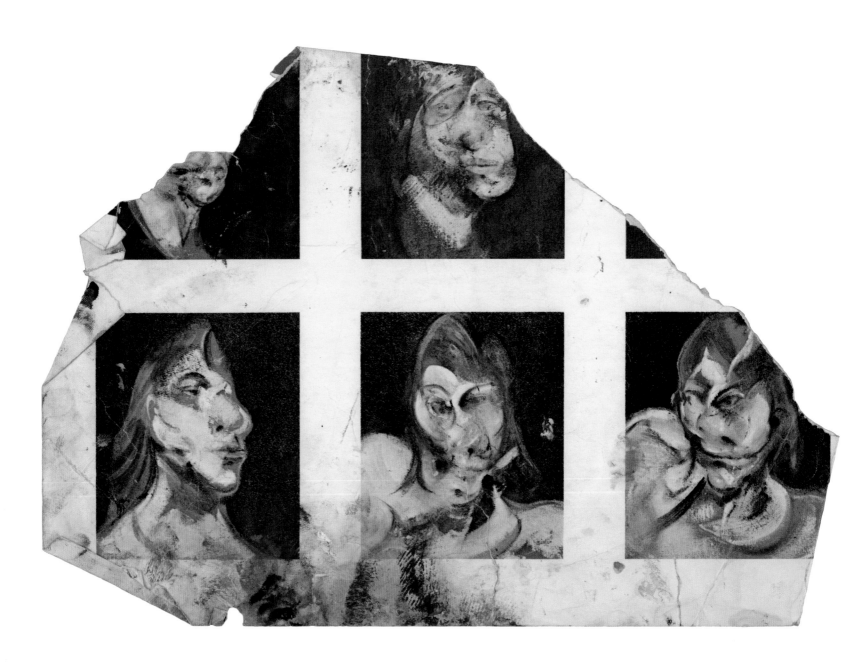

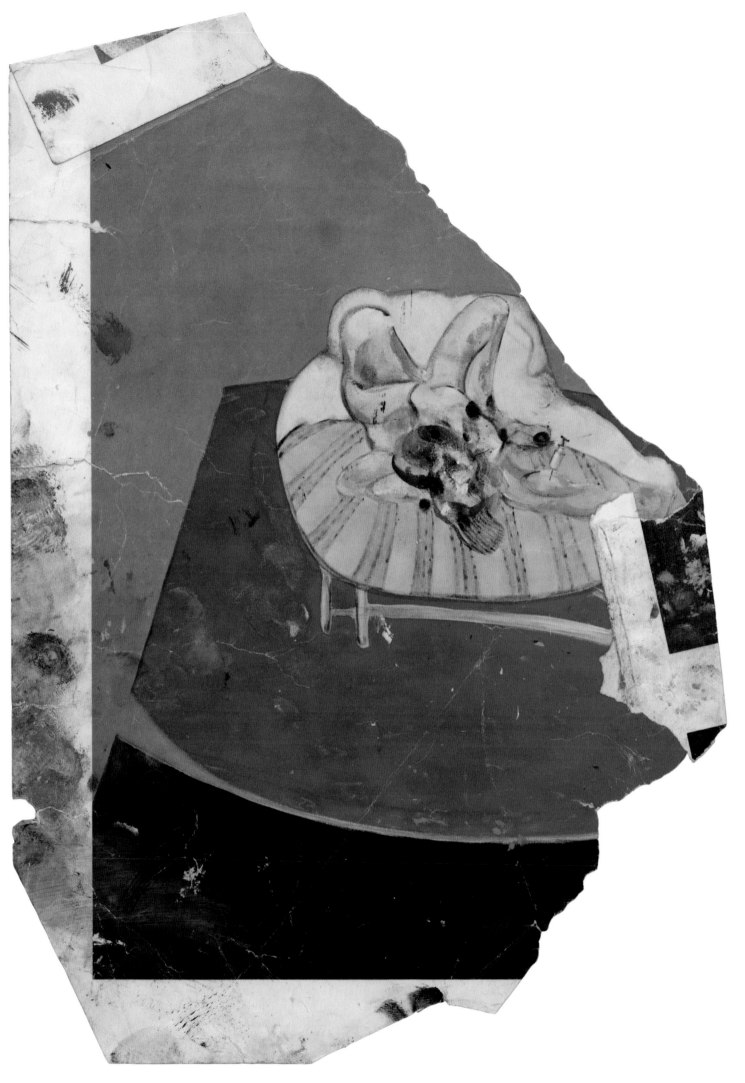

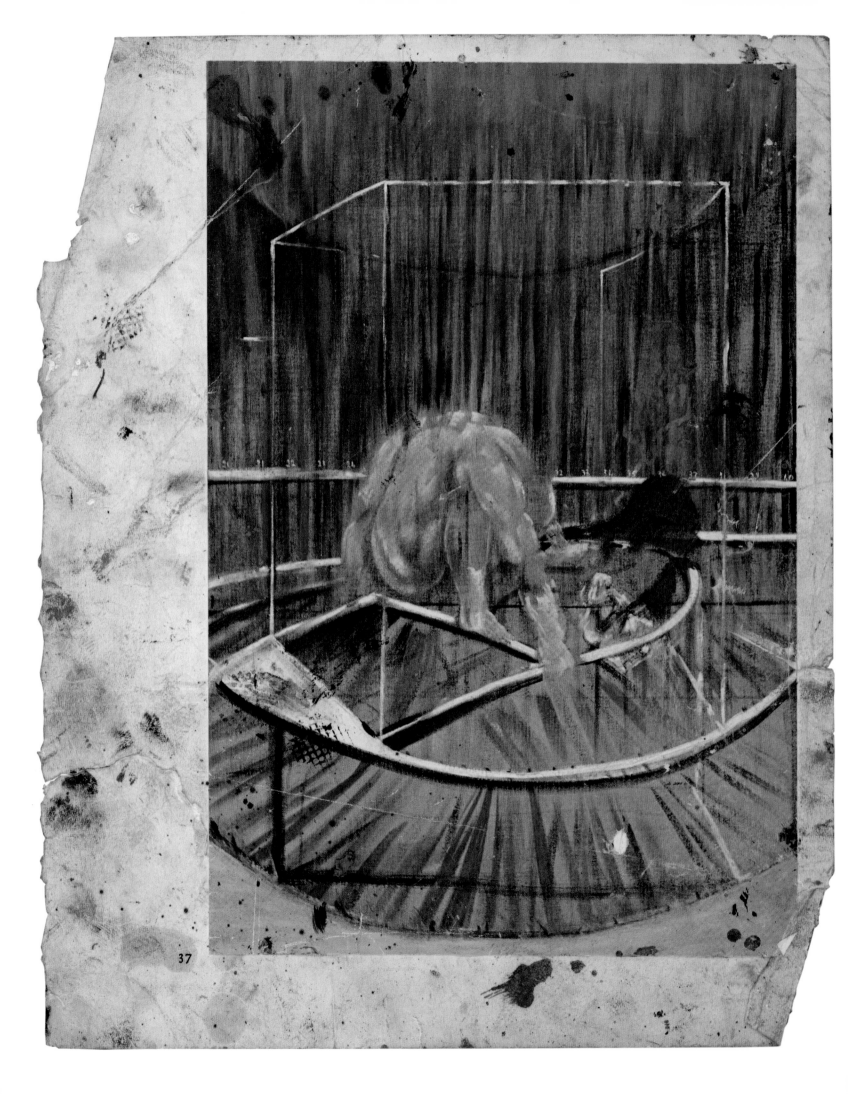

37

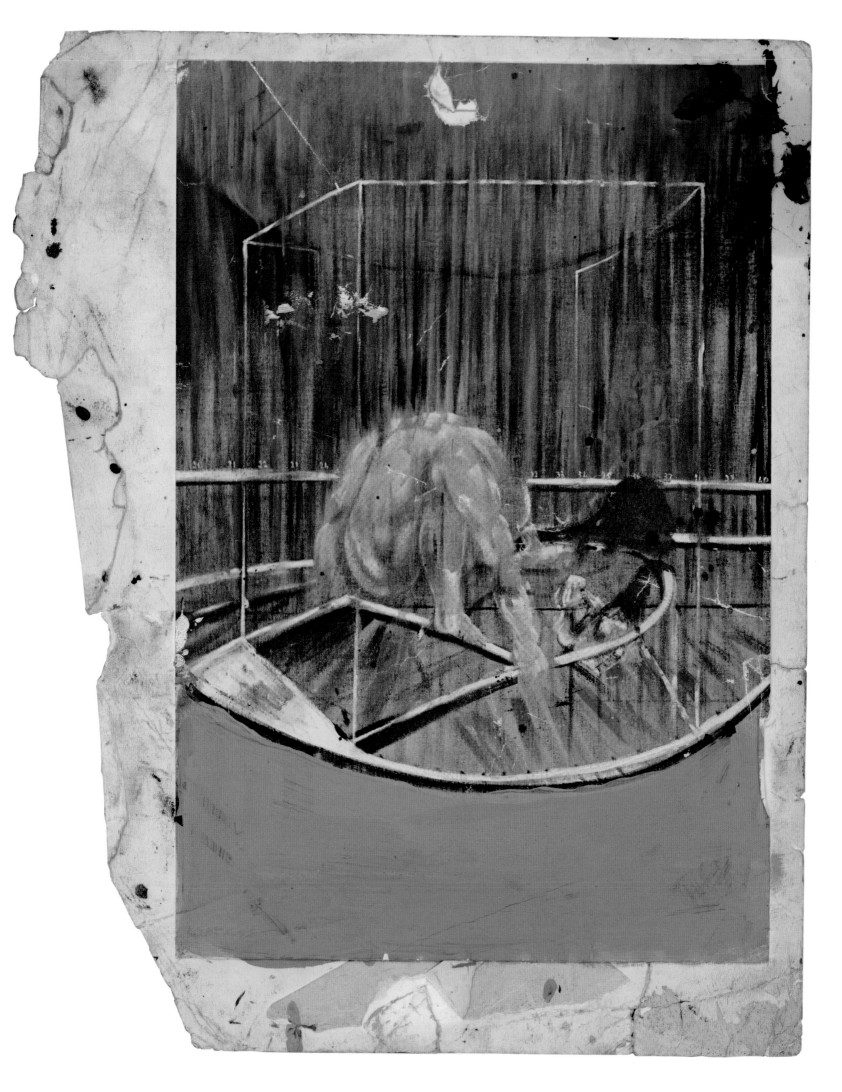

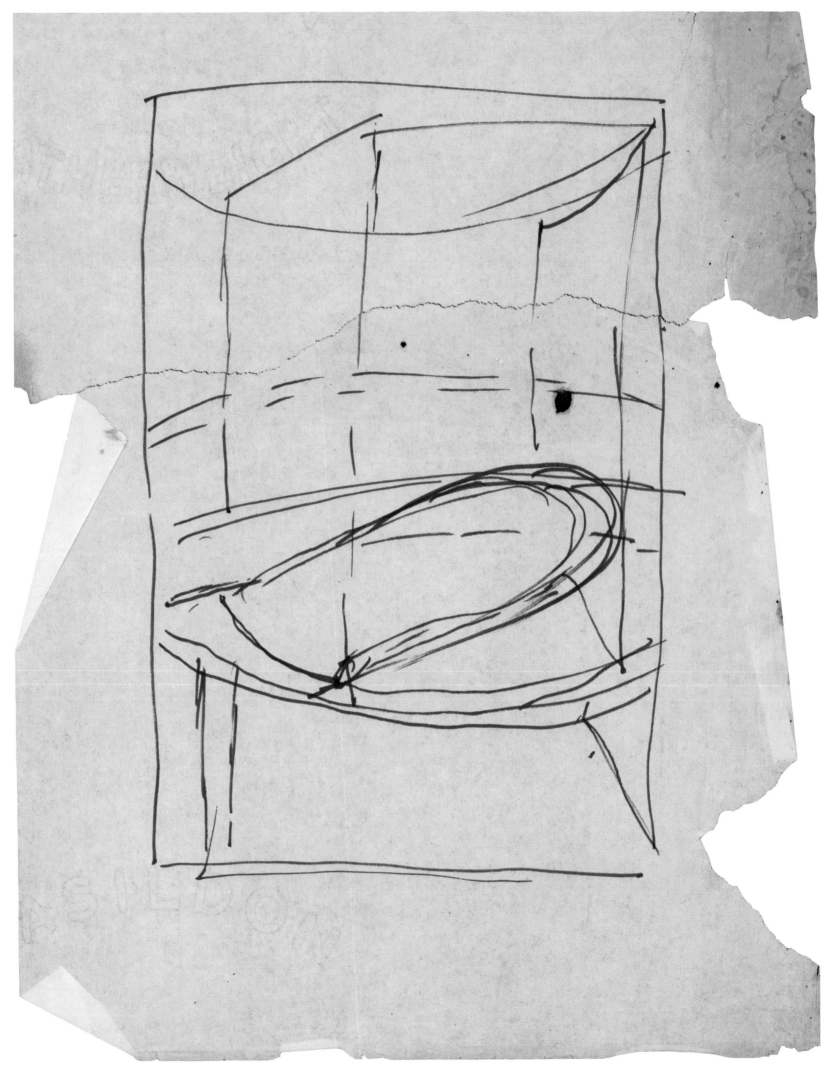

THE
HYPERION MINIATURES
IN THE
MASTERS IN ART Series
present a new library, covering in
individual volumes the life and art of
all the great masters.

VAN GOGH EL GRECO DEGAS
RENOIR BOTTICELLI REMBRANDT
GOYA CEZANNE

Each book is a complete Monograph
with eight reproductions in full colour
and forty halftones.

In preparation :
MANET GAUGUIN TOULOUSE-LAUTREC
PICASSO FRA ANGELICO
LEONARDO DA VINCI BRUEGHEL
VELASQUEZ

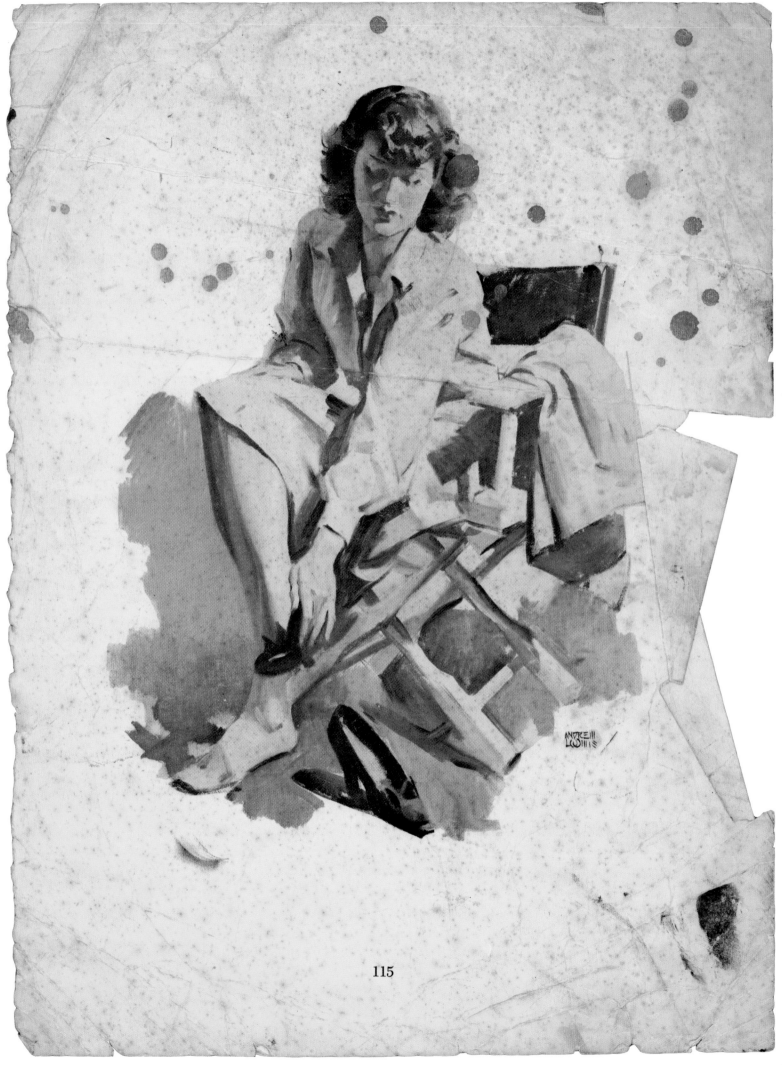

115

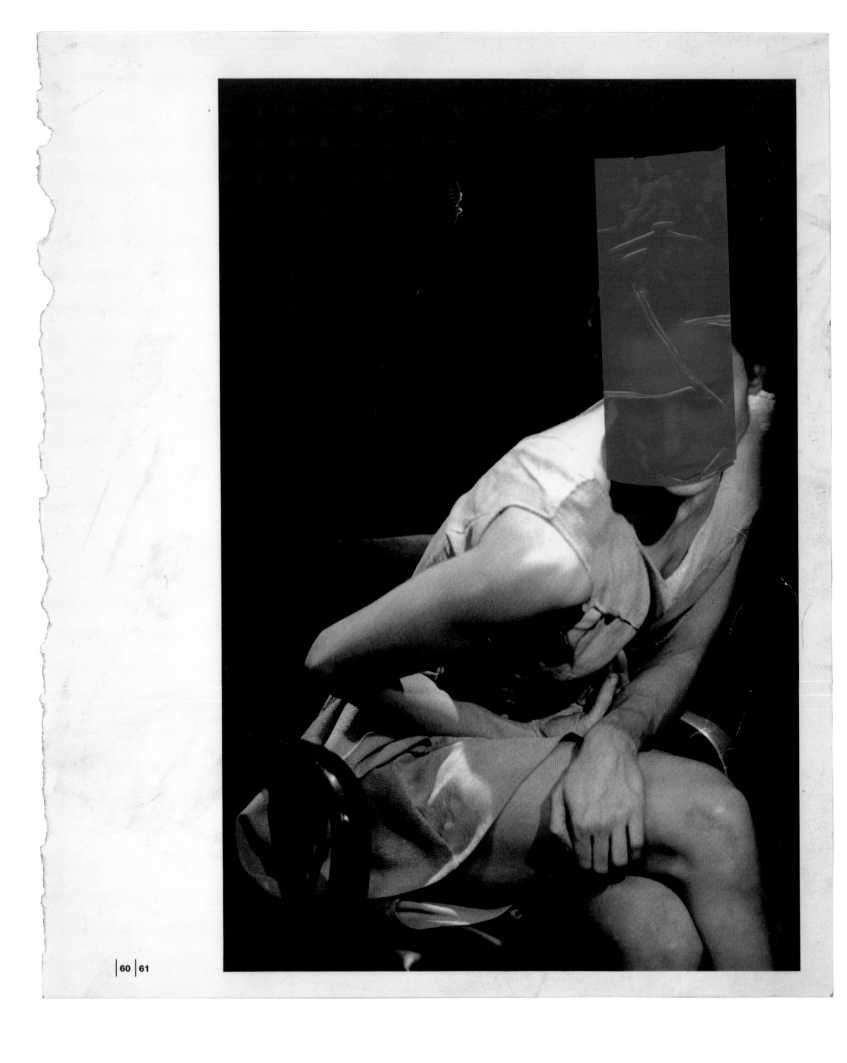

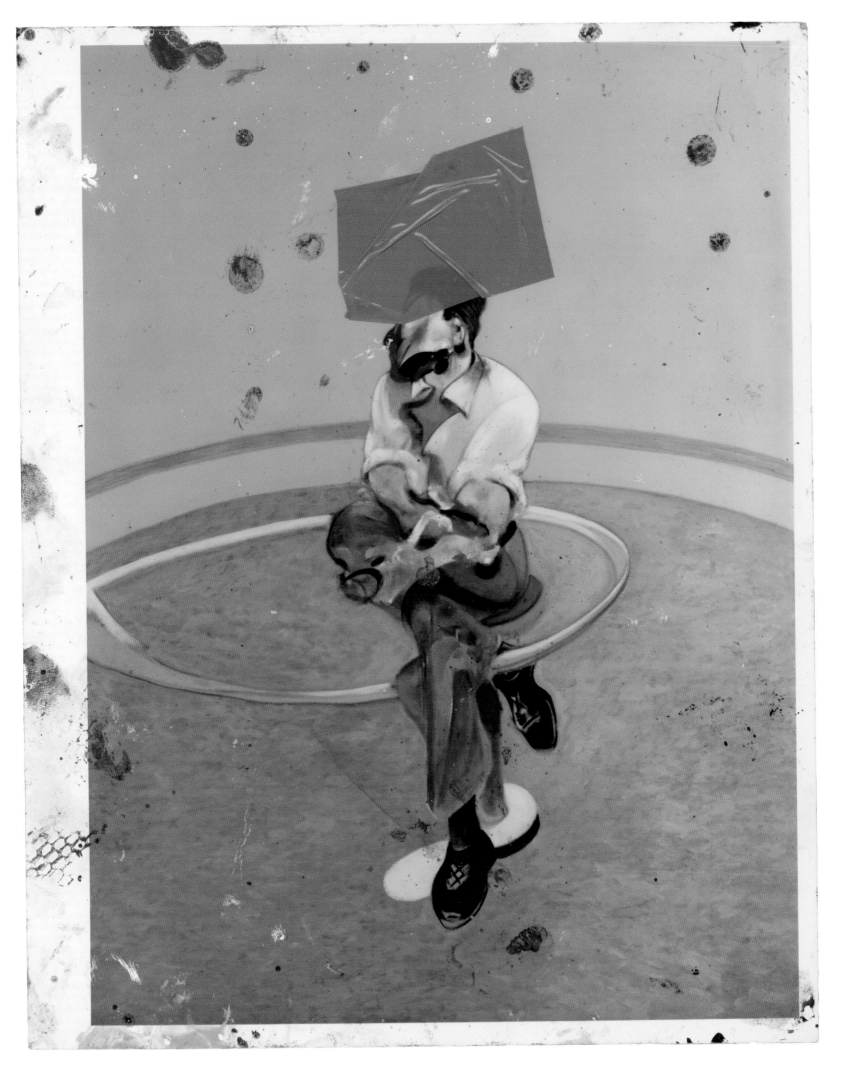

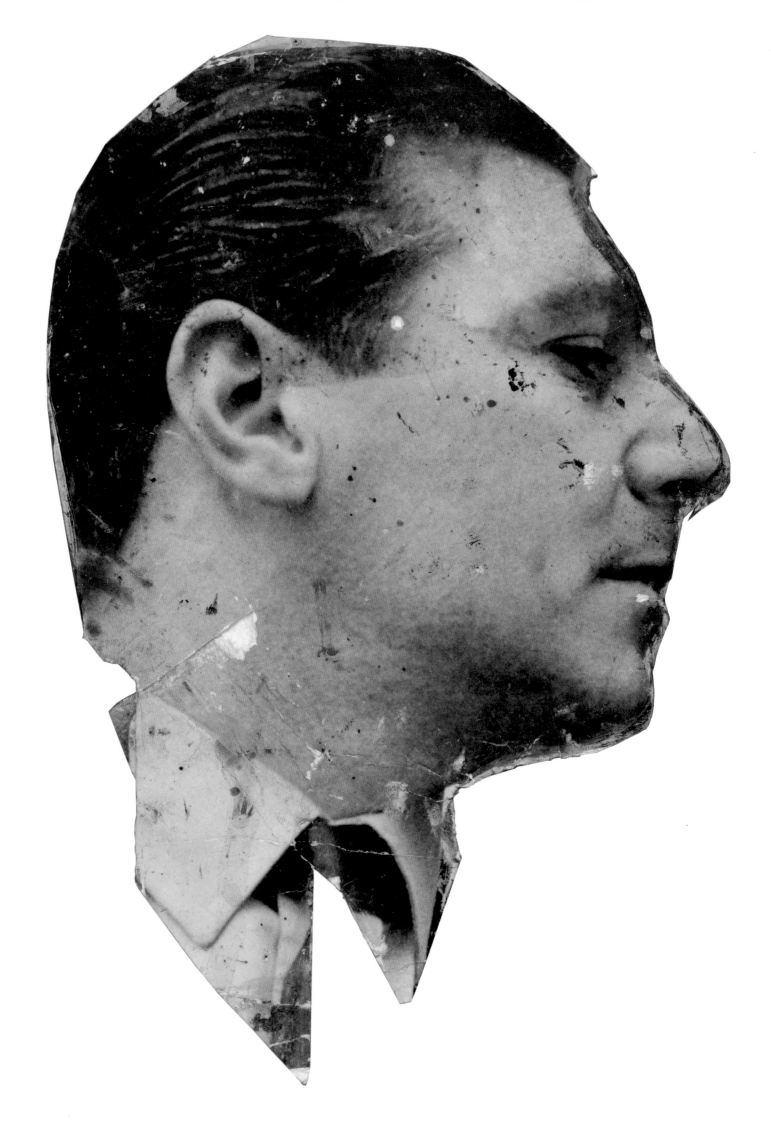

Commentaries

Muybridge's ground-breaking serial photographs, analysing humans and animals in motion, were made between 1872 and 1885. They were first employed by Bacon in 1949 – at the precise moment when the human body became the main subject of his paintings. In combination with other images, and often radically modified (as Bacon put it: 'I manipulate the Muybridge bodies into the form of bodies I have known'), they remained the principal departure point for his depictions of the human figure.

15. 'Man Shadow Boxing', fragment from book, Eadweard Muybridge, *The Human Figure in Motion*, New York: Dover Publications, Inc., 1955 (plate 63, lower left)

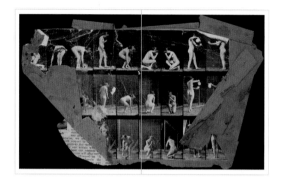

17. 'Various Independent Acts of Motion', leaf from book, Eadweard Muybridge, *The Human Figure in Motion*, London: Chapman & Hall, 1901 (p. 119)

This fragment was cut out by Bacon and mounted on a grey-brown support; just visible is another fragment, from the American nudist magazine, *Sunshine and Health*, 1936.

First published in 1901, the Chapman & Hall volume from which Bacon removed this page was republished in many subsequent editions, until 1955. This page was probably taken from Bacon's copy of the 7th impression, 1931. Given this date, and that of the magazine stuck to its reverse, there is a possibility that Bacon was looking at Muybridge in the 1930s.

18. 'Man Performing Standing High Jump', leaf from book, Eadweard Muybridge, *The Human Figure in Motion*, New York: Dover Publications, Inc., 1955 (plate 28)

19. 'Man Performing Running Broad Jump', leaf from book, Eadweard Muybridge, *The Human Figure in Motion*, New York: Dover Publications, Inc., 1955 (plate 27)

20. (left) Baccio Bandinelli, *Hercules and Cacus*, (right) Michelangelo, 'Two struggling figures', page from book, Martin Weinberger, *Michelangelo: the Sculptor*, London: Routledge & Kegan Paul and New York: Columbia University Press, 1967 (plates 69.1 and 69.2)

Michelangelo occupied an elevated place in Bacon's pantheon of great artists, but only for his sculpture and his drawings.

21. Michelangelo, *Samson and Two Philistines*, leaf from book, Martin Weinberger, *Michelangelo: the Sculptor*, London: Routledge & Kegan Paul and New York: Columbia University Press, 1967 (plate 70; verso of leaf opposite)

The paint marks on these pages are probably incidental, although the obliteration of the head of Samson may have been deliberate (see 196–97).

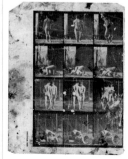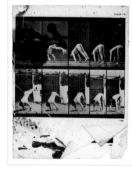

22. 'Man Performing Hand Stand', leaf from book, Eadweard Muybridge, *The Human Figure in Motion*, New York: Dover Publications, Inc., 1955 (right side of plate 73)

23. 'Men Wrestling', leaf from book, Eadweard Muybridge, *The Human Figure in Motion*, New York: Dover Publications, Inc., 1955 (left side of plate 70)

24. Michelangelo, studies for *The Battle of Cascina*, 1504, leaf from book, Luitpold Düssler, *Die Zeichnungen des Michelangelo*, Berlin, Verlag Gebr. Mann, 1959 (unnumbered; Kats 21, 22)

Bacon's folding of this page, using paper-clips to keep the folds in place, seems to echo Michelangelo's drapery folds. Michelangelo's studies for *The Battle of Cascina* were clearly especially resonant for him, and he owned several other books in which they were reproduced.

25. Leaf from book, Luitpold Düssler, *Die Zeichnungen des Michelangelo*, Berlin, Verlag Gebr. Mann, 1959 (unnumbered; Kats 84, 260, 488v.)

The direct relevance, for Bacon, of Michelangelo's drawings of the male figure in motion, is emphasized in his vigorous encircling of the bent leg, lower left.

26. Art Byman, photograph by AMG, front cover of *Physique Pictorial*, Los Angeles, California: AMG, vol. XI-3, March 1962

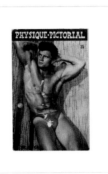

27. Front cover of book, Jean Charbonneaux, *Les Sculptures de Rodin*, Paris: Fernand Hazan, 1949

Bacon's uncle, Sir Cecil Harcourt Smith, was Director of the Victoria & Albert Museum, London, at the time of Rodin's gift of eighteen of his sculptures to the Museum, in 1914. Rodin was particularly important for Bacon in the 1950s.

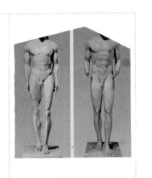

29. Kouroi, 6th century BC, leaf from book, Manolis Andronicos, *The Greek Museums*, Athens: Ekdotike Athenon SA, 1975 (plates 60, 61)

On this occasion Bacon quite neatly folded back the heads in order to concentrate on the bodies. (see *196, 197*)

28. 'The Cyclist and the Thief', by Tom of Finland, front cover of *Physique Pictorial*, Los Angeles, California: AMG, vol. XI-2, November 1961

30. (left) Michelangelo, study of nude for *The Battle of Cascina*, 1504; (right) Belvedere Torso, fragment of leaf from book, Frederick Hartt, *Michelangelo*, London: Thames & Hudson, 1965 (p. 23)

31. Fragment of a black and white photograph of George Dyer, taken by John Deakin in Bacon's studio, c. 1965.

Bacon suggested that his interest in antique sculpture may have been intensified by its invariably fragmentary condition. His tearing of the photograph of Dyer transformed it into an approximation of the Belvedere Torso. Bacon often sat cross-legged, and he painted Dyer in a similar pose to this from 1966 onwards.

32. Leaf from book, Jacques Penry, *How to Judge Character from the Face*, London: Hutchinson, 1952 (Chapter A, plates A8–A11)

Noses featured significantly in Bacon's facial topographics. This book was also an alternative source of his directional arrows.

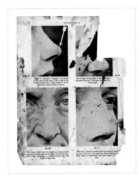
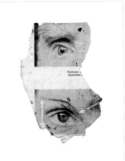

33. Fragment of leaf from book, Jacques Penry, *How to Judge Character from the Face*, London: Hutchinson, 1952 (chapter D, plates D–6 and D–7)

Penry's book was first published in 1939. He went on to invent the 'Photofit', first trialled by Scotland Yard detectives in a murder case in 1970.

34. Front cover of paperback book, Annette Laming, *Lascaux: Paintings and Engravings*, Harmondsworth: Penguin Books, 1959

Bacon, who aimed to 'abbreviate into intensity', was fascinated by the raw language of ancient cave paintings, and collected many images of them, although very few survive.

 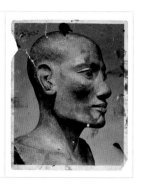

35. 'Salt Head', leaf from book, C. D. Noblecourt, *The Sculpture of Ancient Egypt*, London: The Oldbourne Press, 1960 (plate 24)

The beautiful Salt Head was named for the nineteenth-century Egyptologist Henry Salt, who donated it to the Louvre. Bacon valued Egyptian art above that of any civilization. Possibly of generic rather than direct significance for Bacon's paintings, this illustration was the source for David Hockney, *Four Heads (Egyptian)*, 1963 (destroyed).

36. Leaf from book, Kurt Lange, *König Echnaton und die Amarna-Zeit*, Gesellschaft für Wissenschäftliches Lichtbild, Munich, 1951 (plate 35)

The incised marks made on this photograph of a plaster death mask of an Egyptian (Berlin Museum; tentatively identified as Amenophis III) indicate that in addition to the straighter creases Bacon also traced over the outlines of the face.

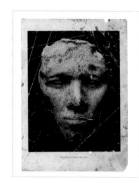

37. Amenophis III (?), fragment of leaf from book, C. D. Noblecourt, *The Sculpture of Ancient Egypt*, London: The Oldbourne Press, 1960 (plate 18)

Reproduced from a different photograph of the death mask opposite, the foldings of this leaf are approximately consistent with the diagonal marks made by Bacon on the earlier image.

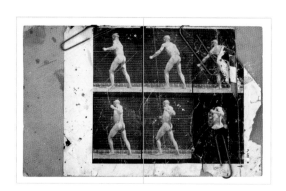

38–39. 'Man Shadow Boxing', page from book, Eadweard Muybridge, *The Human Figure in Motion*, New York: Dover Publications, Inc., 1955 (lower half of plate 64)

The black overpainting of the lower right frame exemplifies one of Bacon's techniques for concentrating on details of source images. Decontextualized, the pose of the figure is transformed into a typically Baconic fragment. Despite this, no paintings have been identified for which this detail definitely acted as the basis.

41. 'News on Camera', cutting from the *Evening Standard*, 10 February 1971 (p. 3)

The 'News on Camera' feature, which ran every weekday in the (London) *Evening Standard*, covered a topical event with briefly captioned photographs. An earthquake in the San Fernando Valley, California, had caused devastation, including the partial destruction of a freeway flyover. The pace of news coverage meant that this story, published in the 'City Prices' edition, had been dropped by the final edition.

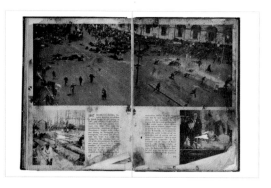

42–43. Double-page spread in book, D. C. Somervell, *100 Years in Pictures*, London: Odhams Press Limited, 1951 (pp. 202–3)

Bacon collected many examples of this famous high-angle image of the 1917 Petrograd riots. He was fascinated by the camera's ability to arrest people in motion in attitudes that, prior to the invention of photography, would not have appeared realistic.

44–45. Double-page spread in book, John Masters, *Fourteen Eighteen*, London: Michael Joseph, 1965 (pp. 60–61)

Symbolic of the new horrors of aerial combat, the impression left on the ground of an airman who had fallen from a Zeppelin may also have intrigued Bacon on account of the angles of the limbs.

46. Leaf from book, Jean Eparvier, *A Paris Sous la Botte des Nazis*, Paris: Editions Raymond Schall, 1944 (unnumbered)

This gravure-printed photographic chronicle of Paris under German occupation was conceived in 1944 and published three months after the city's liberation in August 1944. Bacon seemed fascinated by high-angle photographs that isolated humans in unusual attitudes.

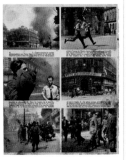

47. Leaf from book, Jean Eparvier, *A Paris Sous la Botte des Nazis*, Paris: Editions Raymond Schall, 1944 (unnumbered; verso of page opposite)

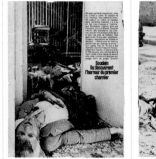
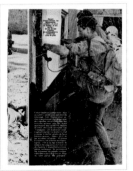

49. Leaf from 'Horreur à Kolwezi', *Paris Match*, 2 June 1978 (p. 99)

French legionnaires stormed abandoned houses in which rebels were hiding. Zairians and Europeans were massacred by soldiers as young as fourteen years old. Bacon folded parts of this leaf, although it is unclear whether it was this page or its reverse (opposite) he was manipulating.

48. Leaf from 'Horreur à Kolwezi', the lead feature in *Paris Match*, 2 June 1978 (p. 100)

This issue of *Paris Match* was devoted to the invasion of the wealthy mining town of Kolwezi, Katanga, Zaire, by the Congolese National Liberation Front.

51. Fragment from the *Sunday Times Weekly Review*, 25 July 1976 (p. 25)

The article was based on revelations concerning Winston Churchill and Desmond Morton, Churchill's personal assistant during World War II, in Martin Gilbert's recently published biography of Churchill. The graphic circling of Sir Desmond's head may particularly have intrigued Bacon.

50. Fragment from front page of *The Times*, 28 August 1971, showing two of the twelve women injured by an IRA bomb in Belfast.

The bandage roughly covering a wound on the woman's cheek (left) may have resonated with Bacon, who used tape to cover parts of his printed sources (see *196*, *197*).

53. Torn image of Nazi rally, Nuremberg 1938, mounted on card, from the *Sunday Times Colour Section*, 18 February 1962 (p. 18)

This fragment is from the first feature to publish Hugo Jaeger's colour photographs in Britain, 'The Buried Life of Adolf Hitler'. Its author was Constantine Fitzgibbon, whose wife, Theodora, had been a friend of Bacon's since the 1940s, when she lived with Peter Rose Pulham. An image of Hitler in the same feature was modified by Bacon for the right panel of *Crucifixion*, 1965.

52. Front cover of *Le Crapouillot*, August 1932

This issue of *Le Crapouillot* was part of a series on World War I, 'Histoire de la Guerre', and showed an early casualty, a dead soldier, in August 1914. Bacon was an aficionado of the satirical *Le Crapouillot*, and presumably acquired copies mainly in France.

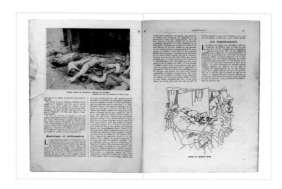

54–55. Double-page spread from *Crapouillot*, May 1938 (pp. 32–33)

Several leaves of this issue of *Crapouillot*, devoted to 'Le Crime et les Perversions Instinctives', were found in Bacon's studio. The juxtaposition of the photograph of a dismembered woman and the George Grosz drawing 'Sex Murder on Ackerstrasse', 1916–17, was probably extremely resonant for Bacon.

56. '2 h 00', leaf from *Crapouillot*, no. 71, 1966 (p. 16)

From a special LSD issue of *Crapouillot*, to which Timothy Leary also contributed. This page is from an extended reportage, photographed by Jean-Philippe Charbonnier, following Jean Henry and Hélène Pinot under the effects of LSD.

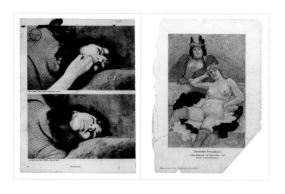

57. Felicien Rops: *Die beiden Freundinnen*, 1885, leaf from book, Eduard Fuchs, *Geschichte der erotischen Kunst: Das individuelle Problem*, Munich: Verlag Albert Langen, 1923–26 (2 vols; unnumbered plate from vol. II)

The Rops is one of many plates Bacon removed from this book. He owned at least two other books by Fuchs, a Marxist cultural historian on whose role as a collector and historian of the art of caricature Walter Benjamin wrote a stimulating essay.

58. Three fragments, mounted on card, *c.* 1969; Géricault, *Couple Amoureux*, *c.* 1815, from book, Klaus Berger, *Géricault et son Oeuvre*, Paris: Flammarion, 1968, p. 41; fragment of wrestlers, from book, Eadweard Muybridge, *The Human Figure in Motion*, London: Chapman & Hall, 1931, p. 215; unidentified cutting, *c.* 1960

The date of Bacon's 'collage' is uncertain, but on the reverse of the card he made a note (now indistinct), 'Triptych 196–', for which this iconography would have been apposite.

59. 'Les Soeurs Papin', page from section torn from *Crapouillot*, May 1938 (p. 17)

In 1933 the Papin sisters, who worked as live-in maids for a retired solicitor, René Lancelin, brutally murdered his wife and daughter. Their trial and imprisonment aroused great public interest in France at the time, and later received attention from Jean-Paul Sartre, Jean Genet and Jacques Lacan.

60. Advertisement for Mode Chemise 1962, torn from *Paris Match*, 17 March 1962

Bacon paid close attention to details of costume in his paintings, particularly to collars and shoes, as he did to hairstyles and noses.

61. Front cover of the *Sunday Times Magazine*, 2 August 1964.

This photograph, by Robert Freeman, announced one of the earliest features on London's emerging 'Mod' movement. Bacon was keenly alert to cultural shifts of this kind.

62. Civilian internment camp, Austria, *c.* 1916. Fragment torn from leaf of book, Leo Longanesi, *Il Mondo Cambia: Storia di cinquant'anni*, Milan: Rizzoli, 1949 (unnumbered)

As Bacon confirmed in a letter to Sonia Orwell in 1954, the book from which he took this image contained some of his most significant pictorial stimuli. The date he acquired it is unknown, but since *Il Mondo Cambia* was published in 1949 the area he isolated in grey paint may be one of his earliest perspectival 'space-frames'.

63. Front cover of book, C. J. Fraser, *Off-Highway Trucks of the World*, Sparkford, Somerset: Haynes Publishing Group, 1985

Bacon disliked conventional artists' palettes, preferring dishes or other implements that were to hand. That he was interested in trucks is entirely plausible, but in this instance the book's hard cover appears to have been picked up to use as an ad hoc palette.

64. Leaf in book, Johannes Itten, *The Art of Color*, New York: Reinhold Publishing Corporation, 1961 (p. 86)

As an artistic autodidact, it is perhaps not surprising that Bacon owned many art primers.

65. Advertisement for Benson & Hedges cigarettes, back cover of the *Illustrated London News*, No. 6986, September 1980

Evidently the inventiveness of Charles Saatchi's Benson & Hedges and Silk Cut advertisements, which ran in the 1970s and 1980s, intrigued Bacon, for several were found in his studio. The American slang term for Silk Cut was 'Bacons'.

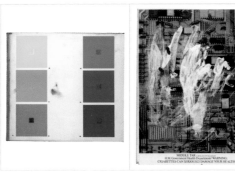
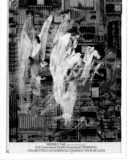

66. Front cover of softcover book, Fred W. McDarrah, *The Artist's World In Pictures*, New York: E. P. Dutton & Co. Inc., 1961

67. Front cover of softcover book, George B. Bridgman, *The Human Machine*, New York: Sterling Publishing Co. Inc., 1961

68. Fragment of leaf torn from *Interview*, vol. XIX, No. 2, February 1989 (p. 61)

Andy Warhol, who died in 1987, was one of the few contemporary artists whom Bacon praised. Warhol had founded *Interview* magazine in 1969. This page was from a feature 'Factory Days', in which Brigid Berlin and Paul Morrissey reminisced about Warhol's Factory in the 1960s: it was timed to coincide with the major Warhol retrospective at the Museum of Modern Art, New York, in 1989.

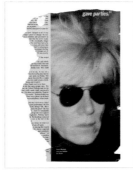

69. Fragment of leaf torn from the *Sunday Times Magazine*, 20 May 1973 (p. 81)

The artist John Minton (1917–57) and Bacon had had a close if sometimes fractious friendship. Bacon informally took over Minton's teaching post at the Royal College of Art for a term in 1950. No doubt Bacon admired this intense and insightful portrait of Minton, painted by Lucian Freud in 1952.

70. 'Sarah Burge', leaf from Victoria & Albert Museum exhibition catalogue, Asa Briggs, *From Today Painting is Dead*, London: The Arts Council of Great Britain, 1972 (plate 46)

Contrary to the original caption, the photograph is actually of Sarah Burgess, a young orphan in a Dr Barnardo's Home in 1883, and the photographer was Thomas Barnes.

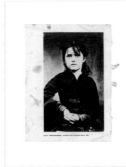

71. Marcel Duchamp, *Sculpture for Travelling*, 1918, leaf from book, Arturo Schwarz and Marcel Duchamp, *The Complete Works of Marcel Duchamp,* London: Thames & Hudson, 1969 (page 303; plate 114)

Duchamp, Picasso and Giacometti were the twentieth century artists Bacon most venerated.

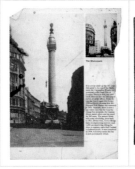

73. Front cover of book, Werner and Bedrich Forman, *Egyptian Art*, London: Peter Nevill, 1962

The black and white photograph of the column used on this cover was not added by Bacon but was, unusually, a glossy bromide print fastened with adhesive by the publisher.

72. 'The Monument', page torn from book, David Whitehead, *London Then: London Now*, London: Dalton Watson, 1969 (p. 14)

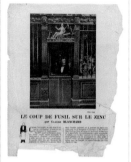

74. Front cover of book, G. Pillement, *Dans les Rues de Paris aux Temps des Fiacres*, Paris: Éditions du Chêne, 1971 (first published 1950)

An ardent Francophile, Bacon loved Paris above all other cities and kept a studio there from 1974 until 1985. This edition was published in 1971, the year of Bacon's triumphant retrospective at the Grand Palais.

75. Leaf torn from *Le Crapouillot*, November 1937 (p. 42)

Eugène Atget (inexplicably mis-spelled in the credit) was a photographer Bacon greatly admired, not least for his depopulated Parisian cityscapes, whose mysterious atmosphere Pierre Mac Orlan and Walter Benjamin had likened to crime scenes.

76. Leaf from book, Stephen Paul, *Illustrator's Figure Reference Manual*, London: Quarto Publishing, 1987 (plate 4:10)

77. Front cover of book, Michael Peto and Alexander Bland, *The Dancer's World*, London: Collins, 1963

78. Dust jacket of book, Stuart Kind and Michael Overman, *Science Against Crime*, London: Aldus Books Limited, 1972

Bacon owned many books on crime and crime-scenes: in his notes of ideas for paintings he referred to the depictions of coupling figures as 'The Bed of Crime'.

79. Front cover of the *Illustrated London News*, No. 6986, September 1980

80. Back endpaper of book, Iain Macmillan and Roger Baker, *The Book of London*, London: Michael Joseph, 1968

Irrespective of his possible admiration for this striking image, Bacon appears to have used it as a surface for testing an aerosol spray. He was fascinated by the semiotics of clothing, and removed book jackets: he spoke of penetrating skin and tore off the hard covers of books – their outer surfaces – recycling them as supports (see *175*) for his iconographical image-bank.

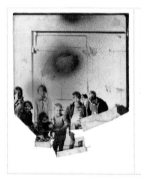

81. Pierre Cardin and Jeanne Moreau, leaf from *Paris Match*, 25 November 1961 (p. 99)

This page was part of a feature on the American dance craze, the Twist, then entering Paris. The meaning of Bacon's paintmarks, which encircle Moreau's face, is unclear.

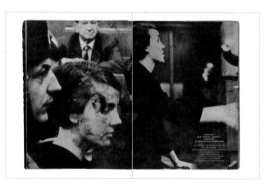

82–83. 'Les Diaboliques de Genève', from *Paris Match*, 21 October 1961 (pp. 108 and 111)

'Les Diaboliques de Genève' reported the trial of Josette Bauer, who had conspired with her rich husband to murder her father. Dressed in a prim black dress, Bauer confounded the jury with her defiant pleas of innocence. She was convicted, but escaped from prison and became involved with a drug smuggling ring in the USA.

Bacon removed the leaf that intervened between these two pages. It is possible (although unlikely) he was more interested in the images he removed, but if so he re-sequenced these already striking photographs into a fortuitously effective double-page spread. His paint marks seem to intensify Bauer's sullied reputation.

85. Joe Louis fighting Nick Braddock, fragment torn from book, Gilbert Odd, *Boxing: The Great Champions*, London: Hamlyn Publishing Co., 1974, (p. 41)

Although Bacon's fascination with boxing was only occasionally manifested directly in his paintings, for example in *Figure in Movement*, 1973, he enjoyed watching the sport and accumulated many images of boxing taken from books and magazines.

86–87. Double-page spread in paperback book, Dennis Signy, *A Pictorial History of Soccer*, London: Hamlyn Publishing Group, 1970 (pp. 128–29)

89. Leaf torn from *Miroir de l'Athlétisme*, no. 89, January 1972 (p. 21)

Bacon tore off the left side of a double-page spread in the magazine, which showed the hurdler Willie Davenport just behind Leon Coleman (depicted here) in the semi-finals of the 1968 Olympics.

88. Tunney v. Dempsey, 1927, leaf torn from book, Nat Fleischer and Sam Andre, *A Pictorial History of Boxing*, London: Spring Books, 1960 (p. 111)

90. Three illustrations showing Joe Louis in action, from book, Gilbert Odd, *Boxing: The Great Champions*, London: Hamlyn Publishing Co., 1974 (p. 42)

91. Archie Moore knocking out Yvon Durelle, 1958, fragment from book, Nat Fleischer and Sam Andre, *A Pictorial History of Boxing*, London: Spring Books, 1960 (p. 176), mounted on the inside cover ripped from a book

92. Leaf from exhibition catalogue, Lawrence Alloway, *Francis Bacon*, The Solomon R. Guggenheim Museum, New York in collaboration with the Art Institute of Chicago, 1963 (p. 19)

Muybridge's sequence 'Some Phases in a Wrestling Match' was the model for all Bacon's coupling figures, and 'Athlete Heaving 75 pound Rock' was adapted for *Study for Nude*, 1951.

93. Highlights of the Hackenschmidt v. Madrali contest, 1906, leaf from book, Graeme Kent, *A Pictorial History of Wrestling*, London: Spring Books, 1968 (p. 161)

94. Syed Kirmani dropping a catch, leaf from book, Patrick Eagar with Graeme Wright, *Test Decade 1972–1982*, Tadworth: World's Work Ltd, 1982 (p. 99), mounted on card

Bacon attended cricket matches with Eric Hall in the 1950s. This book, and David Gower, *With Time to Spare*, 1980, were said to be catalysts for the cricket paraphernalia Bacon incorporated in seven of his paintings between 1982 and 1987, but the batsman's and wicket-keeper's pads and shoes were present in *Seated Figure*, 1978.

95. Front cover of book, Hugh Taylor, *The Scottish Football Book no. 15*, London: Stanley Paul, 1969

In addition to the figures caught in unexpected poses of quasi-balletic motion, Bacon was probably intrigued by the photographic rendition of the crowd in almost abstract soft focus (see *100–1*).

96. The long iron grip, leaf from book, Louis T. Stanley, *Style Analysis*, London: The Naldrett Press, 1951 (p. 65)

One further leaf from this book is all that survives as evidence of Bacon's interest in golf, or the stances and hand-grips of golfers (see 9).

97. Still from *Un Chien Andalou*, leaf from book, Raymond Durgnat, *Luis Buñuel*, London: Studio Vista Ltd, 1970 (p. 10)

Next to Eisenstein, Buñuel was the film director Bacon most frequently cited as an influence, particularly with reference to *Un Chien Andalou*, 1929, and *L'Age d'Or*, 1930.

98. Front cover of paperback book, Kevin Brownlow, *The Parade's Gone By*, London: Abacus, 1973

In 1962 the film-maker and historian Kevin Brownlow had worked on the Arts Council film, *Francis Bacon: Paintings 1944–62*.

99. Stills from *Battleship Potemkin* and of actress Clara Bow, fragment from *Picture Post*, 7 January 1950 (p. 38)

The cry of the nurse in the Odessa steps sequence in *Battleship Potemkin* was the filmic image most frequently quoted in Bacon's paintings: he also stressed the significance, for him, of the entire film, which he first saw not long after its release in 1925.

100–1. Celebration during the 'Prague Spring', fragment from *Paris Match*, 23 March 1968 (p. 56), mounted on card

After twenty years of communist rule in Czechoslovakia, an elated crowd celebrates Alexander Dubček's liberalization policies. In enlarged photographs disintegration of the grain structure (and thus of representation) into near-abstraction appears to have been powerfully resonant for Bacon (see 95).

102. Eugène Atget, photograph by Berenice Abbott, 1927, front cover of *Album*, August 1970

As an (albeit equivocal) connoisseur of photography, it is noteworthy that Bacon owned a copy of this short-lived British magazine (it ran to only twelve issues), and possibly significant that the cover depicted Atget, for whose photographs Bacon's admiration has already been noted.

103. Still photograph of Jean Gabin in Marcel Carné's film *Le Jour se Lève*, leaf from book, Nicole Vedres, *Images du Cinéma Français*, Paris: Editions du Chêne, 1945 (p. 106)

Although the cinema was clearly a crucial formative influence on Bacon, he was economical in divulging information about the films he had seen. It seems likely, however, that he was familiar with this classic of French poetic realism.

104. Robert Medley, fragment from 'British Art Now', the *Sunday Times Magazine*, 2 June 1963 (p. 10)

Medley and Bacon were acquainted from the 1930s. It was from a dinner party at Medley's house in Fulham in the 1950s that Bacon fled in anger, refusing to submit to W. H. Auden's 'disgusting display of hypocritical Christian morality'.

105. Frank Auerbach in his studio, fragment from 'British Art Now', the *Sunday Times Magazine*, 2 June 1963 (p. 9)

Auerbach was one of Bacon's closest friends in London's art community: a section taken from the catalogue of Bacon's 1962 Tate Gallery retrospective can be discerned at the top of this cutting. The photographs, taken by Lord Snowdon, accompanied an article by David Sylvester, in which Bacon also featured.

106. Front cover of paperback book, John Heskett, *Industrial Design*, London: Thames & Hudson, 1987

Bacon had begun his career as a furniture designer in the 1920s. While he later dismissed his modernist designs as derivative, he continued to pay attention to many aspects of design, and this was frequently manifested in his paintings.

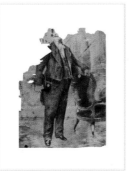

107. Inside pages of an advertising brochure for 'Adaptic', a dental restorative manufactured by Johnson & Johnson Ltd. from 1975 onwards

108. Max Köner in his studio, page from book, Max Jordan, *Köner*, Bielefeld and Leipzig: Verlag von Velhagen & Klasing, 1901 (fig. 1)

It is difficult to imagine that Bacon was attracted to art of Max Köner, an academic portrait painter, but he probably appreciated the artist's distinctive leather jacket.

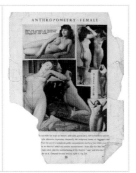

109. Victor Emmanuel II, King of Sardinia, fragment from *Picture Post*, 13 May 1939 (p. 38)

This sepia-toned reproduction was from Part 4 of an early *Picture Post* series, 'History of 100 Years in Photographs'.

110. Untitled picture by Aaron Shikler on torn invitation card to exhibition, *Aaron Shikler; David Levine*, Paris: Galerie Claude Bernard, May 1988

Aaron Shikler (b. 1922) is an academic American artist, renowned for his portraits of politicians. Bacon possibly saw an analogy between the woman's sinewy back and the 'protruding spine' he admired (and mis-read) in Degas' *After the Bath* – beauty mixed with an edgy awkwardness.

111. Leaf from book, John S. Barrington, *Anthropometry and Anatomy*, London: Encyclopaedic Press, 1953 (p. 55)

Another art instruction manual that Bacon may have found useful, this book was aimed principally at amateurs who lacked access to 'ideal models'.

112. Photograph by Roger Mayne from series 'Portrait of Southam Street', from *Uppercase 5*, 1961 (unnumbered; verso of leaf opposite)

Informed by Sir Geoffrey Jellicoe that Roger Mayne was his son-in-law, Bacon exclaimed: 'Oh, the man who takes those marvellous photographs of children'.

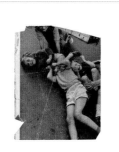

113. Photograph by Roger Mayne from series 'Portrait of Southam Street', recto of leaf from *Uppercase 5*, 1961 (unnumbered)

Mayne's now celebrated photographs of children playing in the streets of North Kensington concentrated on an area that was largely demolished shortly after the reportage was completed. The creasings on this page suggest that Bacon may have concentrated on the disposition of the child's limbs.

114. Back cover of softcover book, Fred W. McDarrah, *The Artist's World In Pictures*, New York: E. P. Dutton & Co. Inc., 1961

116. 'Mandarin dans sa Prison – Suzanne Nicoud à sa Fenêtre', page from *Paris Match*, 24 June 1972, mounted on card (p. 27)

Gérard Nicoud was jailed in November 1971 for his part in organizing protests by the populist movement, CID-Unati. He was photographed in Bonneville prison, while his wife was depicted at the window of the café owned by the Nicouds in La Bâtie-Montgascon. For Bacon the potency of these images may have resided in their aesthetic as much as their political significance.

118. Marcel Duchamp: *Door: 11, rue Larrey, 1927*, page from book, Arturo Schwarz and Marcel Duchamp, *The Complete Works of Marcel Duchamp,* London, Thames & Hudson, 1969 (p. 317)

As found in the Reece Mews studio, this page had been folded by Bacon to isolate the celebrated double-opening door in Duchamp's Paris apartment. Bacon used this modified image as the model for the 'doors' in the outer panels of *Triptych – Studies from the Human Body*, 1970.

120. Fragment from cover of *Chroniques de l'Art Vivant*, no. 39, Paris, May 1973, mounted on card

Edited by Jean Clair, *Chroniques de l'Art Vivant* was published by Maeght Editions from 1968 to 1975; the issue for December 1971/January 1972 contained an interview with Bacon. Details from this nondescript yet curiously suggestive fragment, such as the square light-switch housing and cable conduit, were translated immediately in his paintings, for example, *Self-Portrait* (1973) and *Triptych May–June 1973*.

Kathleen Clark's book *Positioning in Radiography* was first published in 1939. Illustrated with nearly one thousand high quality black and white photographs, it was among Bacon's most frequently consulted source-books of medical imagery.

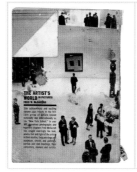

115. Dust jacket (back) of book, Van Deren Coke, *The Painter and the Photograph*, Albuquerque: University of New Mexico Press, 1972

Bacon probably received a complimentary copy of this title (first published in 1964,) since the author discussed his paintings at some length in the context of photography and film. If so, it serves as a reminder that Bacon did not necessarily purchase all the books he owned.

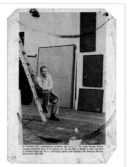

117. Ad Reinhardt in his studio, leaf from book, Fred W. McDarrah, *The Artist's World In Pictures*, New York: E. P. Dutton & Co. Inc., 1961 (p. 173)

Like the page opposite, the relationship between the figure and the simplified geometry of the background may have suggested to Bacon the format of a painting: the two semi-circles added by Bacon reinforce this theory. Bacon was notoriously dismissive of abstract art, saying it was merely decorative and lacked the essential tension between figuration and formal qualities.

119. 'Reflections and Mirroring', photograph by O. William Keck, 1939, from book, L. Moholy-Nagy, *Vision in Motion*, Chicago: Paul Theobald and Company, 1947 (p. 201)

121. Adolf Eichmann in jail, fragment of page torn from *Paris Match*, 15 April 1961 (p. 75)

Bacon mounted this cutting of a Gjon Mili photograph of Eichmann on another page torn from what appears to be a book on Modigliani before mounting both fragments on card. Bacon borrowed Eichmann's bent posture and the brush quite literally for a painting he made c. 1961 but which he later destroyed.

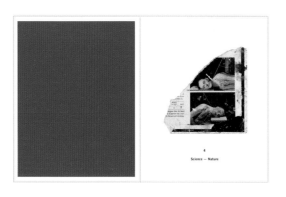

123. 'Mandible', fragment of photograph of page from book, K. C. Clark, *Positioning in Radiography*, London: Ilford Ltd; William Heinemann, 8th edition,1964 (plates 1103, 1104; photograph by Prudence Cuming Associates Ltd, 1974)

This fragment was torn not from the book but from a photograph of a page in Bacon's copy of the book. Bacon captioned by hand, as 'Position in Radiography', the photograph from which he later ripped this portion.

Baron von Schrenck Notzing, his patron Juliette Bisson, and Dr Kafka photographed séances at which spirits were purportedly manifested. One of the heads in Bacon's *Three Studies for Figures at the Base of a Crucifixion*, 1944, was quoted directly from an image in Baron von Schrenck Notzing's book, and imagery that relates to these ectoplasmic auras are prominent in some of his later paintings.

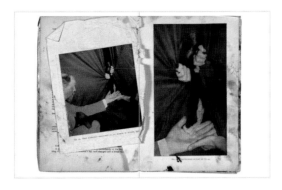

124–25. 'First flashlight photograph by the author, 21 August, 1911', and (right) a magnified section of the same image, a double-page spread from book, Baron von Schrenck Notzing, *Phenomena of Materialisation*, London: Kegan Paul, Trench, Trubner & Co. Ltd, 1920 (figs 43 and 44)

127. Leaf from book, G. H. Percival and T. C. Dodds, *An Atlas of Regional Dermatology*, Edinburgh and London: E. and S. Livingstone Ltd, 1955 (p. 4)

Many pages torn from this book were found in Bacon's studio. While possibly fascinated in a general sense by the gruesome imagery, he may also have found them of specific application when painting distorted anatomical details. The paint markings on many of the plates suggest he frequently consulted the book.

126. 'Author's flashlight photograph of 10 September, 1912', Baron von Schrenck Notzing, *Phenomena of Materialisation*, London: Kegan Paul, Trench, Trubner & Co. Ltd, 1920 (fig. 115)

128. Leaf from book, G. H. Percival and T. C. Dodds, *An Atlas of Regional Dermatology*, Edinburgh and London: E. and S. Livingstone Ltd, 1955 (p. 120)

This Atlas was exceptional in containing as many as 475 coloured plates. Since it was entirely visual it was potentially the most useful to Bacon among the many similar publications. He 'preserved' this page by mounting it on card. Bacon also had many illustrated books on skin diseases of a later date.

129. Leaf from book, G. H. Percival and T. C. Dodds, *An Atlas of Regional Dermatology*, Edinburgh and London: E. and S. Livingstone Ltd, 1955 (p. 5)

These factual images, which might strike non-specialists as macabre, were in a tradition that revolutionized clinical photography. An American book on the subject, published in 1921, described the plates as Dermochromes. T. C. Dodds became Director of the Medical Photography Unit at the University of Edinburgh.

130. Leaf from book, K. C. Clark, *Positioning in Radiography*, London: Ilford Ltd; William Heinemann, 8th edition, 1964 (plates 1137–1140, verso of page opposite)

K. C. Clark's book also served Bacon as a fund of suggestive X-ray images and as an index of idiosyncratic anatomical distortions. Its plates inspired several of his recurrent graphic devices, such as circled areas and directional arrows, as well as poses for figures.

131. Leaf from book, K. C. Clark, *Positioning in Radiography*, London: Ilford Ltd; William Heinemann, 8th edition, 1964 (plates 1134a–1136)

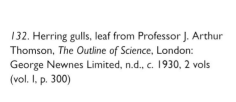

132. Herring gulls, leaf from Professor J. Arthur Thomson, *The Outline of Science*, London: George Newnes Limited, n.d., c. 1930, 2 vols (vol. I, p. 300)

133. Front cover of book, Jen and Des Bartlett, *They Live in Africa: Nature's Paradise*, London: Collins, 1967

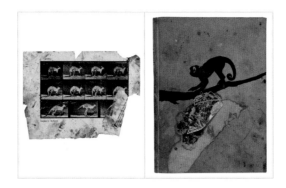

135. Front cover of book, V. J. Stanek, *Introducing Monkeys*, London: Spring Books (n.d.; 1957)

The accretions, besides the cadmium orange and other paints, include a crumpled black and white photograph. Bacon had at least three copies of this book and used the fly-leaves of two of them to make extensive notes of ideas for paintings, in 1958 and 1959.

134. 'The Ricochet', leaf from book, Eadweard Muybridge, *Animals in Motion*, New York: Dover Publications Inc., 1957 (p. 58)

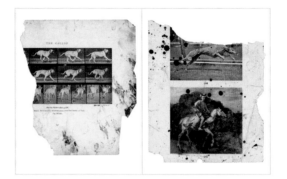

137. A racing greyhound, and Rembrandt: 'The Polish Rider', *c.* 1655, fragment from book, Margaret H. Bulley, *Art and Everyman: A Basis for Appreciation*, London: B. T. Batsford Ltd., 1952; 2 vols (vol. II, plates 644 and 645)

Not only did Bacon venerate Rembrandt, he frequently gambled at greyhound tracks in London in the 1950s. The attribution of the 'Polish Rider' to Rembrandt has, of course, long been questioned, some scholars having given it to Willem Drost.

136. 'The Gallop', leaf from book, Eadweard Muybridge, *Animals in Motion*, London: Chapman & Hall, 1901 (p. 191)

139. 'Face to Face with the African Buffalo', from book, Marius Maxwell, *Stalking Big Game with a Camera in Equatorial Africa*, London: William Heinemann, 1925 (frontispiece, Chapter VII)

This image was attached by Bacon to the back of a nineteenth-century engraving after Holbein (see *170*).

138. 'Telephotographs' of Oryxes, in A. Radclyffe Dugmore, *Camera Adventures in the African Wilds*, London: William Heinemann, 1910 (plates unnumbered; between pp.138–39)

141. 'Roaming the Forest', page from Chapter 4, 'Apes and Monkeys' (by E. P. Boulenger) in book, *Wild Life Illustrated*, London: Odhams Press Limited, 1945 (p. 79)

This page, depicting a gorilla, was on one of two leaves torn from the book that were found in Bacon's studio.

140. Humboldt's Saki and Silky Marmoset, from book, Frank Finn and Martin A. C. Hinton (this vol.), *Hutchinson's Animals of All Countries*, London: Hutchinson & Co., n.d., *c.* 1924, (4 vols; vol. I, p. 105)

142. A nineteenth-century lithograph by Daniel Perea demonstrating the *quiebro* performed from a chair, page from book, Eduardo Bonet, Luis Fernandez Salcedo et al, *Bulls & Bullfighting*, New York: Crown Publishers Inc., 1970 (p. 241)

143. Page from book, Eduardo Bonet, Luis Fernandez Salcedo et al, *Bulls & Bullfighting*, New York: Crown Publishers Inc., 1970 (p. 95)

144. Front cover of book, Robert Daley, *The Swords of Spain*, London: Allen Lane The Penguin Press, 1967

145. Front cover of book, Robert Daley, *The Swords of Spain*, London: Allen Lane The Penguin Press, 1967

Three copies of this book were found in Bacon's studio, all with different paint markings on the cover. It is one of many examples of his multiple acquisitions of the same book or image. The bullfight (which he called 'a marvellous aperitif to sex'), first entered his iconography in 1967.

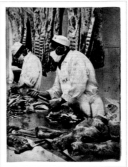

146. Leaf from feature 'Il veut abattre la Citadelle de la Viande, *Paris Match*, 25 November 1961 (p. 43)

This issue of *Paris Match* also contained a cover feature on Rembrandt (at the time of the sale of *Aristotle with a Bust of Homer* to the Metropolitan Museum of Art, New York) as well as the image of Pierre Cardin and Jeanne Moreau (see *81*).

147. Page from feature 'Il veut abattre la Citadelle de la Viande', *Paris Match*, 25 November 1961 (p. 47)

Undercover *Paris Match* reporters penetrated an abattoir, the 'forbidden city' at la Villette, which Secretary of State François Missoffe had been trying to modernize or shut down since 1958. The photographer of this feature, Claude Azoulay, photographed Bacon at the Galerie Claude Bernard in Paris in 1977, both at the gallery and at the pre-demolition Les Halles.

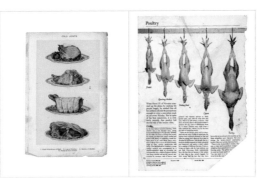

148. 'Cold Joints', plate from book, *Mrs Beeton's Cookery Book*, London and Melbourne: Ward Lock & Co. Limited, 1923 (plate F)

Bacon's friends regarded him as an accomplished cook, specializing in simple but delicious recipes, mainly handed down to him by his mother. It is tempting to speculate whether he also inherited this book from her.

149. 'Poultry', from book, Terence & Caroline Conran, *The Cook Book*, London: Mitchell Beazley, 1980 (p. 84)

Terence Conran and Bacon were friends, and when Conran opened his restaurant *Bibendum* in 1987, it became a favourite haunt of Bacon's. *The Cook Book* was published in the year before Bacon painted a triptych in which the left panel was based on the middle bird on this image (see *8*).

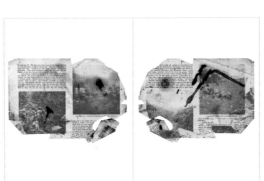

150. Fragment from book, J. E. Burns, *Adventures in Wildest Africa*, London: W. Walker & Sons (n.d.; 1949)

151. Fragment from book, J. E. Burns, *Adventures in Wildest Africa*, London: W. Walker & Sons (n.d.; 1949)

A record of a big game hunting expedition in Tangyanika, 'Illustrated with Third Dimension Pictures', this was also an early experiment in three-dimensional printing, anticipating by several years the 3-D craze of 1953.

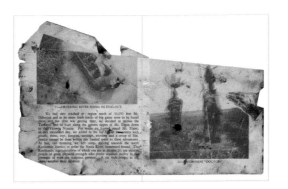

152–53. Fragment from book, J. E. Burns, *Adventures in Wildest Africa*, London: W. Walker & Sons (n.d.; 1949)

Bacon's trips to South Africa in 1950 and 1951 were manifested in several paintings inspired by the wild animals and landscape. The double register of 3-D imagery may have informed his paintings, for example *Two Figures in a Room*, 1959.

155. Detail of Velázquez, *Infante Felipe Próspero*, 1660, leaf from book, Jonathan Brown, *Velázquez: Painter and Courtier*, London and New Haven: Yale University Press, 1986 (p. 227)

Long after he had ceased quoting from his paintings, Bacon's admiration for Velázquez remained undimmed. It is significant that, as late as 1986, he saved this page.

156–57. Self-portrait of Velázquez (detail of *Las Meninas*), on double-page spread from book, José Ortega y Gasset, *Velásquez*, London: Collins, 1954 (plate 105)

Evidently Bacon owned copies of both this and the simultaneous French edition (*169*), which had identical plates. Presumably the marks on these pages are incidental: only one painting by Bacon relates to *Las Meninas*, *Triptych March 1974*, but he may have retained this reproduction as much out of admiration for the Spanish master.

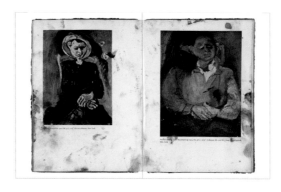

158. Bacon's preference for Soutine's Céret-period landscapes has often been noted, but clearly the portraits also informed Bacon's paintings of the late 1950s.

159. Chaim Soutine, *Boy with Round Hat*, 1922 and *Portrait of the Sculptor Miestchaninoff*, 1923, double-page spread from exh. cat., Monroe Wheeler, *Soutine*, New York: Museum of Modern Art, 1959 (pp. 58–59)

Despite equivocating about Soutine, at least in his public pronouncements, during the period between 1956 and 1962 Bacon was clearly impressed by both his paintings and his direct method – the eschewal of drawings.

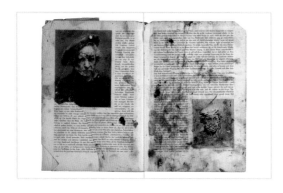

160–61. Double-page spread (with lower part of left page removed) from book, Wilhelm Pinder, *Rembrandt's Selbstbildnisse*, Königstein im Taunus and Leipzig: Karl Robert Langewiesche Verlag, 1945 (pp. 102–3)

Bacon was especially familiar with the Rembrandt self-portrait, *c.* 1660, in the Musée Granet, Aix-en-Provence (upper left). Like many Rembrandt paintings its authenticity has been questioned, but at present the attribution to the master is generally considered secure.

162. Fragments of two separate plates (D–6 and D–9) from Jacques Penry, *How to Judge Character from the Face*: London, 1952

The characteristically distorted physiognomies in Bacon's paintings are anticipated in this twisted combination of his multiple base materials.

163. Fragments of Rembrandt, *Self-Portrait at the Easel*, 1660, from book, Tancred Borenius, *Rembrandt*, London: Phaidon Press, 1952 (plate 79) and leaf from book, Orrin Keepnews and Bill Grauer Jnr, *A Pictorial History of Jazz*, London: Robert Hale Limited, 1955 (pp. 79/80)

Bacon worked intensely on this assemblage, which he pinned together and over-worked in blue paint. He attached Rembrandt's head to the body of pianist 'Papa' Jimmy Yancey, probably in the period between 1955 and 1960.

164. Raphael, *The Miraculous Draught of Fishes*, leaf from book, John White, *The Raphael Cartoons*, London: Her Majesty's Stationery Office, 1972 (plate 1)

Seven of Raphael's tapestry cartoons are in the Victoria & Albert Museum, close to Bacon's studio, and he is known to have admired them. David Sylvester proposed a link between *The Miraculous Draught of Fishes* and Bacon's *Two Men Working in a Field*, 1971, which cannot, of course, have been indebted to this later reproduction.

166. Detail of Velázquez, *Philip IV of Spain*, cut by Bacon from a feature, 'Velázquez', *Paris Match*, 21 October 1961 (p. 87) and mounted on an envelope

Velázquez was Court Painter to Philip IV. David Sylvester compared the King's 'withdrawn look', 'elongated Bourbon features' and Velázquez's 'beautiful dryness of paint' with the head in Bacon's *Study after Velázquez*, 1950. It is not clear where *Paris Match* found this image, which does not appear in the authentic Velázquez canon.

168. Velázquez, *Portrait of a Dwarf* and the *Infanta María Teresa,* two pages from book (intervening leaf removed), José Ortega y Gasset, *Velásquez*, Paris: René Julliard, 1954 (plates 84 and 87)

170. Engraving by Edouard Lièvre after Hans Holbein the Younger, *The Passion: Disrobing of Christ*, fragment from book, Paul Mantz, *Hans Holbein*, Paris: A. Quantin, 1879 (plate 8)

Although, in the 1940s, like Graham Sutherland he was indebted to the example of Grünewald, Bacon was inclined to deprecate Northern art, objecting particularly to superficial comparisons between his paintings and those of Bosch. This leaf is glued to the back of the photograph of an African Buffalo (*139*).

172. Seurat: *Une Baignade, Asnières*, 1883–84, double-page spread from book, John Russell, *Seurat*, London: Thames & Hudson, 1965 (plate 127)

Seurat was among Bacon's favourite painters. John Russell, the author of this book, published a monograph on Bacon in 1971.

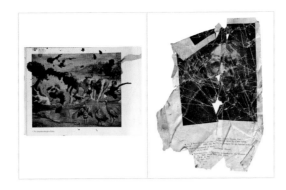

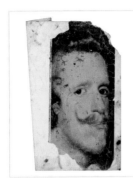

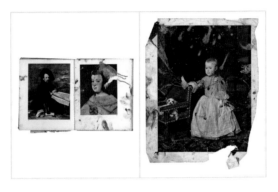

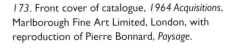

165. Rembrandt, *Self-Portrait, c.* 1660, page torn from book, Claude Roger Marx, *Rembrandt*, New York: Universe Books Inc., 1960 (p. 319)

Another reproduction of the Aix-en-Provence self-portrait (see *160*). Bacon was fascinated by this painting's anti-illustrational aspect, the creation of a factual record from what he described as non-rational, abstract marks.

167. Velázquez: *Philip IV of Spain, c.* 1656, leaf from book, José Ortega y Gasset, *Velásquez*, Paris: René Julliard, 1954 (plate 90)

Bacon knew this Velázquez intimately, and admired it as 'on the edge of caricature'. It was in the collection of the National Gallery, London, and he selected it for the exhibition *The Artist's Eye* at the National Gallery in 1985. This leaf is visible in a 1960 photograph of Bacon's studio at Overstrand Mansions: thus it was an earlier item that survived the move to Reece Mews in 1961.

169. Velázquez, *Infante Felipe Próspero*, 1660, leaf from book, José Ortega y Gasset, *Velásquez*, Paris: René Julliard, 1954 (plate 98)

In 1973 Bacon told David Sylvester he regarded Velázquez as 'in some ways the most miraculous of painters'. He considered this 'one of the most astonishing paintings because it's so intimate yet such an extraordinary image'.

171. Detail of Ingres, *Le Bain Turc*, 1862–63, front cover of exhibition catalogue, *Ingres*, Paris: Petit Palais, 1967–68

Le Bain Turc was evidently one of Bacon's favourite paintings by Ingres. The creases in this example indicate that Bacon folded the image in order to concentrate on the form of the back in the dominant foreground figure.

173. Front cover of catalogue, *1964 Acquisitions*, Marlborough Fine Art Limited, London, with reproduction of Pierre Bonnard, *Paysage*.

174. Front cover (folded) of *Artforum*, January 1977

Although *Artforum* published some of the most original writing on Bacon in the 1970s and 1980s, he is not known to have read the magazine: given the non-figurative bias of most of its content it is, perhaps, unlikely. He probably received a copy of this issue because it carried an advertisement for his exhibition at Galerie Claude Bernard, Paris.

175. French postcard of sand dunes, mounted on inside cover of book (B. S. Johnson, *Street Children*, London: Hodder & Stoughton, 1964)

Bacon may have consulted this image while painting *Sand Dune*, 1983, and the specific profile of the dunes is comparable with other landscapes he painted at this time.

The fragment on the right is clipped over a leaf from a catalogue illustrating a work by Paolo Gilio, *L'Uomo de Eakins*, 1982. The torn fragment is from George B. Bridgman, *Bridgman's Complete Guide to Drawing from Life*, New York: Sterling Publishing Co., 1952 (p. 31) but Bacon added the stool under the figure, bottom left, in black pen. The stool resembles a design used frequently in Bacon's paintings and is similar to that in the left panel of *Three Studies for a Portrait of John Edwards*, 1984.

176–77. Two leaves attached with metal paperclips to cardboard, *c.* 1984

On the left is a typically abbreviated note by Bacon for a painting: 'The image of body to come over white circle'.

178. Copy of photograph of Peter Lacy near Genoa, enlarged from original taken by Bacon in 1954, with spilled paint on copy.

Bacon considered Peter Lacy the love of his life and kept this image on his mantle-shelf until his own death, thirty years after Lacy's. Thus, although it may have inspired earlier paintings, in this case it appears to have served as a personal memento, as well as a possible source image.

179. Photograph of Peter Lacy (possibly at Ostia, Italy), taken by Francis Bacon, 1954

The roll-film format snapshots that Bacon and Lacy took of one another on a trip to Italy in 1954 are of special significance in that they were some of the earliest photographs which informed Bacon's paintings of individuals from within his inner circle. Bacon seldom made use of original gelatin silver prints before 1962.

180. Photograph of house owned by Peter Lacy, Barbados, *c.* 1950s

Lacy asked Bacon to make a painting based closely on this photograph, a request to which Bacon, unusually, acceded. The small (66 x 56 cm) painting that resulted is *House in Barbados*, 1952.

181. Velázquez, *View from the Villa Medici in Rome (Afternoon)*, 1650–51, leaf from book, Enrique Lafuente Ferrari, *Velázquez*, Ohio: World Publishing Co. (Albert Skira), 1960 (p. 81)

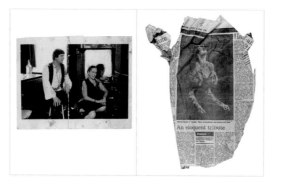

182. Photograph by John Timbers of Ian Board and Muriel Belcher in the Colony Room, London, *c.* 1975 (see *10–11*)

183. Marcia Haydée in Onegin, performed by the Stuttgart Ballet, photograph by Nobby Clark, cutting from the *Observer*, Sunday 4 June 1978 (p. 28; see *11*)

184. Francis Bacon, *Seated Figure on Couch*, 1962

The complex dialogue between the material in this book and Bacon's paintings is a separate and continuing project. The juxtaposition here is intended to indicate the potential significance of this line of research.

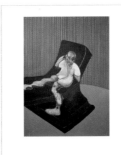

185. Fragment of leaf with illustration by Don Bachardy of Igor Stravinsky and a notice of Bachardy's first exhibition, at Redfern Gallery, London, from *Queen*, 27 September 1961 (p. 4)

Bacon's re-framing of this image, and the sketchy form he added at the right, may relate to the genesis of the figures on couches he painted at this time, such as *Seated Figure on Couch*, 1962.

186. Photograph of Francis Bacon, *Study for Portrait II (After the Life Mask of William Blake)*, 1955

During the period Bacon was represented by the Hanover Gallery, London (1949–58) his paintings were normally photographed only in black and white. Lawrence Alloway suggested that the hotter palette Bacon employed after 1955 may have been attributable to the increased proportion of colour printing in the mass media.

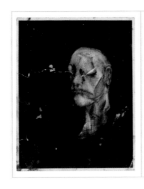

187. Photograph of Francis Bacon, *Study for Portrait of Van Gogh II*, 1957

In the 1960s Bacon's gallery, Marborough Fine Art Ltd, began to have all his paintings photographed in colour. According to Wieland Schmied, Bacon was shown a transparency of a new painting in which, through a fault, the colour had a pronounced blue shift: he liked the unintended effect and, partially in response to this, had the painting returned to him to repaint.

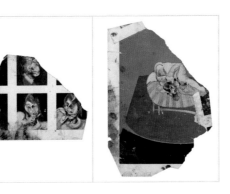

188. Fragments of reproductions of Francis Bacon, *Study for Three Heads*, 1962, and *Three Studies for a Portrait of Henrietta Moraes*, 1963, torn from book, John Rothenstein, *The Masters, 71: Bacon*, Bristol: Purnell & Sons Ltd, 1967 (plate XIII)

189. Francis Bacon, *Lying Figure with Hypodermic Syringe*, 1963, fragment torn from book, John Rothenstein, *The Masters, 71: Bacon*, Bristol: Purnell & Sons Ltd, 1967 (plate XIV; verso of plate XIII, opposite).

Bacon's most significant visual references were his own paintings, and after he moved to 7 Reece Mews in 1961 he kept copies of some of the most important pinned to his kitchen wall.

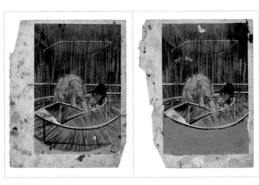

190. Francis Bacon: *Study for a Crouching Nude*, 1952, leaf from book, John Rothenstein and Ronald Alley, *Francis Bacon*, London: Thames & Hudson, 1964 (plate 37)

191. Francis Bacon, *Study for a Crouching Nude*, 1952, leaf from book, John Rothenstein and Ronald Alley, *Francis Bacon*, London: Thames & Hudson, 1964 (plate 37)

Numerous reproductions of this painting were found in Bacon's studio. His handwritten notes record many attempts to develop the 'Crouching Nude' theme. He used this reproduction to make a relatively minor formal change to the composition, simplifying the foreground by eliminating the detail below the rail.

192. Francis Bacon: compositional sketch, closely replicating the formal arrangement of *Study for a Crouching Nude*, 1952

While at first sight preparatory to the painting, this sketch was executed with a felt-tip pen, and probably relates to a variation Bacon was contemplating on the 1952 *Crouching Nude*.

193. Francis Bacon, sketch of figures on a circular rail, c. 1960s

Ultimately another variant of *Study for a Crouching Nude*, 1952, this compositional sketch is comparable with the format of several Bacon paintings of the mid-1960s.

194. Final page (p. 48) of book, Henri Dumont, *Rembrandt*, London, Paris, New York: The Hyperion Press, 1948, with compositional sketch in blue ink by Bacon on the flyleaf opposite

In addition to the works on paper belonging to Tate Britain and a few in private collections, 81 sketches were found in Bacon's studio. This example possibly relates to the painting *Reclining Man with Sculpture*, 1960–61, and the bust may have been based on William Redgrave's bronze bust of Bacon.

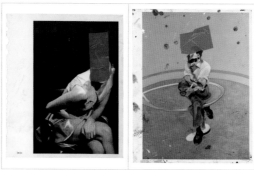

195. Leaf from book, Andrew Loomis, *Creative Illustration*, New York: Viking Press, 1947, or subsequent printings to 1950 (p. 115)

Another item that suggests Bacon may have attempted, in private, the study of conventional drawing techniques.

196. Nathalie Million in 'La Chambre', performed by l'esquisse; photograph by Delahaye, 1988, from book, Joëlle Bouvier and Régis Obadia, *l'esquisse*, Paris: Collection Angle d'ailes, 1991 (plate 60)

The dance magazine *Adage 94*, 1986, reproduced Bacon's *Lying Figure in Mirror*, 1971, an excerpt from Gilles Deleuze's book on Bacon, *Logique de la Sensation*, and an advertisement for an earlier edition of *l'esquisse*. The image here is from the October 1991 edition, and this must have been one of Bacon's last 'interventions'.

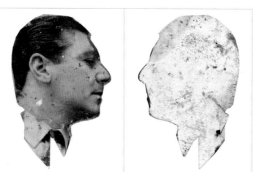

197. Gloss-finish colour photograph of *Study for Portrait of Lucian Freud (Sideways)*, 1971

Bacon may have erased the identity of individuals in order to concentrate on limb positions or other aspects of a composition. Fingerprints, paint-marks, and the imprint of a rubber glove point to this image's use as a protective shield while spraying aerosol paint. Two drawing-pin marks on the reverse suggest that it was pinned down before spraying commenced.

199. Verso of photograph (opposite) by John Deakin of George Dyer, *c.* 1965, cut out by Bacon as template for profile head

The thirteen pinholes at the top of this image indicate that Bacon pinned it to his canvases as a template. It is comparable in size with the profile head in *Study for Head of George Dyer*, 1967.

198. Photograph by John Deakin of George Dyer, *c.* 1965, cut out by Bacon to use as template for profile head

Acknowledgments

To identify the original sources of Bacon's imagery, sometimes based only on evidence contained in the merest torn scrap of paper, can seem an almost impossible task – more forensics than art history. Many organizations and individuals have graciously and patiently helped in bringing the task of researching the caption details to fruition.

At Dublin City Gallery The Hugh Lane our direct communication was with Patrick Casey, Curator for the Permanent Collection, and his unstinting co-operation and enthusiasm for the project has been crucial at many points.

We also offer our most grateful thanks to the following for their help in many ways: Deirdre Abbott (Dublin City Gallery The Hugh Lane), Tim Meaker (Archive Bookstore, Marylebone), Kate Austin (Marlborough Fine Art Ltd), Elizabeth Beatty (The Estate of Francis Bacon), Isabelle Beauquin, Victor Bristoll (British Library Newspapers), George Newkey-Burden (Daily Telegraph), Brian Clarke, Sandra Coley, Clare Conville, Peter Cormack, Prudence Cuming Associates, Christophe Dejean (The Estate of Francis Bacon), Fouli Elia, Gerard Faggionato and Anna Pryer (Faggionato Fine Arts), William Feaver, Glenne Headly, Suzanne Hodgart, Catherine Lampert, Eugene Langan, Jacqueline Little, David A. Mellor, Ian Nevill, Jessica O'Donnell (Dublin City Gallery The Hugh Lane), Gianni Pizzi (Biblioteca Sormani, Milano), Michael Rand, Barbara Schlager, Richard Selby (Redfern Gallery) and Massimo Valsecchi.

My wife, Amanda Harrison, has not only lived through many months of intensive research with her customary forbearance and sympathy, she has actively contributed to days of (often fruitless) searching through dusty shelves in second-hand bookshops. Rebecca Daniels, rightly acknowledged for her pioneering research into Sickert's 'Press Art' sources, had the most strenuous assignment of researching certain newspapers and magazines: since many titles are now only available in microfilm format, this already difficult task was rendered considerably more onerous. Bacon did not respond to microfilm or computer imagery but to the stimulus – both physical and visual – of screenprinted reproductions. As a result of the accelerating trend to jettison original paper materials (it is happening in Paris and Milan as well as in London) the study of European twentieth-century mass-media culture will, in the future, become virtually impossible. In this context, the threat to remove the British Library's Newspaper Library from London is to be deplored.